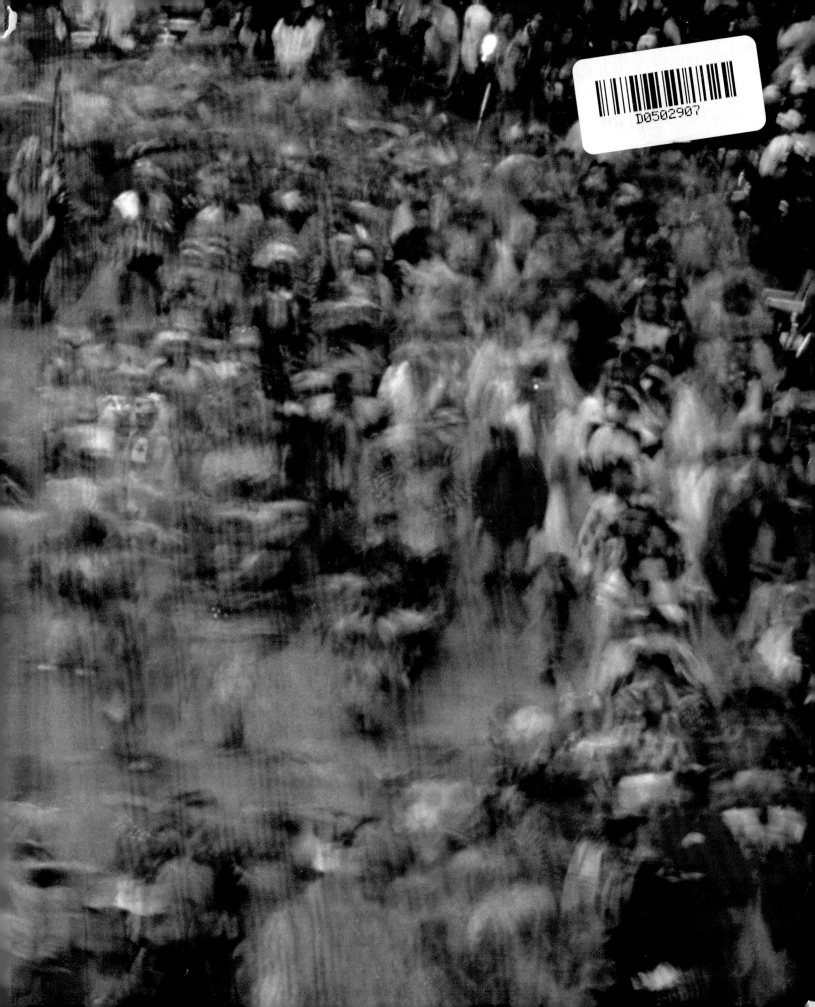

# FACES
*from the*
# LAND

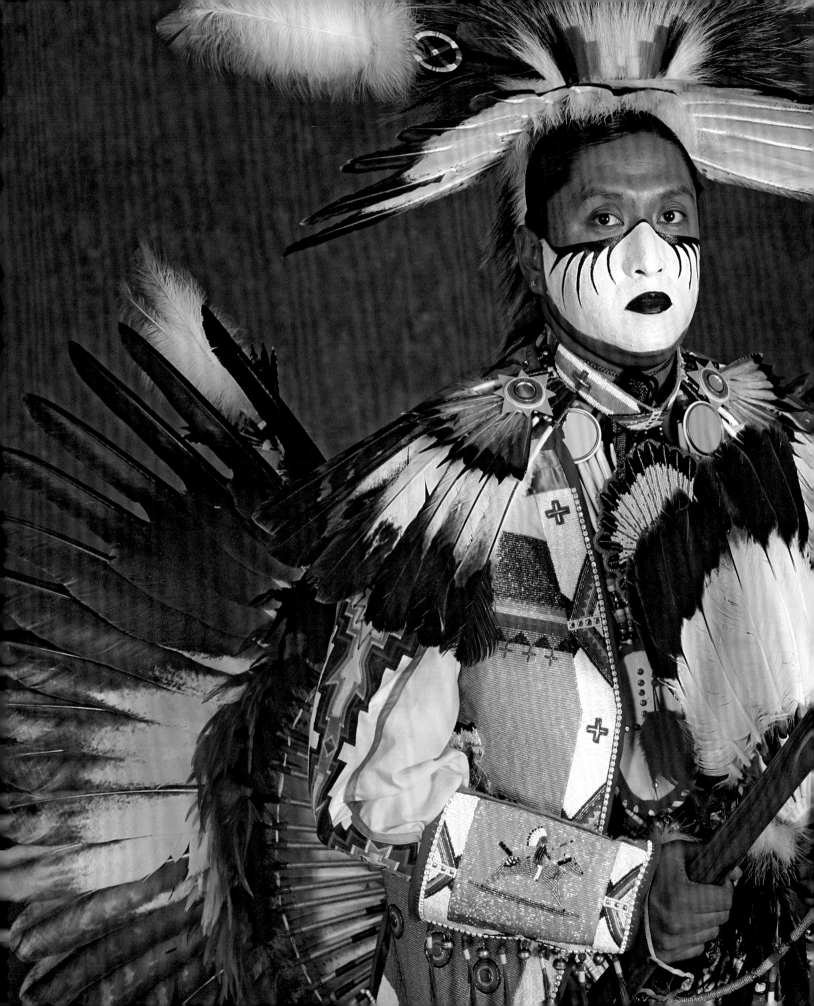

BEN and LINDA MARRA

Photographs by
BEN MARRA

Foreword by
GEORGE P. HORSE CAPTURE

Afterword by
JOANNA COHAN SCHERER

ABRAMS, NEW YORK

# FACES *from the* LAND

TWENTY YEARS OF
POWWOW TRADITION

# and we will not depart from it forever."

—Satank, Kiowa

With gratitude, this book is dedicated to all the dancers—featured or not—who have stepped before our cameras over the last twenty years. While it is impossible to include everyone in this book, we will not forget each contribution to our rich experience documenting North American Indians across this great land. Moreover, many have touched us deeply and everyone, photo subjects and others, has been significant. *Faces from the Land* allows us to share our photographic adventure with every reader who will pick up this book. It is only a token of our gratefulness for the rich memories we now share.

The majority of texts from powwow participants were gathered at the time that the photographs were created, or shortly thereafter. Therefore, some texts are several years old. We strive for accuracy, but we sometimes cannot be certain if tribal words and references are correct.

*frontispiece:*

# Nathan Largo

*Diné*

°

I am the son of Norman and Phyllis Largo, of the Diné people residing in northern New Mexico. I am a descendant of War Chief Manuelito, who fought for his people. I enjoy dancing the Contemporary Northern Traditional style because I am telling my own story without the use of words.

As a new father, I have become aware of how much my daughter is going to want to learn. All of our children will need to be taught the ways of the powwow and how to respect traditions. My own love for participating in the powwows began at the age of five and will never fade as long as the drumbeat is always there.

# Contents

# Foreword

Nothing compares with the impact of being a part of the Grand Entry of a powwow. Vivid colors, handsome people, singing, drumbeats, and flags fill the air with sounds and excitement. Like the warriors of old, fully garbed participants dance into the arbor with feathers a-flying to the pulse of a drama that has been told since the beginning. An honor guard and flags lead the procession of prancing American Indian traditionalists, while we all stand tall and proud to honor them and ourselves for being Indian. A myriad of kinetic feathers, shawls, and buckskins fill the air, but my heart soars when the lovely jingle dress dancers, all in a synchronous row, spring by with hands on hips, heads held high and cones ringing. It is overwhelming, and I feel like bursting with admiration and pride. It wasn't always this way with us.

As a child living with my grandmother on the Fort Belknap Indian Reservation in Montana seventy years ago, we were awakened each morning by the Indian singing of our uncle; when the magic overwhelmed us we would jump out of bed and dance around in our bare feet. The rest of the day we would play everywhere like most country kids. For several years our way of life never altered much and so became part of our soul. As a result of this exposure, we learned how to sing Indian songs and perform the various styles of Indian dance; they became part of us and I still remember those songs.

Soon the yellow school bus carried us off Reservation to the school in town, where our white teachers and townsfolk told us that the Indian people and their ways are no good, and we believed them. Like our parents before us, we believed we had to lose those things that made us Indian to escape the prejudice around us so we could develop unfettered. Many of us moved far away from the pain and tried to be non-Indian; some succeeded. Our visits back home declined as we got good jobs and attempted to blend into the mainstream, but emptiness inside our hearts always kept happiness and fulfillment away in spite of the memory of fry bread.

In the late 1960s, Indian awareness took hold across the country and we began to question our lives and our place in the world. Each of us in our own way decided to change the racist environment and found that truths in our heritage would lead the way. As we started our journey on the Red Road we let our hair grow long in the style of our ancestors and seriously searched out our traditional history and beliefs. These tribal beliefs eventually led us to climb buttes on vision quests or enter sun dance lodges to fast and pray in the way of our grandfathers. It is a wonderful ongoing resurgence. Changing one's life must be guided by need, awareness, decisiveness, and an extended commitment.

On the Great Plains our major musical road is traditionally expressed by a community ceremony called a powwow. They say the original Narragansett Indian word meant "medicine man." Since then it has undergone many interpretations and means much more today.

To more deeply understand the dance one must understand the culture. Long ago there was no formal police department to protect society.

Protection had to be provided by the Indian societies themselves, so the tribes developed a warrior class, whose main duties were to protect the tribe. When successful they were honored by their communities, reenacting their exploits accompanied by society songs while bedecked in special attire. This spiritual ceremony quickly spread from the Omaha Tribe, to the Sioux and beyond, and evolved into the powwow. It is solely American Indian and today most tribes have adopted it.

Each category of dance is differentiated by its apparel and accoutrements. The outfits are all individually constructed or handed down from one's ancestors and are a form of traditional art. A man's traditional attire is the most complex to fashion as it is of fur, beadwork, porcupine quillwork, ribbon work, rawhide, weaving, and other materials. The most special items are the eagle feathers, a spiritual necessity, which require approval from the tribal and federal government to own and can never be sold.

Upon entering the arbor the dancing procession circles clockwise, each category dancing their style according to their attire. Once you as a dancer are in the arbor and dancing hard to a good song that permeates your heart and soul, the world around you recedes and you are dancing with your ancestors of long ago and with the buffalo. You are "shaking the Earth" and the times. This is the only place in the world where this feeling exists—this is Indian Country.

Today our pride knows no bounds. We have come to the forefront with large numbers of Indian college graduates and Indian professionals; there is even a National Museum of the American Indian in Washington, D.C. Every viable Indian community sponsors a powwow most weekends; non-Indians are welcome.

This book is a good reason to celebrate the changing times. Not only do the Marras visit our communities and sensitively present the contemporary Indian people in their finest traditional clothing, they also record the dancers' identities and comments, and even compensate them. So, we wish them long lives for their work as they help us enjoy this new day.

George P. Horse Capture
*A'aninin [Gros Ventre]*
SENIOR COUNSELOR TO THE DIRECTOR EMERITUS
NATIONAL MUSEUM OF THE AMERICAN INDIAN
SMITHSONIAN INSTITUTION
WASHINGTON, D.C.

# Introduction

We were married in 1987 and the following year we attended our first powwow. Since that time, we have driven thousands of miles, met and photographed hundreds of people, listened to the songs of many drum groups, witnessed amazing dancers, and have been honored to view the grand experience called the Powwow. Although we realize these gatherings are only one aspect of American Indian life, our journey has been powerfully inspired by the people we encountered and the pride conveyed in the photographs we have created. The first powwow seems like a very long time ago; however, it profoundly shaped our marriage, brought meaning to our photographic work, and laid the foundation for this book.

Ben, a Seattle commercial photographer, was asked by a printing company client to create a colorful photograph that would illustrate the company's latest printing capabilities. With a theme of "Celebrate Washington State," obvious postcard-type images came to Ben's mind but he quickly discarded them. Instead, he presented the idea of photographing a North American Indian—a descendant of the first people to call Washington *home*. The client's excitement was only surpassed by Ben's challenge of locating, photographing, and completing the assignment in three days. The concept had presented itself without a road map, and we didn't know any Native Americans. Following a few frantic phone calls, we learned of a powwow scheduled that weekend at a small, alternative junior high school, and contacted the principal for permission to photograph.

We had no idea what to expect at a powwow. Proceeding cautiously, we hauled our photo equipment into the vintage school and began setting up a brown background, power packs, and lights in a narrow hallway between the students' lockers. From the gymnasium down the hall we began to hear loud, high-pitched singing voices and thunderous drumming. After waiting an hour in vain for dancers to find us, it became painfully clear that we had to muster the courage to approach the gym and find a compelling subject to photograph. Linda realized this was her job. With trepidation, she opened the door to the gym and stepped into another world.

The result of that evening's photo session not only pleased the printer beyond his expectations; it also sparked our interest in powwows and American Indians, which continues to this day. Within a few weeks, we were off to another powwow—this time, just for the enjoyment and excitement of seeing whom we might meet and photograph. At that time, our only visual reference for Native Americans, aside from Hollywood, were black-and-white images of oppressed reservation Indians or Edward S. Curtis' vintage, sepia-toned photographs.

The stunning color and detail of the elaborate dance regalia amazed us—particularly when we learned that the designs, bustles, and beadwork were usually created by the dancers and family members. Their splendid artistry was constantly evolving into intricate regalia that deserved our photo-documentation. Proper lighting and camera skills could showcase every bead and feather, but it was the dancers' faces that inspired us.

We consider the portraits our "signature work," although Ben shoots action-oriented dance scenes as well. Yearly, both styles fill two wall calendar titles published to expand powwow awareness and provide a fund-raising opportunity for Native youth groups. As the portfolio grew over the years, the portraits spoke most powerfully to us; they seemed to gaze at us and say: "We're still here."

Our awareness grew beyond what we were taught in high school. We learned about the appalling history of this country's ill-treatment of American Indians—the shameful events of Wounded Knee, the Trail of Tears, the Battle of the Big Hole, the Sand Creek Massacre, and the Long Walk of the Navajos, to name merely a few.

Yet at powwows, despite history's deplorable treatment of Indians, we observed American flag motifs incorporated into dance regalia and watched as the Native spectators respectfully stood during Grand Entry while soldiers and veterans were honored for their service in the U.S. military. Respect was shown for elders and small children as well. Shortly after birth, the young children were often brought into the dance circle each cradled in the arms of a trusted family member. As soon as crawling became walking, a child's dancing journey would commence with the family constructing outfits and modeling steps for the Tiny Tots to emulate. Between dances, clothed in elaborate regalia, the children kicked up dust laughing and chasing each other around the powwow grounds, having the time of their lives. Observing this aspect of Native America, complete with present-day warriors, revered elders, and large extended families passing traditions down to children, was heartwarming and inspiring.

Few non-Indians were in attendance during our early years of traveling to powwows, but we never felt uncomfortable in any way. Indian casinos were nonexistent prior to 1992, although plans for many new tribal properties would eventually include powwows. Today powwow's widespread popularity is evident in multiple locations throughout every state and Canadian province as families hit the road to follow their favorite drum groups, dress in their finest regalia, devour Indian tacos, and line up for the spectacular display known as Grand Entry.

Twenty years on the powwow trail have made us realize that powwows are more than mere social occasions with handsome people dancing. The people have chosen a path of commitment, a way of life. They've told us they dance to follow the Red Road—a healthy and meaningful path for life—which also means they have chosen to live free of alcohol and drugs. Many American Indians have experienced firsthand or close-up the devastations of alcohol and drug abuse. They believe deeply that substance abuse short-circuits a natural connection to Spirit and the ancient teachings of Mother Earth's healing properties. By making the commitment to follow the Red Road and dance on the powwow trail, their connection with the Creator can become strong again. Dancing enables them to heal their wounds and live with honor and pride in being Indian. Alcohol and drugs are prohibited at powwows. The Red Road is a healing path for Indian

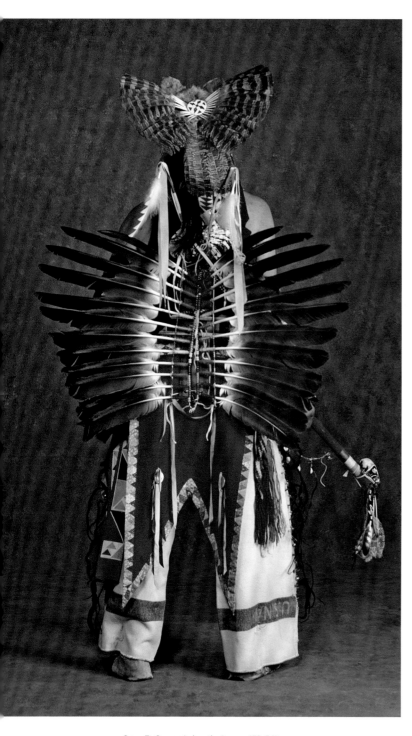

Gary E. Greene's bustle (pages 152–54)

identity in both body and spirit—a path to the Creator.

Our methods for photography haven't really changed much since the beginning. Ben has always used film for the documentation, utilizing the wonderful colors and sharpness found within Fuji's Velvia. Our muslin backdrop was painted for us after the second powwow and has been a connecting element to all the images over the years. The lighting patterns have remained as similar as possible in order that a photo taken twenty years ago can be exhibited with those taken last month. The project is entirely based on personal relationships and trust we have built with the Indian community over the years. We obtain permission to photograph and gain access to a protected physical environment fairly close to the dancing, where we set up our quasi-studio. Although the portraits appear as if they've been created under pristine conditions, the opposite is true. We've been set up in some hectic, bizarre locations such as an abandoned airplane hanger, a former greyhound dog-racing kennel, and an Indian smoke shop. We don't announce ourselves publicly, but rather scout personally for photo subjects by spreading the word among those we know. Now, tribes often contact us to document their powwows.

"Photo-quality" is the key element we're seeking, not necessarily champion dancers; in fact, sometimes the smaller country powwows lacking in fanfare produce the best subjects for us. We believe the spirit of the powwow imbues that special "photo-quality" that might otherwise be missing or have to be created on

location. Often, the dancer has just finished an intensely physical series of dances, beads of sweat trickling down his brow as he rushes in to be photographed. In a brief five- to ten-minute opportunity, Linda greets him, records personal information and tribal affiliations, and strives to create an atmosphere conducive to optimum interaction between Ben and the dancer. Later she will contact him and request a personal narrative to accompany his photograph. No one is ever turned away from being photographed, and all receive one or more photos from the session. Many families tell us the photos are proudly displayed in their homes. We've realized that we are now photographing offspring of children we photographed many years ago.

The photographs have brought interesting opportunities, including an earlier Abrams' book, *POWWOW: Images Along the Red Road*. When the Lewis and Clark Bicentennial Commemoration took place, we were contacted to exhibit thirty-six photographs and personal narratives at the Speed Art Museum in Louisville, Kentucky. We realized our documentary project included individuals from many of the Native American cultures encountered by two important expeditions: Lewis and Clark's Corps of Discovery (1804–06) and Prince Maximilian of Wied's journey across North America and up the Missouri River with artist Karl Bodmer from 1832 to 1834. The Joslyn Art Museum in Omaha, known worldwide for its collection of Bodmer watercolors and prints, presented our exhibit for thirteen months, and the exhibition continues to travel to museums and other venues.

Reflecting upon our life together with photography and powwows as a backdrop, we've been very fortunate that our individual talents and temperaments blended well. The project created a bonus to our marriage and strengthened our resolve personally and professionally. The idea of working full-time together never occurred to us until the amount of powwow images began to cover every working surface in Ben's downtown studio. Linda created the first seeds of the documentary project to which we've dedicated our photographic life. It has captivated and inspired us. As we share this portrait of North American Indian identity, we hope that our photographs and the personal narratives will offer insight, alter some old misconceptions, and contribute to healing.

Ben and Linda Marra

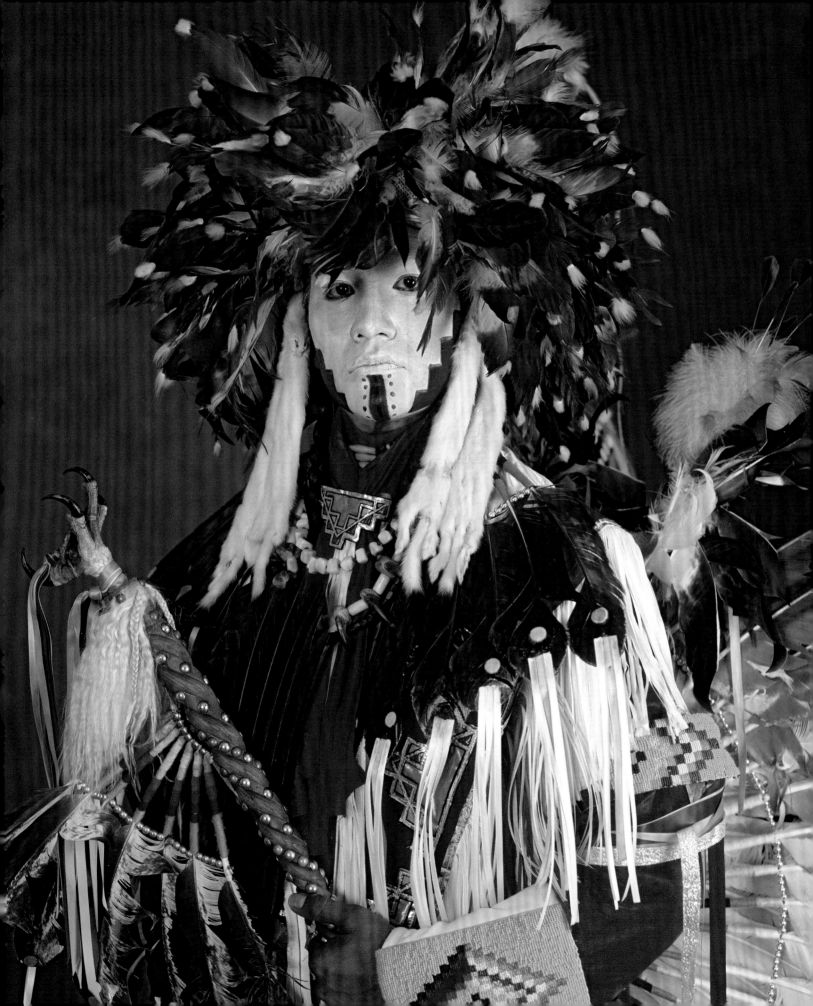

# 1

## "We are all related."

—Mitakuye Oyasin

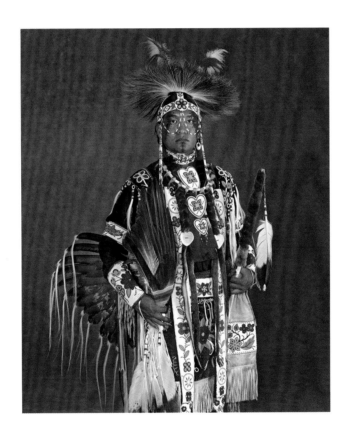

Adam Tsosie Nordwall

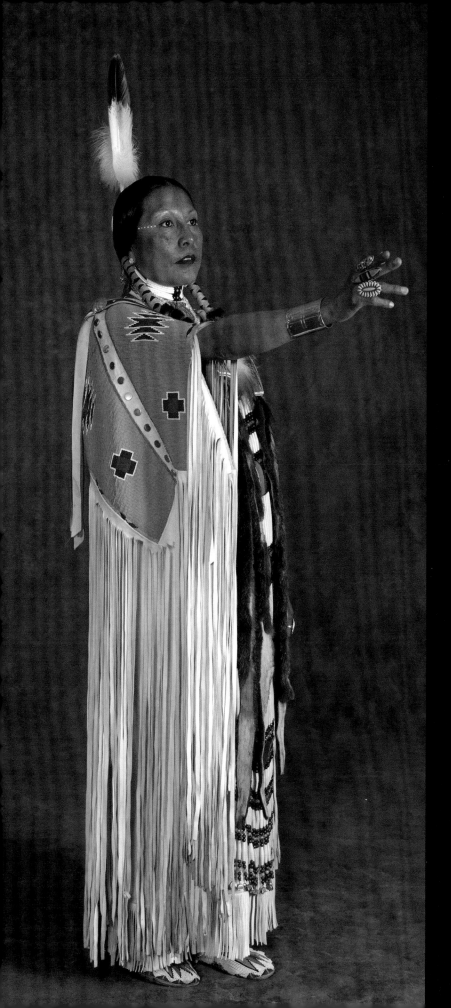

*previous pages:*

# Adam Tsosie Nordwall

*Shoshone ✤ Chippewa ✤ Diné*

I am an Original-Style Grass dancer, although previously I danced Contemporary Traditional. I am wearing the outfit my grandfather handed down to me. It is an old-style Chippewa with floral beadwork. Although I don't remember seeing my grandfather dance, people say that I dance his dance.

My earliest memories have always been on the Powwow Trail, of my father and I spending the entire summer traveling the United States and Canada. I now pass on the memories of "the road" to my children, as we travel the powwow circuit all year, going from coast to coast. "The road" is an uncertain place and our prayers go out to all of those powwow-lifers that travel the many miles from powwow to powwow. May you arrive at the next powwow safely. *Hoka!*

# Rose Ann Abrahamson

*Lemhi Shoshone (Aqui-dika)*

My people are Sacajawea's people. We were raised with a deep respect for tradition, culture, and the joy of dancing. I am most proud to be a family descendant of this great Native woman through my great-great-grandfather Chief Tendoy, the last Lemhi "Aqui-dika" Chief. My role model was my father, Wilford George, who was a champion Men's

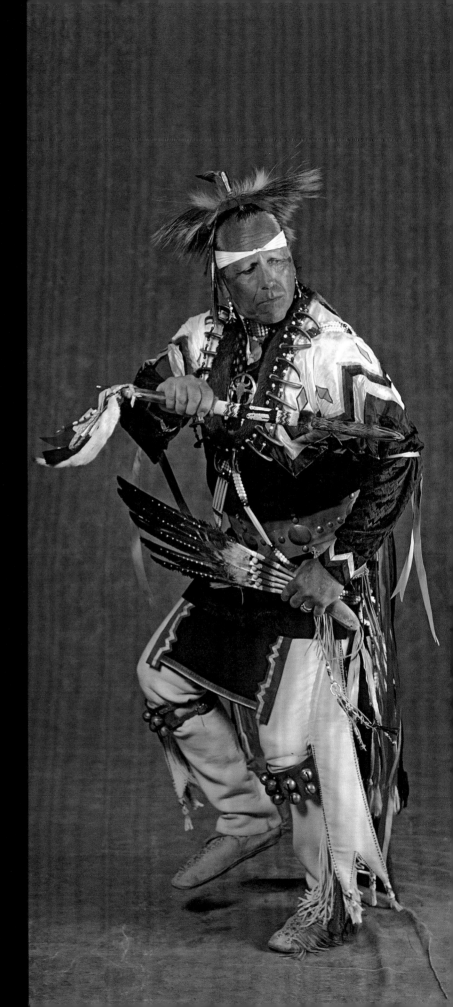

traditional dancer in the 1960s and '70s and taught me the cultural purpose of dancing. He told me that as dancers, we represent our people, our tribe, when we go out to dance. He said that the parts of the animals and birds we are wearing come alive again when we dance. We make the eagle fly again when we bring it up over the people. A woman blesses her people with her fan when she waves it over them as she dances within the Sacred Circle. So, I remember the teachings of my father, and wear the green beaded dress made by my loving mother, Camille, as I continue to dance with pride in the footsteps of my father and my Lemhi ancestors.

## C. Eaglesmith, Chebon Tenitkee (ThunderBoy)

*Shawnee � Muskokee (Creek)*

Powwow is a journey, where genetic memories from yesteryear move through our hearts, manifested today, and promising into tomorrow. In this way it is a continual transformation that captures the immediacy of time. It is the power of this Spirit that flows through the singers and dancers. It is why we feel what we feel. It is how we are all related.... Powwow kills lonesome that way. Here Grandfather comes and stands with us and Grandmother cradles us and wipes away our tears.... Powwow is victory! *A-ho!*

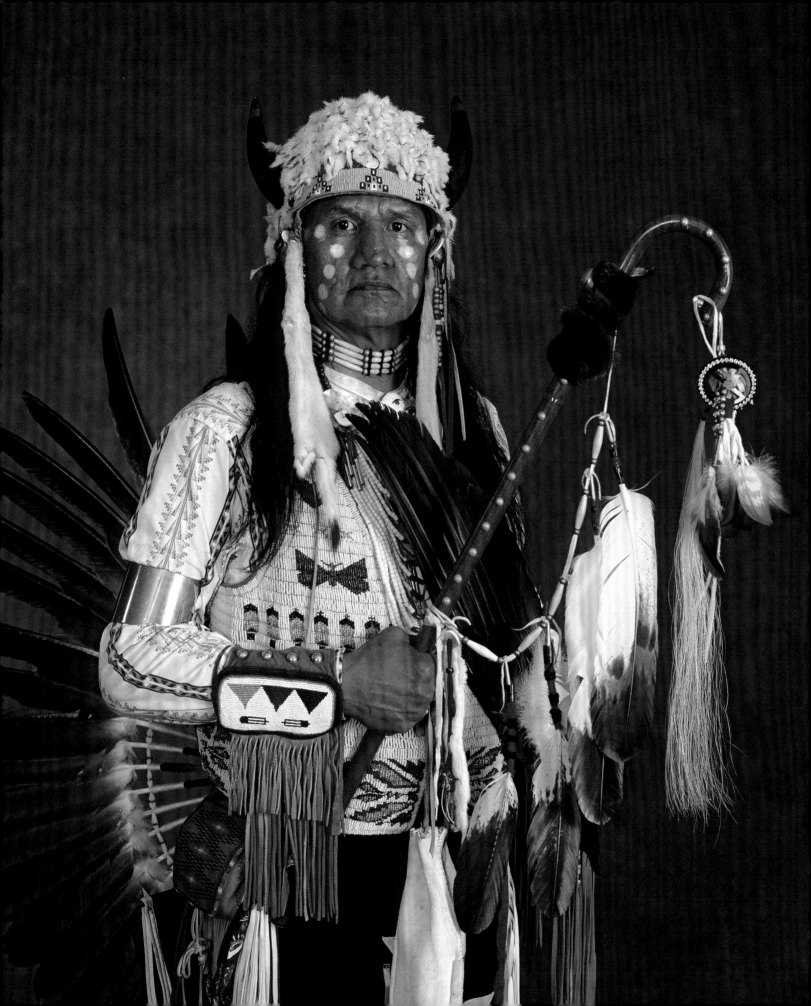

# Les Wahsise, Slock-I-Wash

*Colville ❦ Yakama*

My regalia includes a vest of my son's elk hide with various colored beads, and my buckskin leggings of deer hide with multicolored beads and beaded breechcloth. Most of these items were made by family and friends or given to me. It is now as it was in the past, when our elders from across the country met different cultures, and each culture shared or traded things that enhanced their beauty, giving a feeling of worth and respectability to everyone.

# Dorothy Crowfeather

*Hunkpapa Lakota*

I'm from the Standing Rock Sioux Tribe, and I've been dancing since I was able to walk. Dancing brings joy and happiness to my life as well as to my family's life. Dancing is a major part of who I am; I dance not only for myself, but for all people and especially for the ones who can't dance.

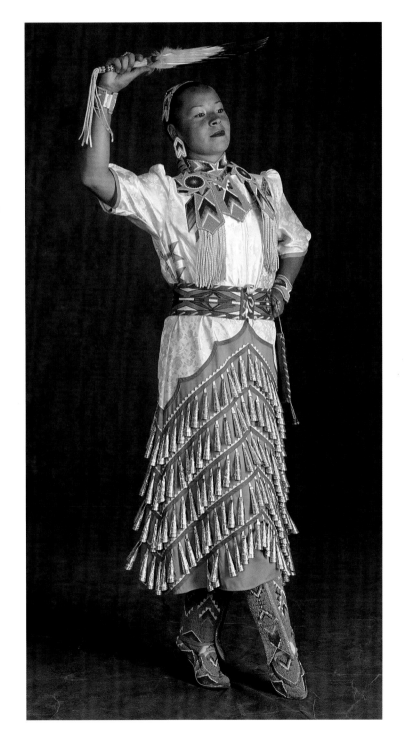

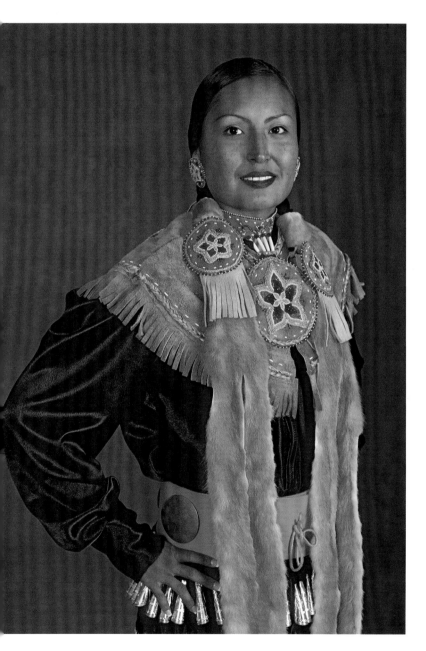

## Leah Omeasoo-Syrette (Universal Woman)

*Plains Cree*

*Tansi.* I am member of the Samson Cree Nation in Hobbema, Alberta, Canada. I began powwow dancing as a Fancy Shawl dancer at two, and at six, I was initiated into the powwow circle as a Jingle Dress dancer. Then I became an Old-Style Jingle Dress dancer.

My parents taught me the richness and beauty of our culture and the importance of being a strong, educated Cree woman. I'm very grateful to them for introducing me to this way of life and to my family and community for their support of my dancing. *Hai Hai.*

## Michael "Mickey" Mason

*Caddo*

I am a member of the Caddo Nation out of Binger, Oklahoma. I am proud of my Caddo heritage. My grandfather was Michael "Silvermoon" Martin. My great-grandfather was Thomas Wooster, who was once a Caddo chief. My aunt, LaRue Martin Parker, is the current Caddo chairwoman. I dance in their honor and for the rest of my family.

When I enter the Circle, the paint on my face is a medicine and a protector. I always enter in a good way with an open heart—no hatred, bigotry, or intolerance toward anyone. I try to share my blessings with others by dancing in prisons and nursing homes, and, for several years, I danced for the local Special Olympics festivities.

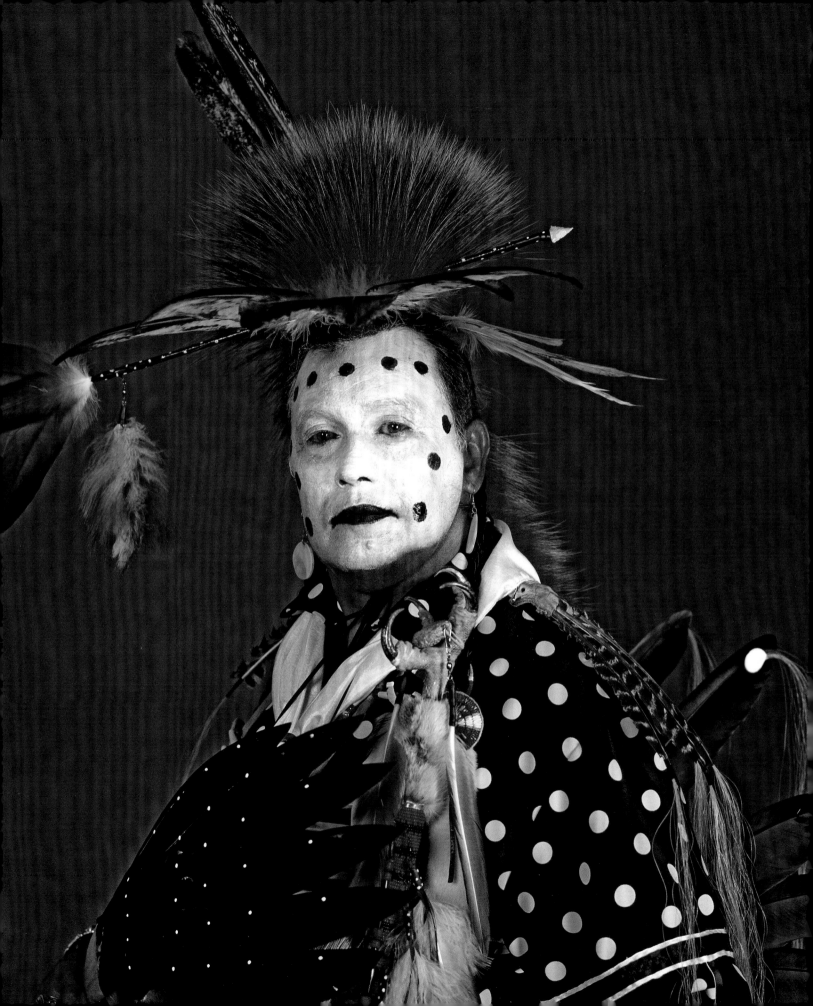

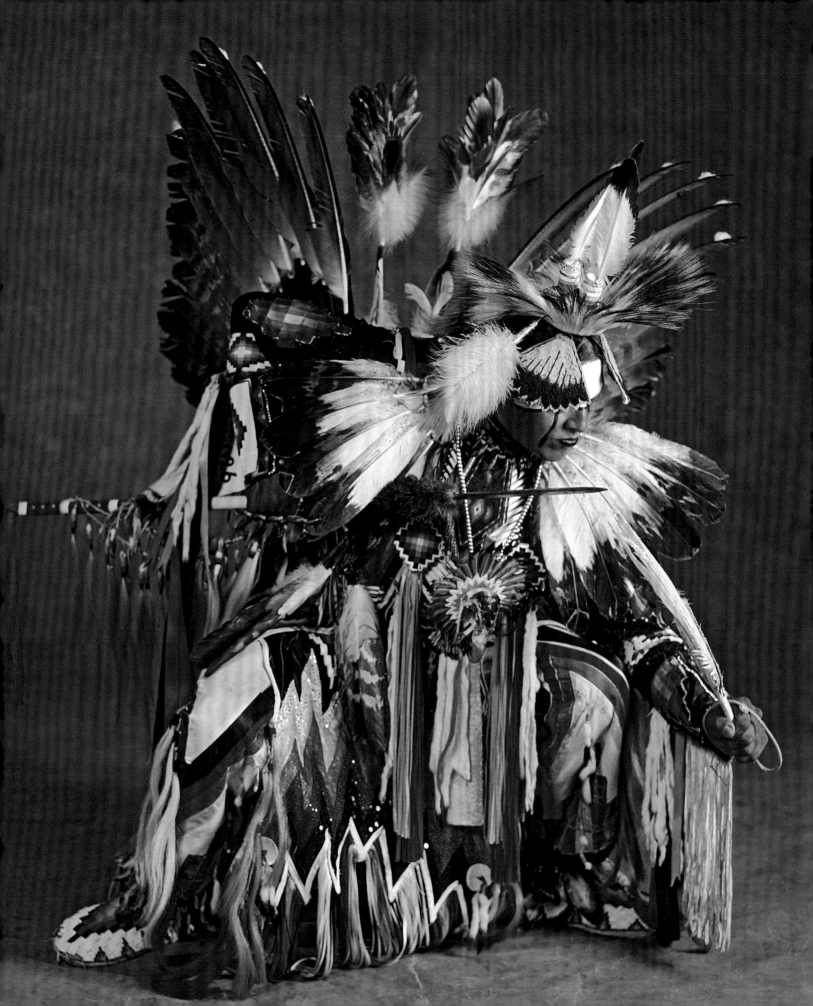

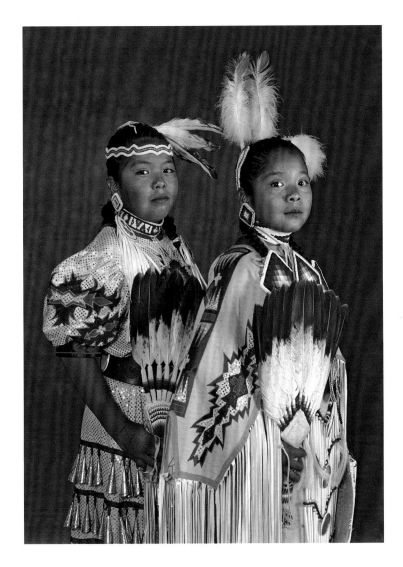

# Paris Leighton, Sr., Khul-Khul Hut-suut

*Nez Perce*

My Indian name was given to me because of my great-great-great-grandfather Eneas Sakup, who died in the Bear Paw Mountains in battle. This is why I chose to dance Contemporary Traditional, because when I dance as a warrior, I believe my ancestors who died in battle come alive in me. Contemporary Traditional brings out the warriors we once were— and back to life the ones we lost. When I dance, you see animals as well as warriors hunting or killing; my uncles, who were all dancers, singers, and sweat lodge people, taught me to study the animals of our mountains, to learn their movements and interpret them with my dancing.

# Valerie and Michelle Lent

*Northern Paiute ❧ Tachi ❧ Mono ❧ Yokuts*

*Ha'uuh.* ("Hello" or "How are you doing?")

We are both eleven years old and have been dancing since we were three years old. We are glad our mom and dad chose to put us on the pow-wow trail, and we are proud to be part of the dance circle. Valerie dances Jingle and Michelle dances Northern Traditional. We dance for our family and those who cannot dance. There is nothing we enjoy more than dancing at powwows, and we hope to see you all on the powwow trail.

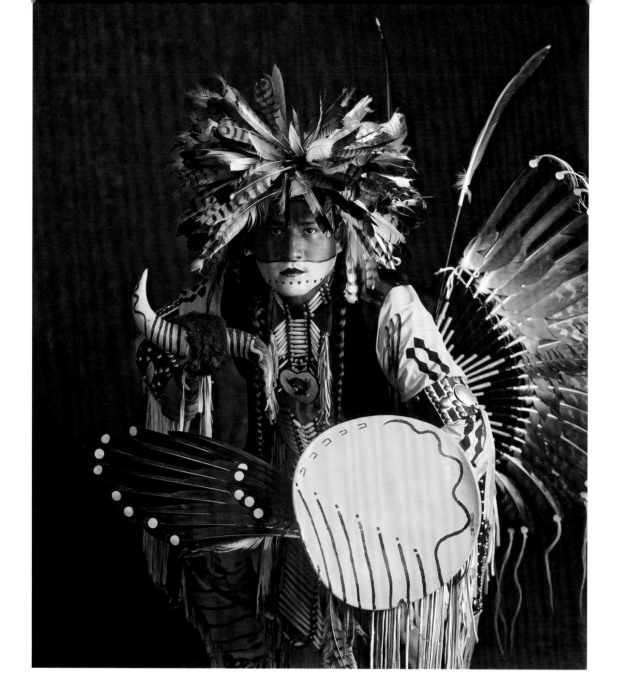

# Travis Bear Ike, Nonka Gthezhe (Spotted Back)

*Omaha*

I am from the Umonhon and Ho-Chunk people. Years ago, the Ho-Chunk were forced out of Wisconsin and traveled south to where the Umonhons lived in Nebraska. The Umonhons put the Ho-Chunk on half of their land, and that is where we both live today.

I have learned pride, generosity, humility, and respect from my people. These and other ways are the things that I carry when I dance in the Sacred Circle.

# George Kicking Woman,
## Ii oks kaina

*Blackfeet*

I was told by the old people when I was young to learn the old ceremonial ways. I feel that through their guidance and the guidance of spirits, my path was set. I feel I was specially selected to learn the songs and the rituals. Some of this has come through visions or dreams. Once when I was on Chief Mountain (our holy mountain), I heard voices of people. I couldn't make out what they were saying, but I know somebody was there. My outfit represents me and my surrounding environment. I dance because it makes me feel good. I want to be remembered, when people see my picture, as a person who helped preserve our culture.

*George Kicking Woman passed away on April 7, 2005. An elder and traditional spiritual leader of the Blackfeet Tribe, George and his wife, Molly, were the keepers of the Long Time Thunder Medicine Pipe. George danced clockwise at the North American Indian Day Celebration each year. He wears in this photograph a beaded buckskin suit with a full headdress. George gave a large portion of his time to maintaining the songs, beliefs, and values of the tribe. He was also an international elder for the keepers of the Medicine Pipes on Canada's Black-foot Confederacy reserves. He committed time and energy to honoring all medicine pipes throughout the spring of each year, serving as an advisor to all people desiring to know the ways of his tribe.*

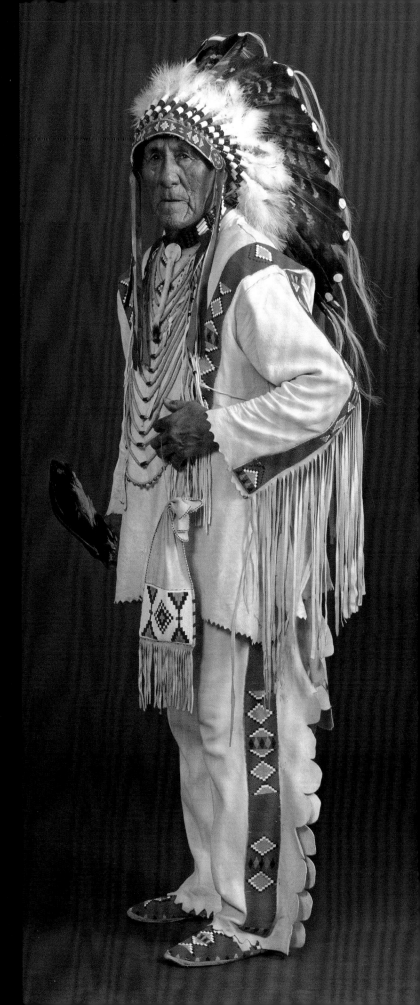

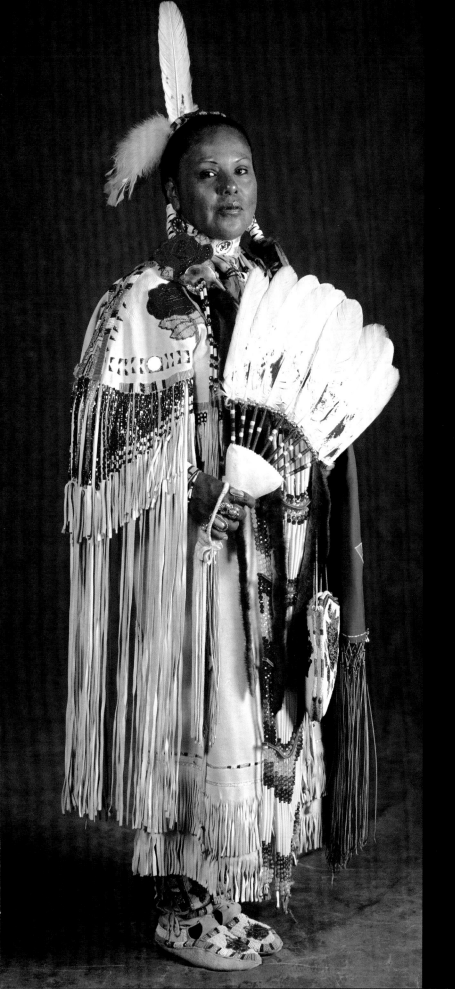

# GeorGene Nelson

*Klamath ✤ Modoc ✤ Yahooskin Snake Paiute*

My family takes great pride in its members who dance. I feel it is a way of carrying on the traditions. My great-aunt helped me get my dancing outfit together, and also outfits for my two daughters. I think of my great-aunt each time I dress to dance, and I am thankful she took the time to share her teachings with me. Powwow is our way of life and a heritage I am thankful to pass down to my children.

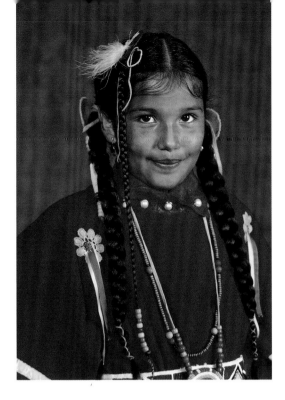

# Leslie Ann Asencio (Morning Star)

*Flathead* ⬇ *Crow*

*Shoo ta chii*

⬇ From the thunder of the drums my heart begins to pump;

⬇ then my feet start to move me forward

⬇ lightly tapping the ground like the clouds rolling up in the sky and

⬇ with my arms gracefully moving up and down beside my body

⬇ like the eagle glides in the wind.

⬇ With my head held high and counter movements between each step, with a hop.

⬇ My hair begins to float like mother earth.

⬇ Then inside it seems I, too, begin to walk on air as I dance around the arbor

⬇ showing the graceful movements of my ancestors.

*Diia wah-kaa wik*

*overleaf left:*

# Colby White

*Yakama* ⬇ *Diné*

This photo was taken when I was about nine years old. I am presently twenty, married to Taunie M. Cullooyah (pages 86–87), and have two children, who I will raise in the powwow traditions. My great-grandfather on my mother's side was once the chief of the Yakama tribe. When Lewis and Clark were passing through the Columbia River basin in 1806, his great-great-grandfather traded a dog with them for a shirt. My grandfather on my mother's side was a champion Hoop dancer and could dance with eighty-six hoops at one time. My grandfather on my father's side was a medicine man in the Navajo Nation.

My mother, Virgilina, passed away in 1995. I wish she could see how I am growing up and raising my family. I know she would be proud.

*overleaf right:*

# Curtis Robert One Bear

*Crow* ⬇ *Cheyenne*

*Sho'o Daa'Chi.* (How do you do?)

*Na tse'he sta he*—I'm Northern Cheyenne. I began dancing in Lame Deer doing the *Absaa Loga* style. My grandpa John helped me gather my regalia, and my grandpa Jim One Bear taught me to get ready. I would watch him dance into the late night and early-morning hours, until I would fall asleep. He danced a very old style. Other dancers often did not know or see this style. He was a very good dancer. I miss him very much. Hope and pray everyone gets blessings.

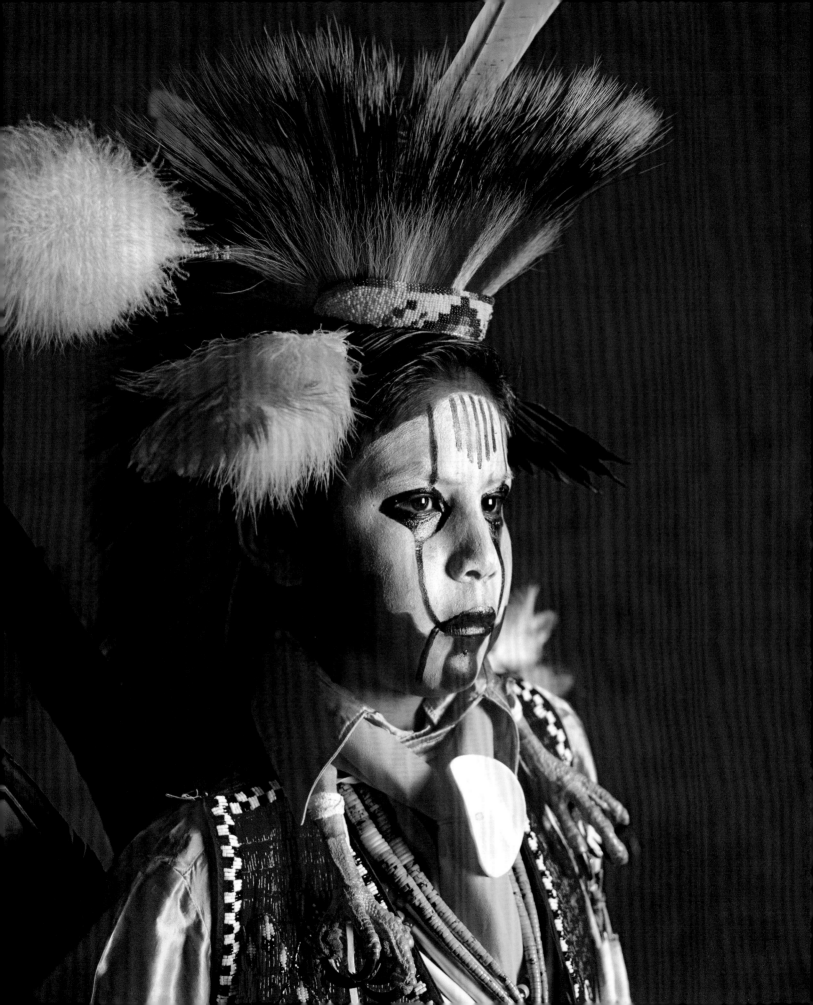

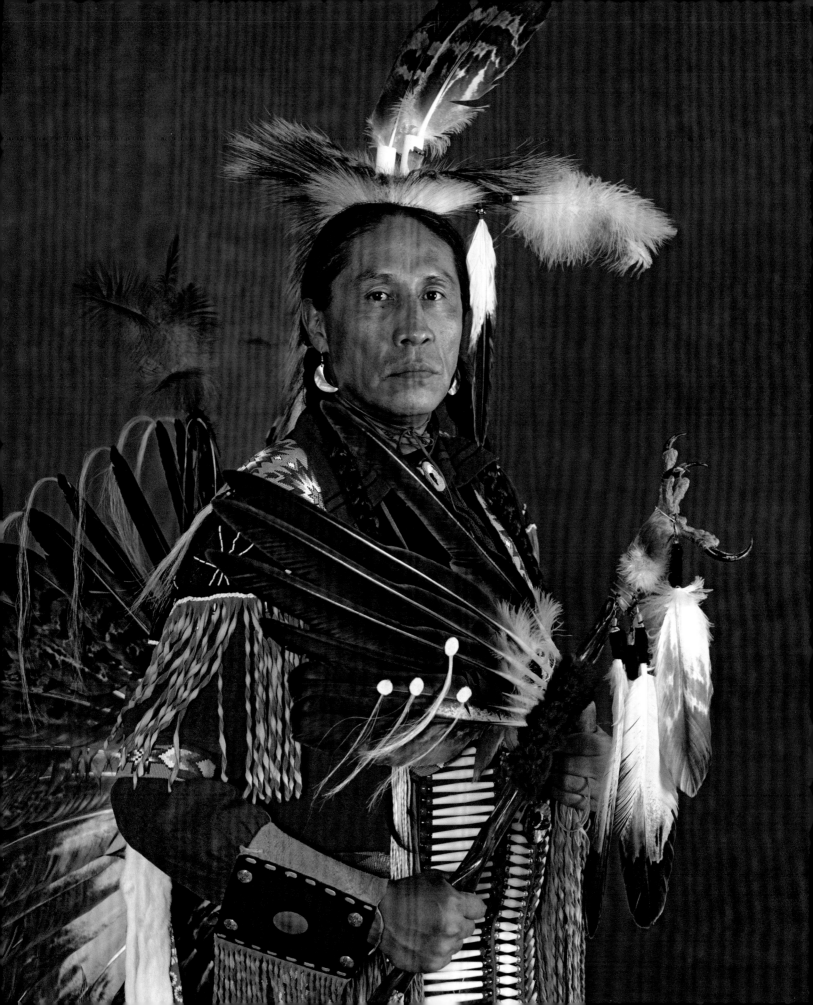

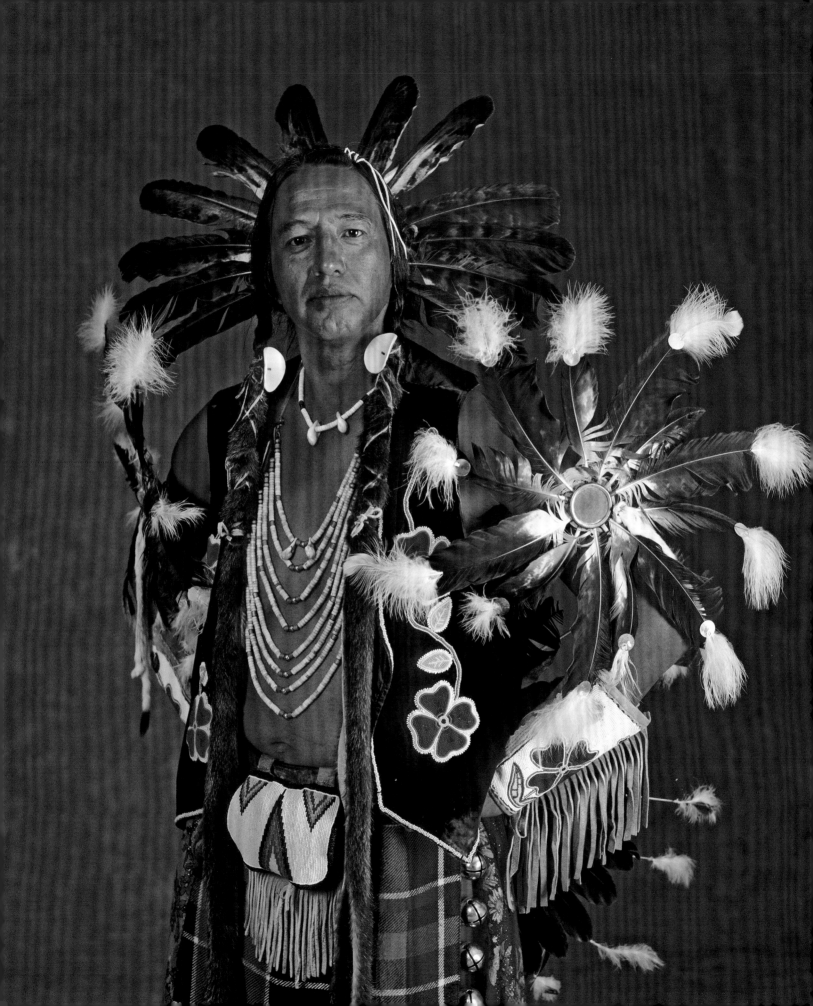

# Louie McDonald

*Flathead*

My name is *La'wi*, a Flathead Warrior. When I hear the heartbeat of Mother Earth (the drum), calling her people to dance, my blood rushes, there is an excitement in the air, my feathers come alive, and I am carried away—like in a trance.

I dance and dress in the Traditional Old Style. I use the Round Bustle/Prairie Chicken style of dance as a form of prayer. I dance for those who can't. I dance for our young, to be a positive role model. I dance for our elders, to put hope in their hearts and a smile on their faces. I dance for our ancestors from the Bitterroot who have passed on, for they have sacrificed so much. I dance just because I can. There is no better feeling—I can go on all night!

*overleaf left:*

# Misty Stafford-Flores

*Puyallup ⁂ Seneca*

My parents, grandmother, aunts, and uncles played a major role in bringing me into the powwow circle by either making or giving me the items that make up my regalia. Without the support of my family, I don't think I would be where I am today. My children have recently entered the powwow circle with this same support. I am, and will always be, grateful to the Creator for blessing me with the family that I have been given.

*overleaf right:*

# Josephine George

*Yakama*

I have been dancing since my grandmother first brought me into the powwow circle when I was seven years old. Eleven years ago I was very ill and an Eagle Spirit visited me in my room. A medicine man from Canada told me that, in order to get well, I had to make my dancing outfit based on that Eagle Spirit. The power of the Eagle Star made me well. I believe in this Spirit.

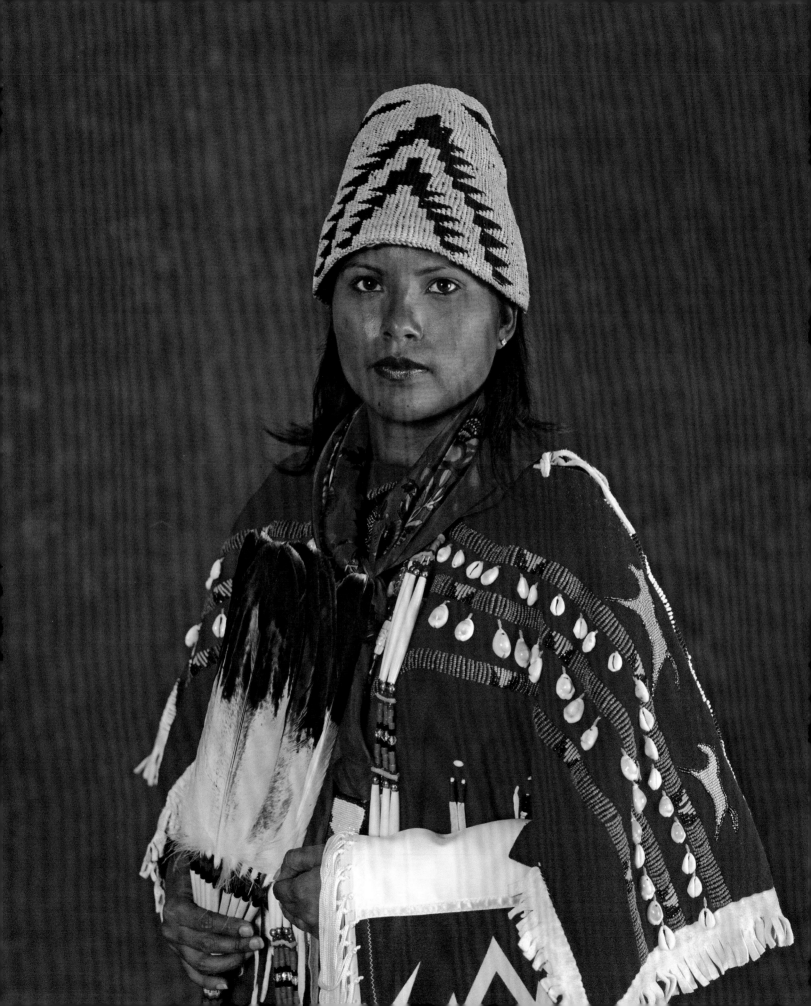

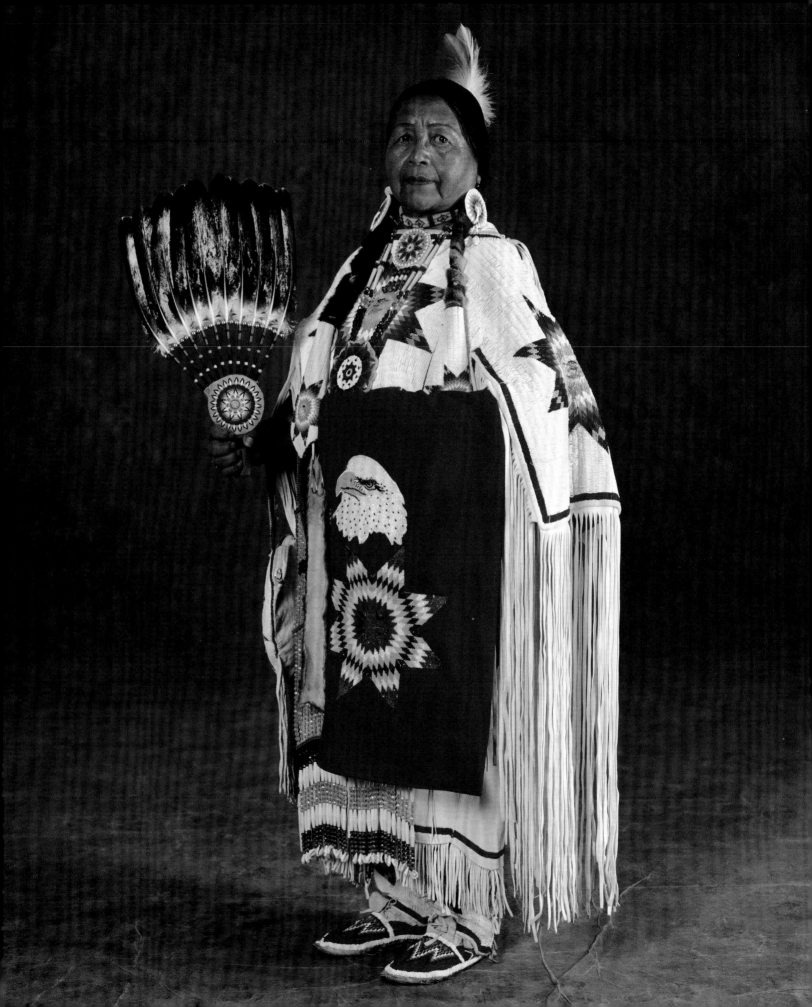

# Nichole "Niko" DeRoin, Na-Da-Mi-Thu-Si-Jima (Woman of the Red Feather or Flower)

*Otoe-Missouria ⬇ Choctaw*

It is hard living in two worlds. On the one hand, you have traditions and old ways of living. On the other hand, you have school, jobs, and many things that can distract you from the Red Road. As a teen-ager, there are daily challenges that come my way: peer pressure, stereotypes, going to school while maintaining a job. It is great to see so many young people like me dancing, being role models, and representing the generations that took the time to teach us.

# Cetan Thunder Hawk

*Oglala Lakota ⬇ Ottawa*

At powwows you can find me on the dance floor enjoying the intertribals or singing at the drum. I try to enjoy life to the fullest because you never know what might happen the next day. My late uncle Irving Milk told me, when he gave me my regalia, to dance hard for the people and represent who you are and your family. I look forward to teaching my children and anyone who wants to know the ways of the powwow trail.

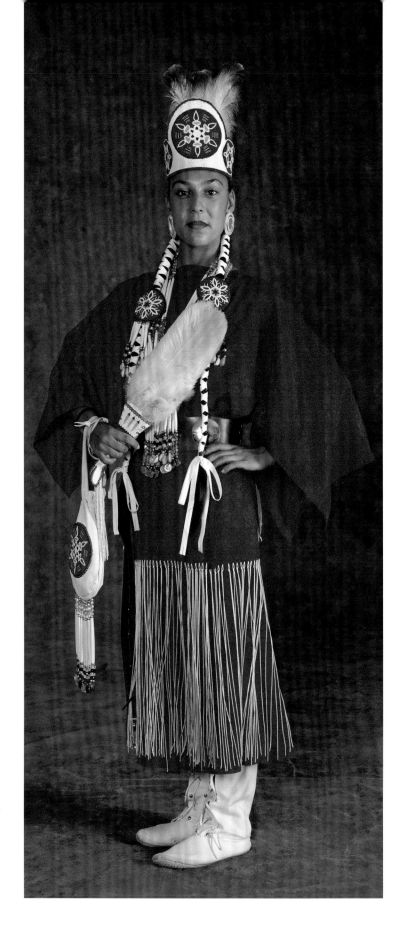

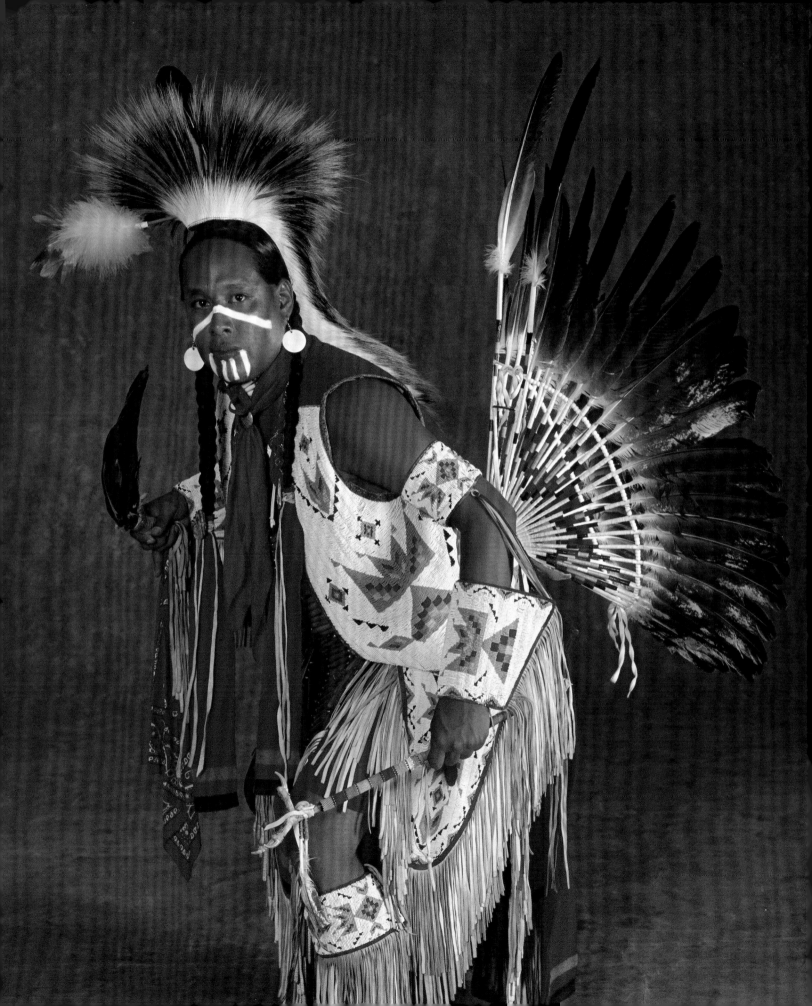

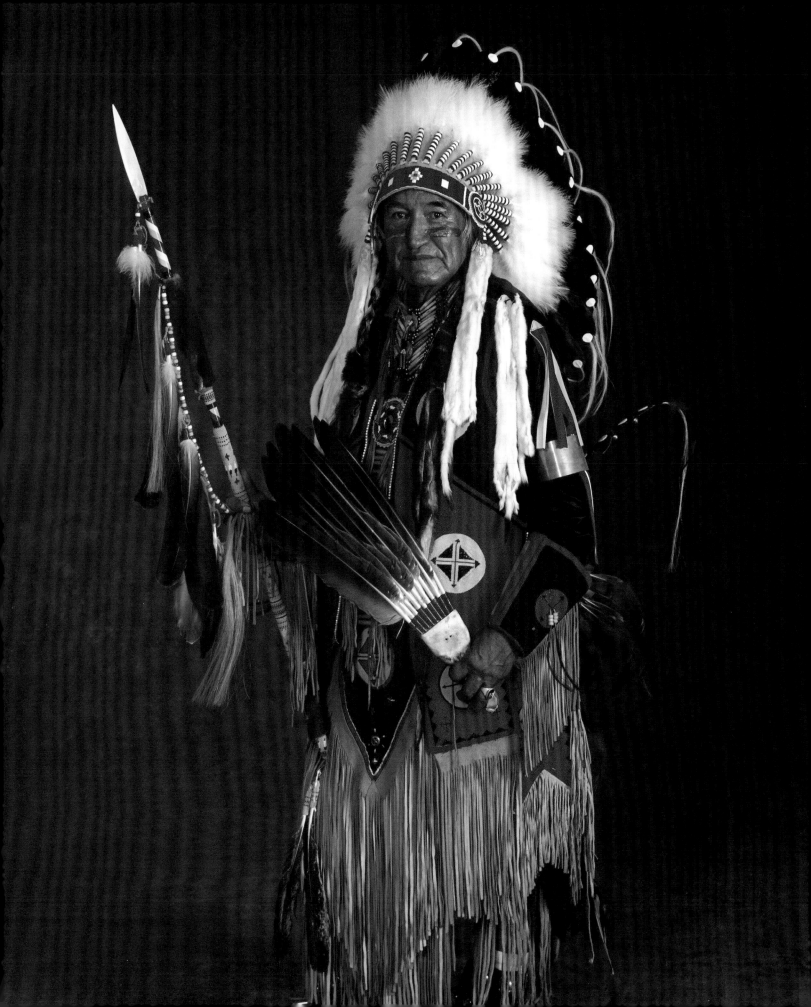

# 2

"It was my father's boast that the blood of a white man never reddened the hands of a single Indian of the Flathead tribe. My father died with that boast on his lips. I am my father's son and will leave that same boast to my children."

—Chief Charlot, Flathead

Stephen Small Salmon

*previous pages:*

# Stephen Small Salmon

*Pend d'Oreille Flathead*

When I was very little, I remember my grandpa holding my hand and walking me to the dancing arbor in Arlee, Montana. I had a little black outfit with fringes. I could hear the drums as we walked. I remember how anxious I was to dance. I still feel the same way whenever I hear the drums. The drums are sacred; the ground we dance on is sacred. We dance in a circle; to us, the circle is sacred.

Thirty years ago, I remembered my grandpa's black leather outfit and knife scavenger with brass beads and buttons. So I designed and made my own black leather and fringe outfit with brass and silver. I dreamed the design and took my uncle's colors: red, yellow, and orange. I still wear this outfit. I also have a blue beaded outfit my mother, Mary Small Salmon, made about forty years ago. She beaded it in the old way, tying every second bead. It takes many, many hours to do it this way.

Now that I am an elder, I have begun to wear a war bonnet, which is worn with a feathered bustle in the traditional Pend d'Oreille way as my father wore in his time. We paint our faces in the Flathead way, to protect us from our enemies and the evil spirits.

# Bonnie Tomahsah

*Comanche*

My fascination for the Fancy Shawl style of dance came about through my family's many travels into the northern states and Canada. My deep-rooted love for singing and dancing comes from my Comanche ancestral background. This was the tribe's way of life from ancient times. Therefore, it came natural for me to be in the arena from the beginning of my life.

I feel as though I'm a role model because I started young and I have continued dancing. I encourage the younger generation to carry on the traditions and Indian ways—thereby making us a stronger Indian Nation.

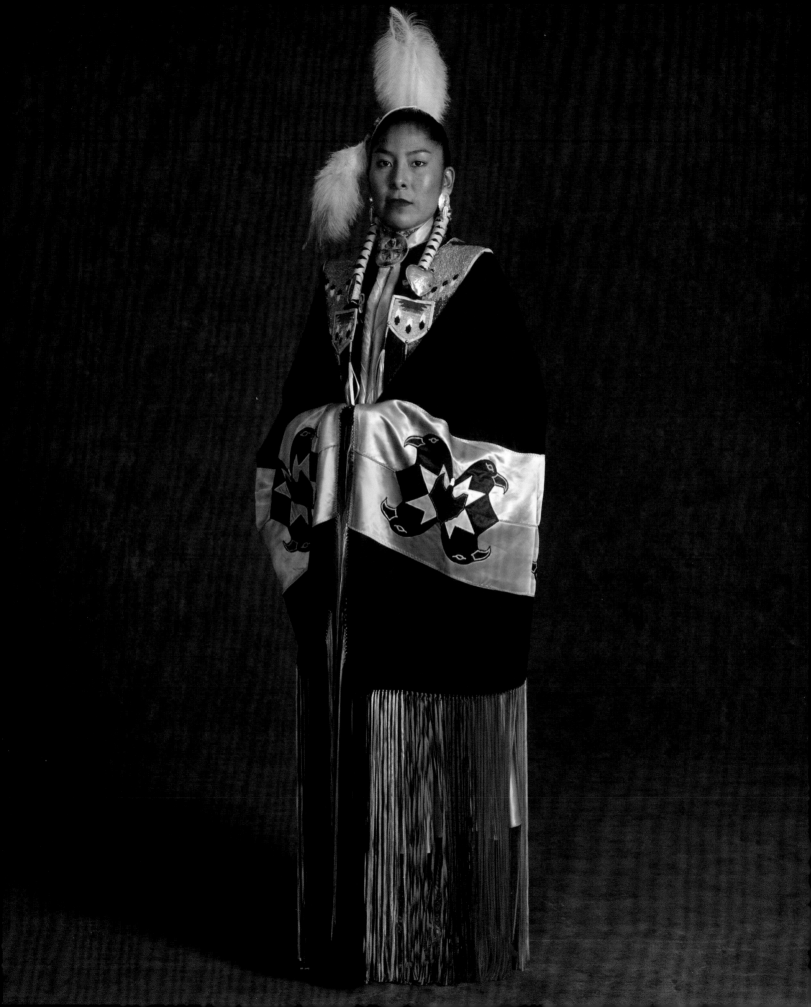

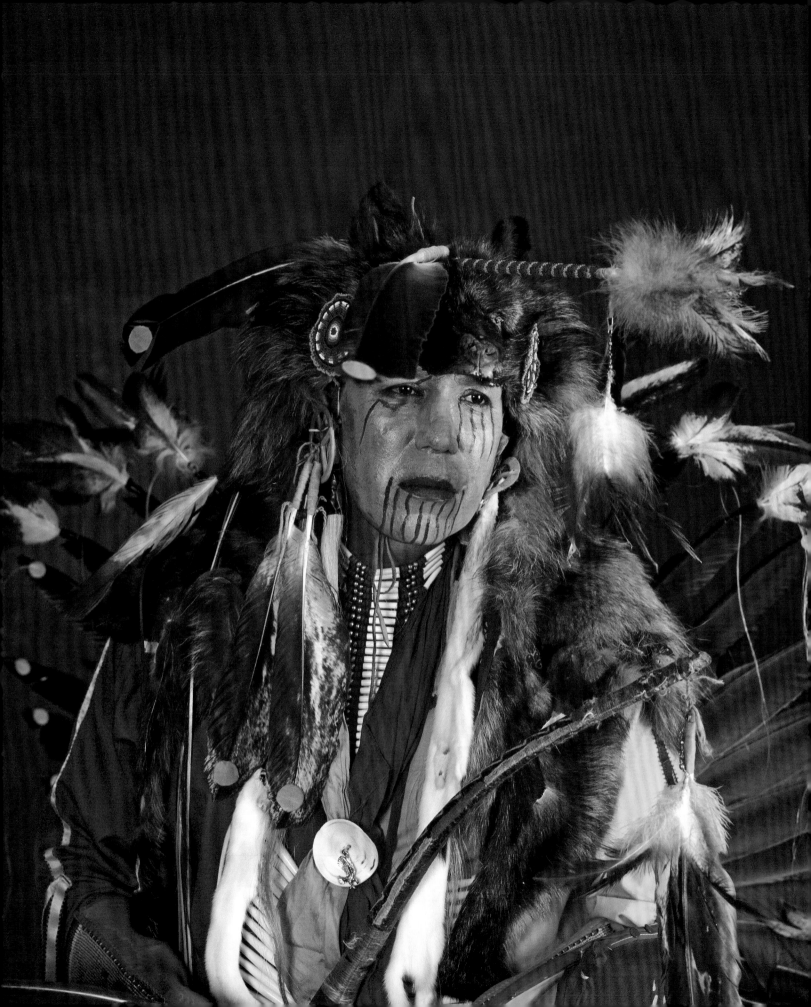

# Norman "Sonny" Kelly-Kinew
# Niiganigabo (He Who Leads)

*Ojibwe*

My full Ojibwe name is Niiganigabo, Niitawchii'eb, Pizhiw n'dotem (Lynx Clan), Kagagiminisino-onigaming (Where the Ravens Nest Portage). I was born and raised on the shore of Lake of the Woods in Ontario, Canada. My grandmother had knowledge of life around her—she saw life through Ojibwe eyes. When we lay down at night hers was the voice I heard until I fell asleep—the legends, the stories, and the love she had for us children. It was beautiful and still is in my mind.

# Thomas Morning Owl and
# daughter Edwina

*Umatilla* ✺ *Kainai*
*Kamithlpam* ✺ *Apsaalooke*

Powwow is a way to teach younger generations of the importance of the past and what it means to be Native. It has become pan-Indian and is practiced among all tribes, yet it cannot supplant tribal traditions. As different tribes, we have our unique identity that includes our ceremonies and religious practices. These must also be taught to our children. Powwow has become a catalyst for change, but families must strengthen family bonds to keep traditions alive.

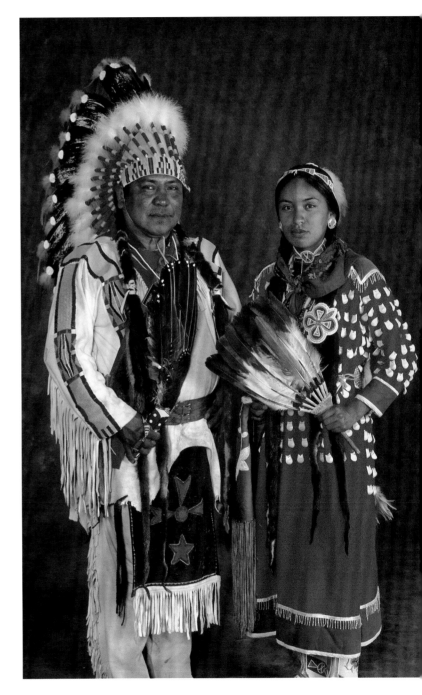

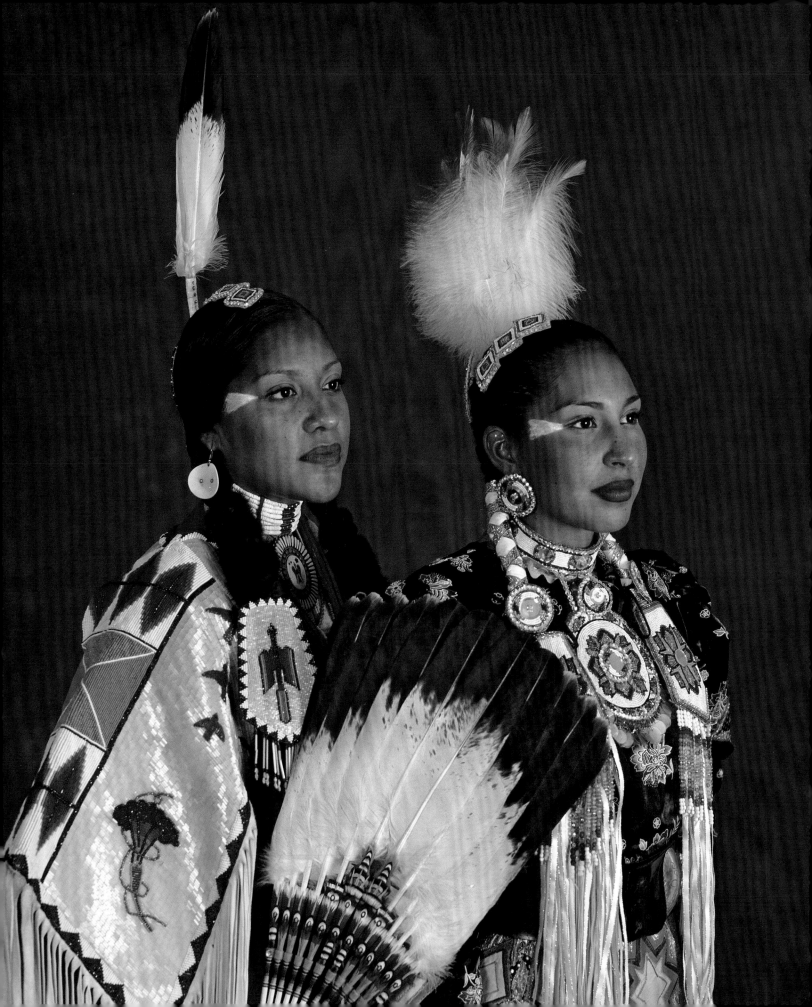

# Summer Baldwin and Willow Abrahamson Jack

*Lemhi Shoshone-Bannock*
*Lemhi Shoshone-Bannock* ⟱ *Colville*

*Hau-uh-muneepun.* From a young age our parents and grandparents encouraged us to dance. The outfits we are wearing were made with the love of our family, especially our grandmother. Powwows teach you respect, unity, and help you have a cultural identity. We both agree powwows are our favorite pastime. We hope to keep going to powwows for the rest of our lives. *Oose.*

# Christine V. Johnson, Yow-Sta

*Warm Springs* ⟱ *Wasco* ⟱ *Yakama*
⟱ *Wailaki*

Dancing to the beat of the drum in the powwow circle opens our hearts to express what we have inside. It truly makes me happy to see the younger generation look upon their favorite dancer or drum group and learn what excites them in their movement and footwork. It is the voices that touch their hearts, and the talent that encourages them to keep on dancing or singing and learning the Indian ways. I learned the tradition from my beautiful grandmother Katie Black Wolf, and I have the privilege of passing it on to the next generation as they join the powwow circle.

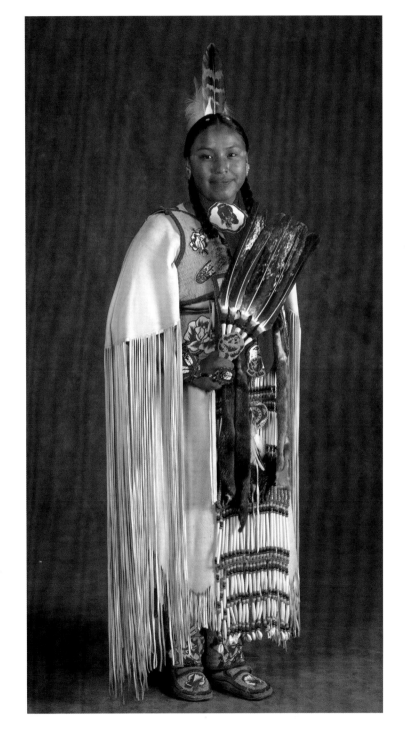

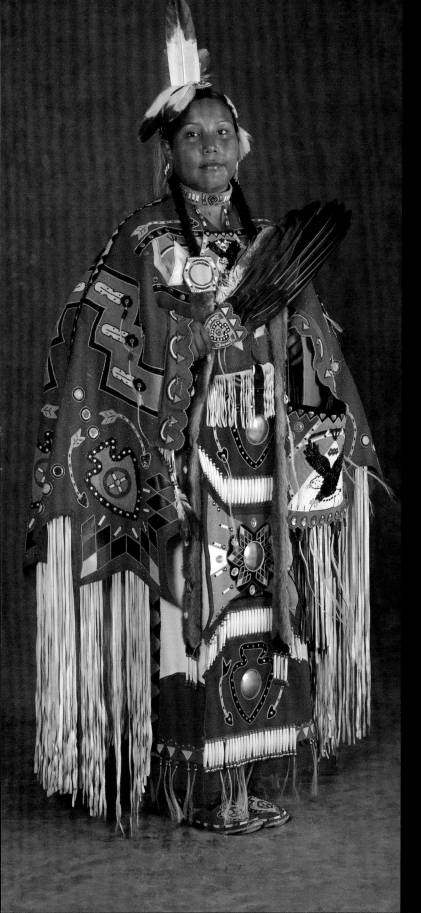

# Tamara Shouting (Otter Woman)

*Blood*

*Oki, nitaanikko Piinotoyiaakii, nitomoht'too Kainai.*
My parents were an inspiration to me and encouraged me as a child to continue dancing and to practice my traditional ways. They sacrificed a lot of time and effort in creating and designing my outfit and transporting me all over North America to compete. Without them I would not be the person I am today.

# Horace Axtell

*Nez Perce*

I am four quarters Nez Perce. I chose to become a Traditional dancer because I strongly believe in our Indian way of life. Being a veteran of World War II, I like to feel the strength of all warriors from the past and hear and dance to the old songs.

On the Red Road, we try to follow the footsteps of our elders. They walked on clean land, drank clean water, breathed clean air, and ate clean food provided by Mother Earth. Most of these things we no longer have, but we still try to maintain what is left by building on the great spiritual foundation that our ancestors and elders laid down. In order to keep the Red Road clean and good, we must be strong followers of our Indian ways. We must help all people in the war against drug and alcohol problems, which threaten to destroy our young today.

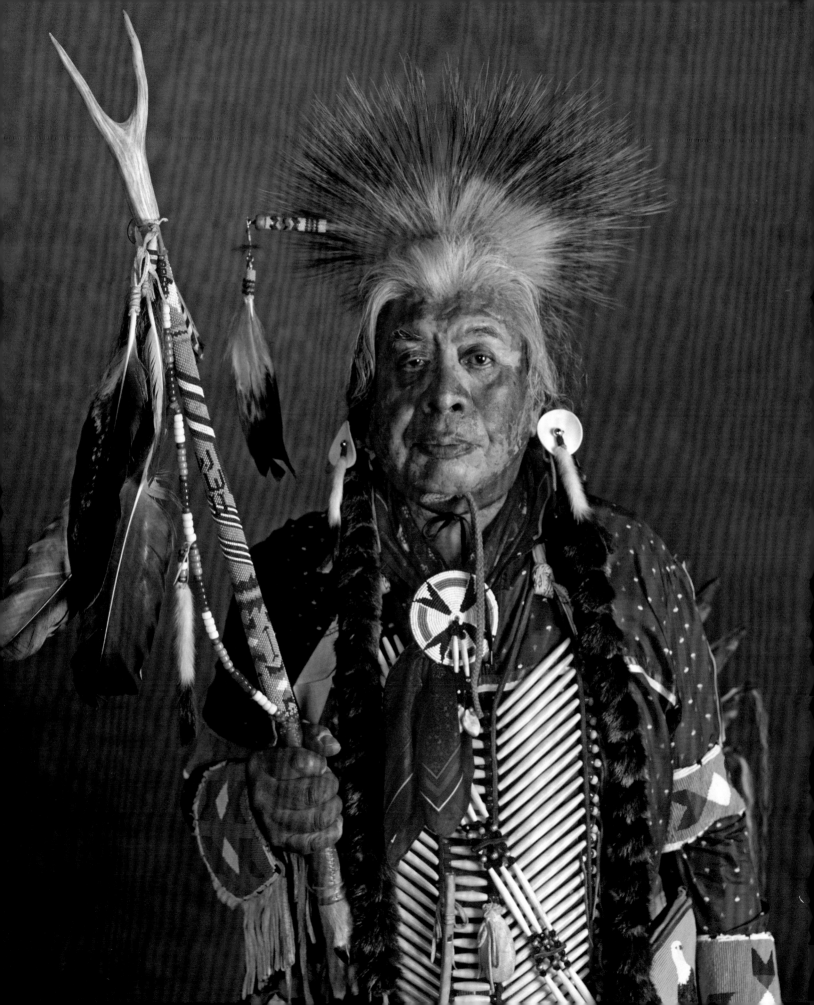

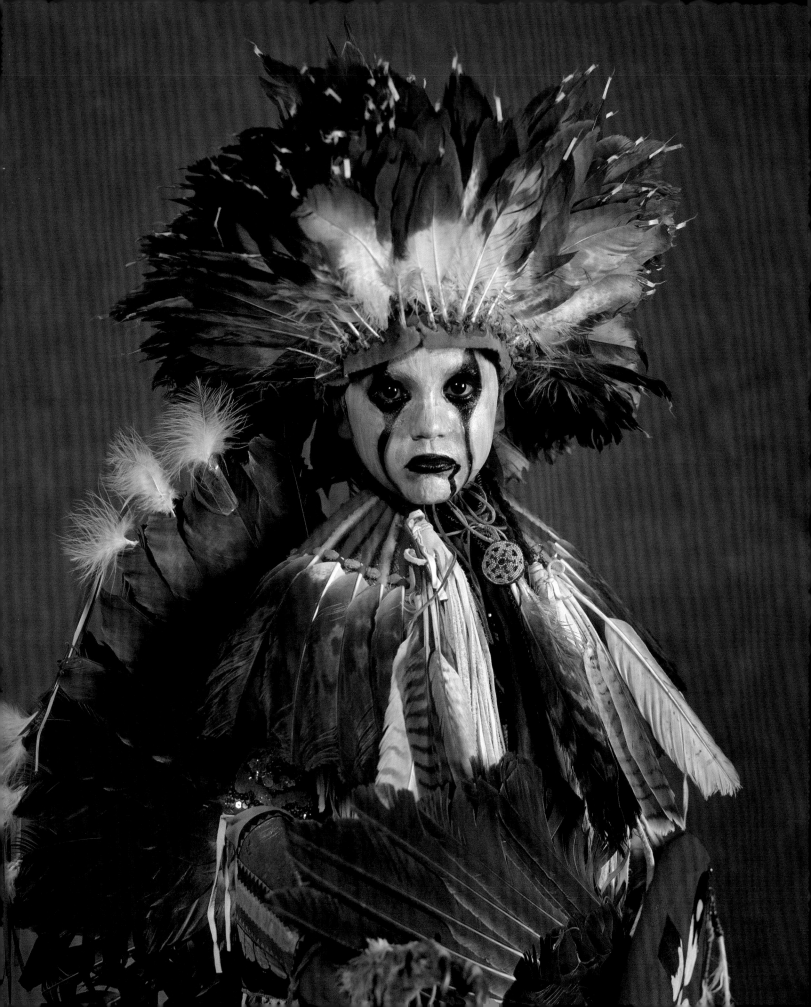

# Sparrowhawk Walsey, Ka'las (Raccoon)

*Warm Springs* ⍓ *Wailaki* ⍓ *Yakama* ⍓ *Shoshone-Bannock*

I dance in the Junior Boys' Traditional category and am one of the lead singers of the Eagle Spirit Singers of the Yakima Valley. The outfit that I am wearing was made by my parents, Ronnie (see pages 158–59) and Edith Walsey. The sequin beadwork was done by my auntie Leah McGurk.

overleaf left:

# Irwin Tso

*Diné*

The Circle is a place to heal.
⍓ a place where minds may think alike
⍓ a place to enjoy the songs
⍓ a place to express dance
⍓ a place to celebrate life
⍓ a place to make new friends
⍓ a place to strengthen friendship
⍓ a place to share the need to heal people and to be healed.

overleaf right:

# Jade Rae Peone

*Colville*

I grew up in Ford, Washington, on the Spokane Indian Reservation, but am enrolled as a Colville tribal member and a descendant of the Spokane Tribe. I am a Fancy dancer and would love to become an all-around dancer as well. My parents, grandparents, and siblings have been my motivation and inspiration for dancing. As I go through life's obstacles, I plan to stay in the dance circle, and I look forward to the many powwows to come.

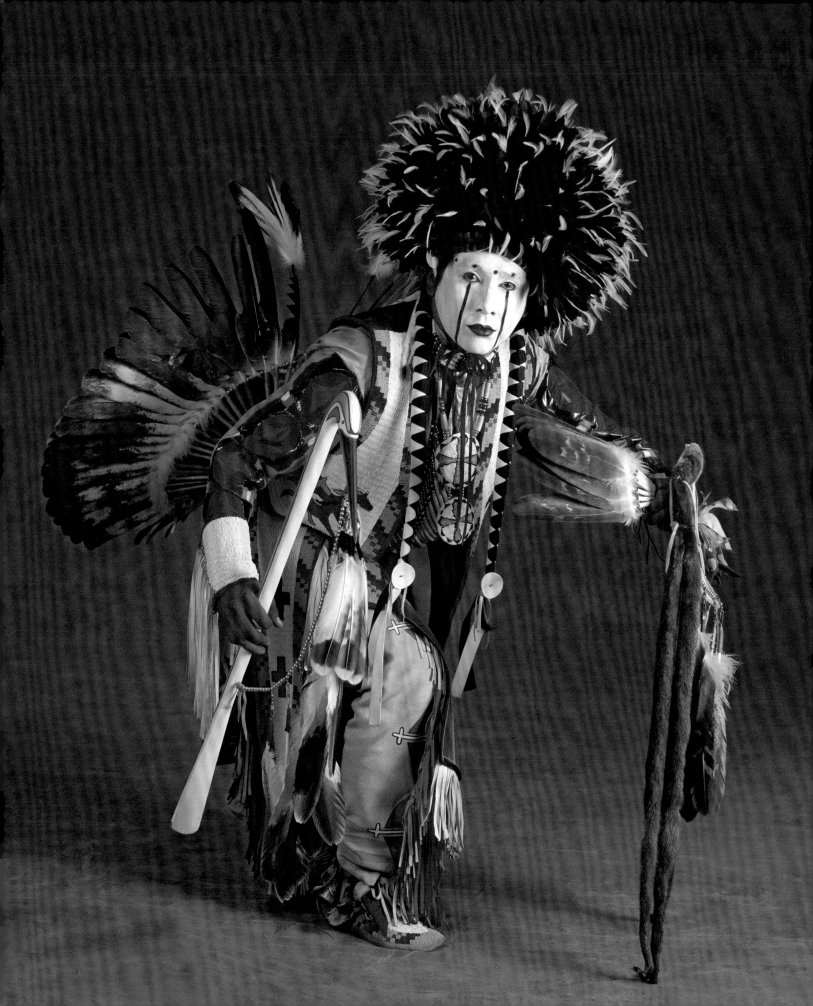

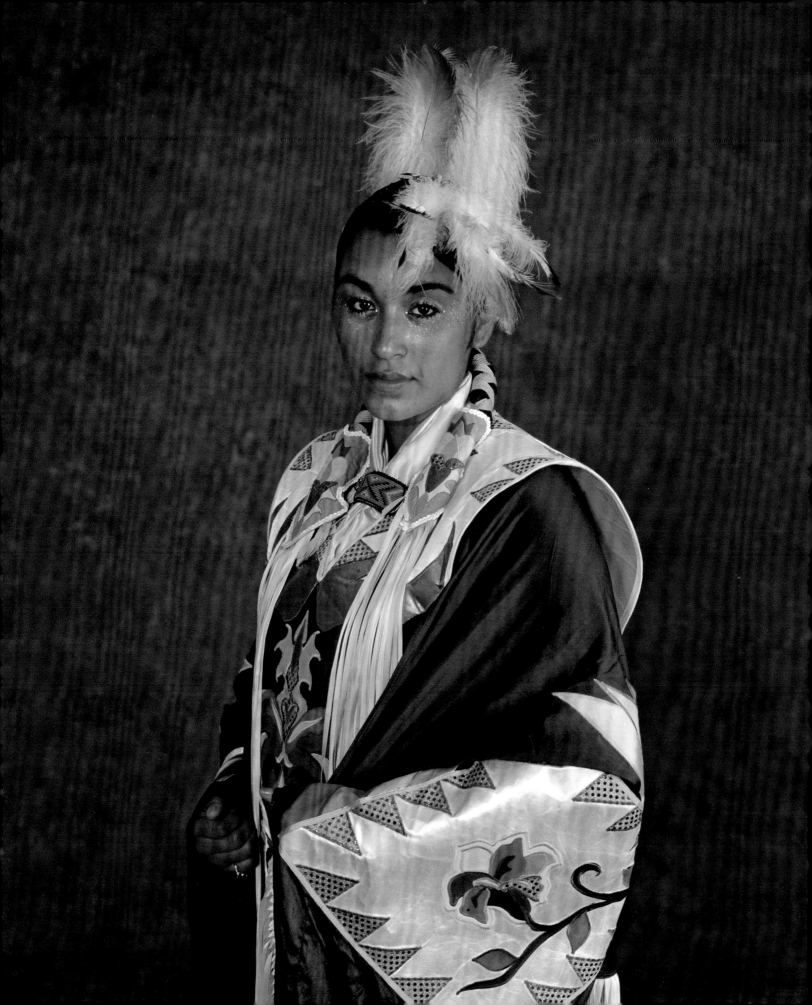

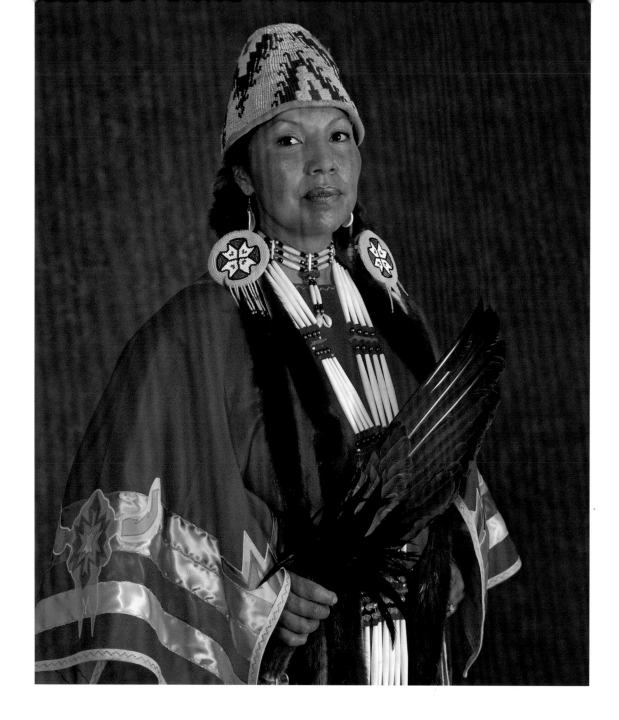

# Laura Stensgar-Mokry

*Coeur d'Alene*

I did not fully appreciate the work and love that Mother and Grandmother put into my regalia, but now that they have both gone into the Spirit World, I realize the significance of each bead. My grandmother did the beadwork that I am wearing in this photo. She spoke the Coeur d'Alene language fluently. *Khwa'tsqwa'qwe'elstmet khwa a qwamqwamtsis he gul snshi'tsntsut.s 'etspute'stmetlsh*. (When we speak the beautiful language of our ancestors, we honor them.)

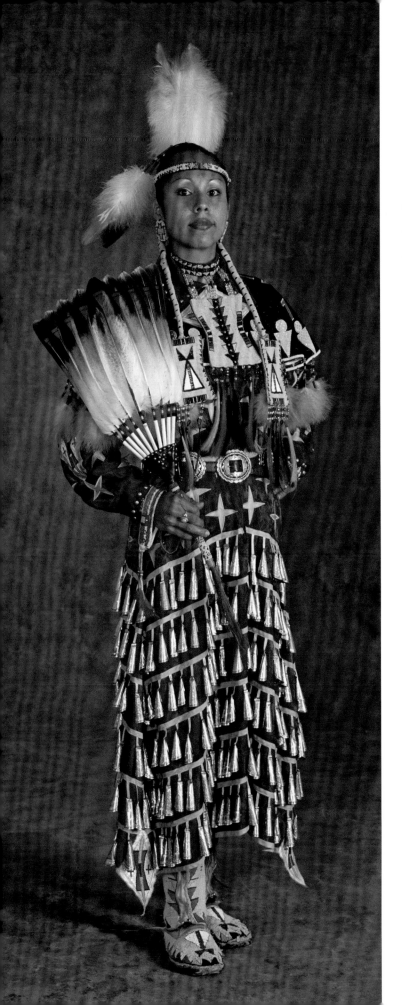

# Paula McCurtain

*Blackfeet* ⬇ *Choctaw*

On a cold January morning in 1870, a large band of Piegan grandmothers, women, and children rested peacefully as the men were away on a hunting party. But their camp was being surrounded by two hundred U.S. cavalrymen. As the leader of the campsite, Chief Heavy Runner, came out of his lodge waving a safe-conduct paper, the first shot was fired, killing him instantly. What came next was a hailstorm of military fire that annihilated over two hundred grandmothers, women, and children.

Not as celebrated as the famous Massacre at Wounded Knee, the "incident" at Marias Pass in Montana was deemed the greatest slaughter of Indians ever made by U.S. troops, although it remains insignificant in U.S. history. However, the story has been passed on through the descendants of the victims.

Later in the 1900s, all of the children of the Blackfoot Confederacy residing within the U.S. were taken from their homes and forced to learn the white man's ways in an attempt to "kill the Indian and save the man."

My children and I are living proof that the U.S. government did not destroy everyone in the Marias Massacre, nor could they "kill the Indian and save the man."

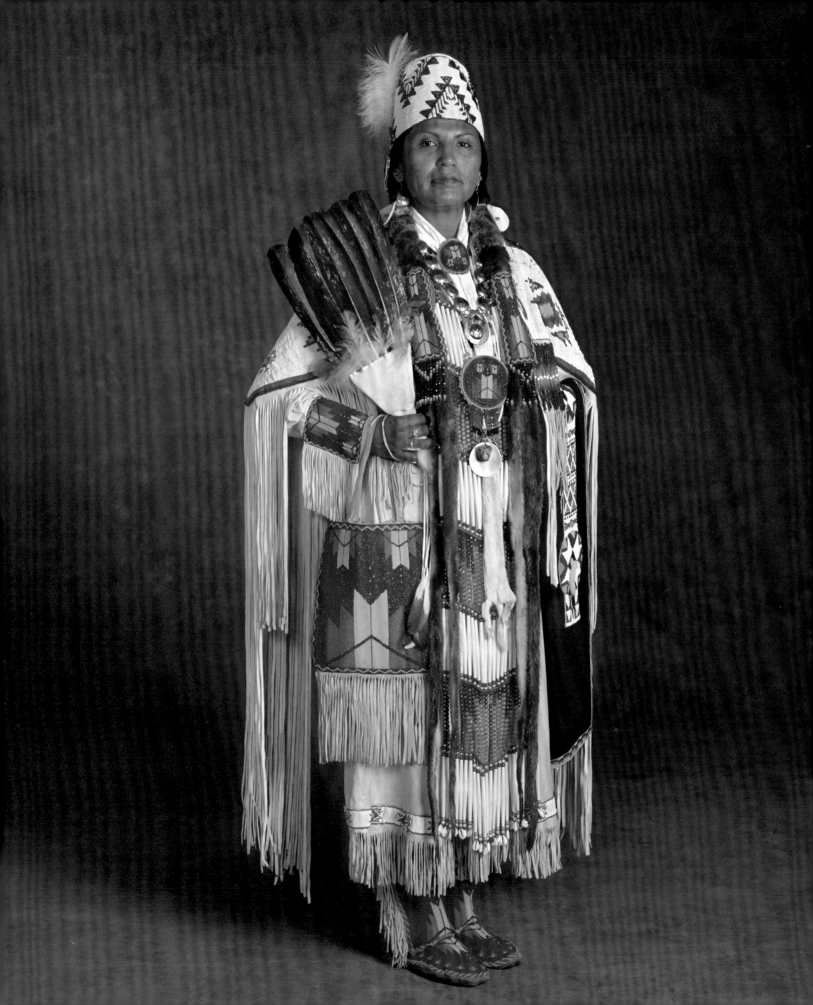

# Charlene Tillequots, Tein-un-mi

*Yakama ⬇ Nez Perce*

When I first began dancing, I was disciplined by my grandmother about taking care of the things I wear, because a lot of time had gone into sewing and designing the beadwork. It is also important to respect the life of each animal that went into the regalia, such as the eagle, deer, otter, porcupine, and horse, because the lives can become a medicine to guide or help us physically, mentally, and spiritually. As I've grown older and wiser, I've learned to respect the dance circle more and more.

*overleaf left:*

# Adrian LaChance (Four Eagles Dancing)

*Plains Cree*

When I first started dancing I was unsure if I was doing the movements and steps right, but my heart told me that I was doing something that honors the Creator. I feel very blessed to have met champion dancers that took the time to share their hopes and dreams with me, and inspired me to find my own style. Today, I share what little I have with the world, because the elders tell me you can only keep what you have by giving it away. *Hiy hiy.*

*overleaf right:*

# Arnie "A.J." McDonald

*Salish ⬇ San Felipe Pueblo*

I have been a soldier in the U.S. Army since April 2002, and have been deployed to Afghanistan twice and Iraq once since my enlistment. When I was first stationed in Afghanistan, I began the beading on the outfit I'm wearing now. With each deployment, I'd bead at every free moment I had; and upon returning to the States, I'd put my work away. After returning from my last deployment in 2006, I worked to finish my outfit. Since then powwow has become a big part of my life.

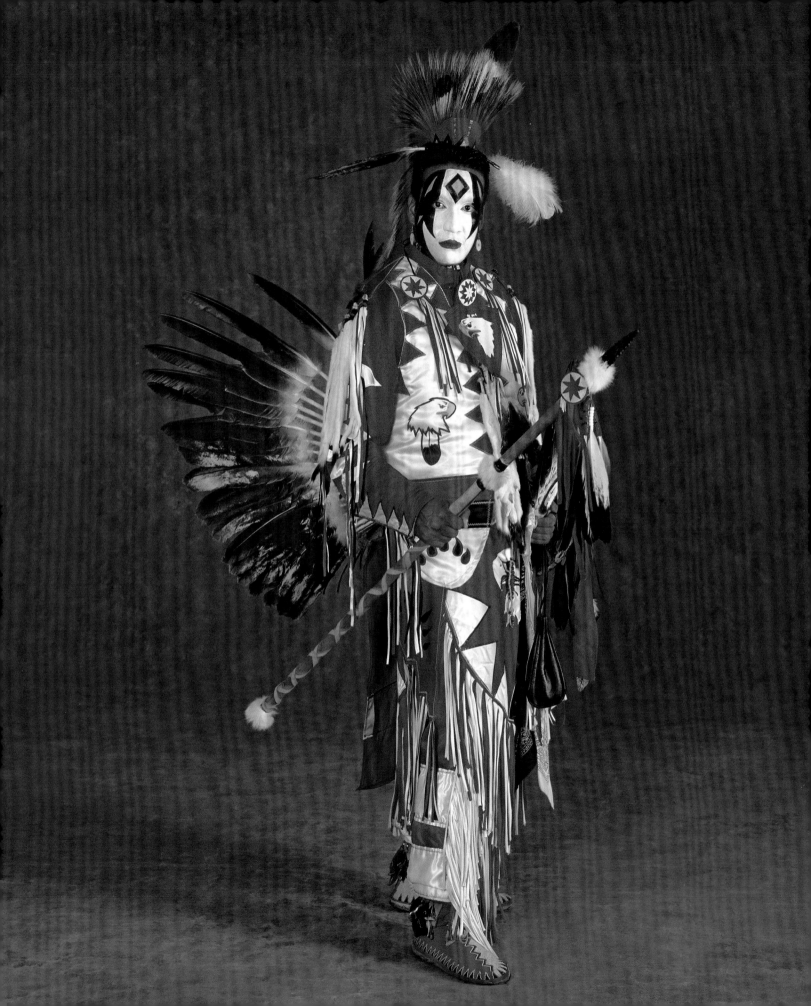

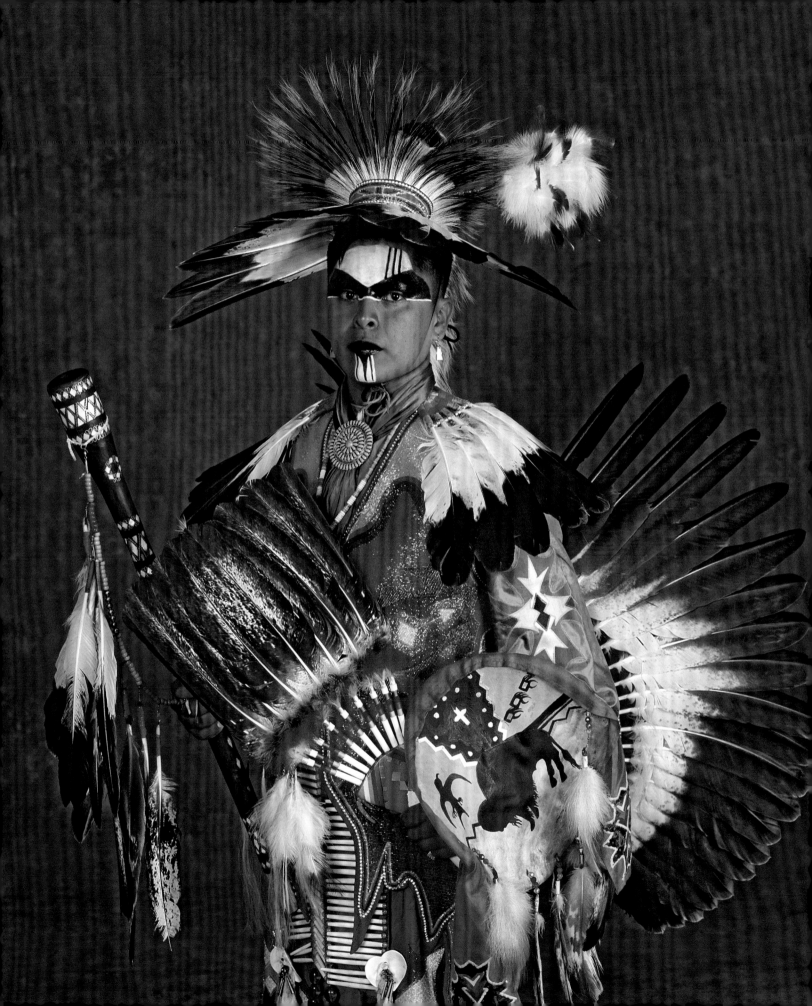

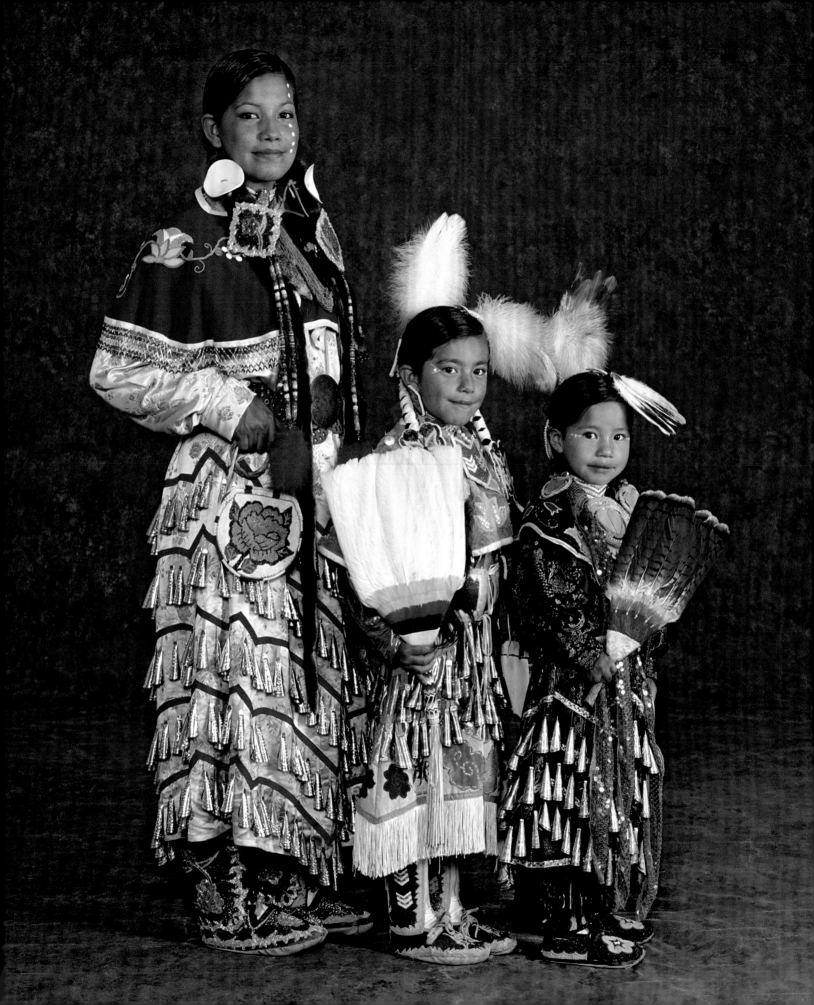

# Tiny Belgarde Rosales and daughters Azelena and Genesis

*Turtle Mountain Band of Chippewa*

*Tiny:* Jingle dance was given to my people, the Anishinanbe, for the healing of sickness. I listened to the legends as I was learning my steps, and now I've passed along the same stories to my daughters. Non-Indian people always ask how we learn to dance or want to know who teaches us. Children just follow their parents into the arena and start dancing. As babies, we're carried by parents and family members; mothers dance with their unborn babies. It is a natural part of being Indian.

# William Pawnee-Leggins

*Oglala Sioux*

"The power and ways are given to us to be passed on to others. To think or do anything else is pure selfishness. We only keep them and get more by giving them away, and if we do not give them away we lose them . . . . The survival of the world depends upon our sharing what we have . . . . If we don't, the whole world will die. First the planet, and next the people." —Fool's Crow, Oglala Sioux holy man

*William was a dancer, singer, and Sun Dancer. His grandfather was Fool's Crow. He had two children: Lester and Florakate. During the 1990 Goodwill Games in Seattle, the authors arranged for him to be honored by representing the Daybreak Star Indian Goodwill Village. William passed away on April 7, 1995.*

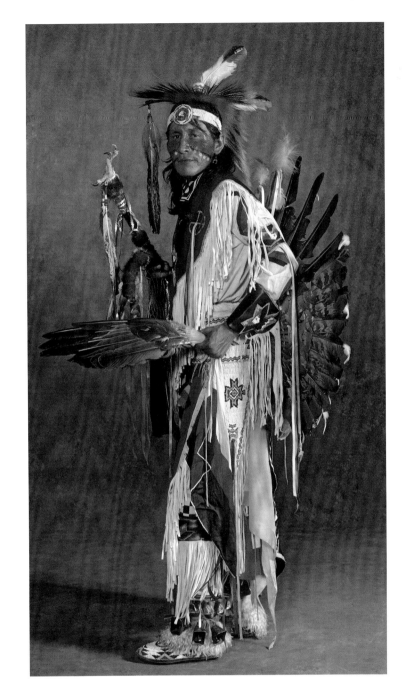

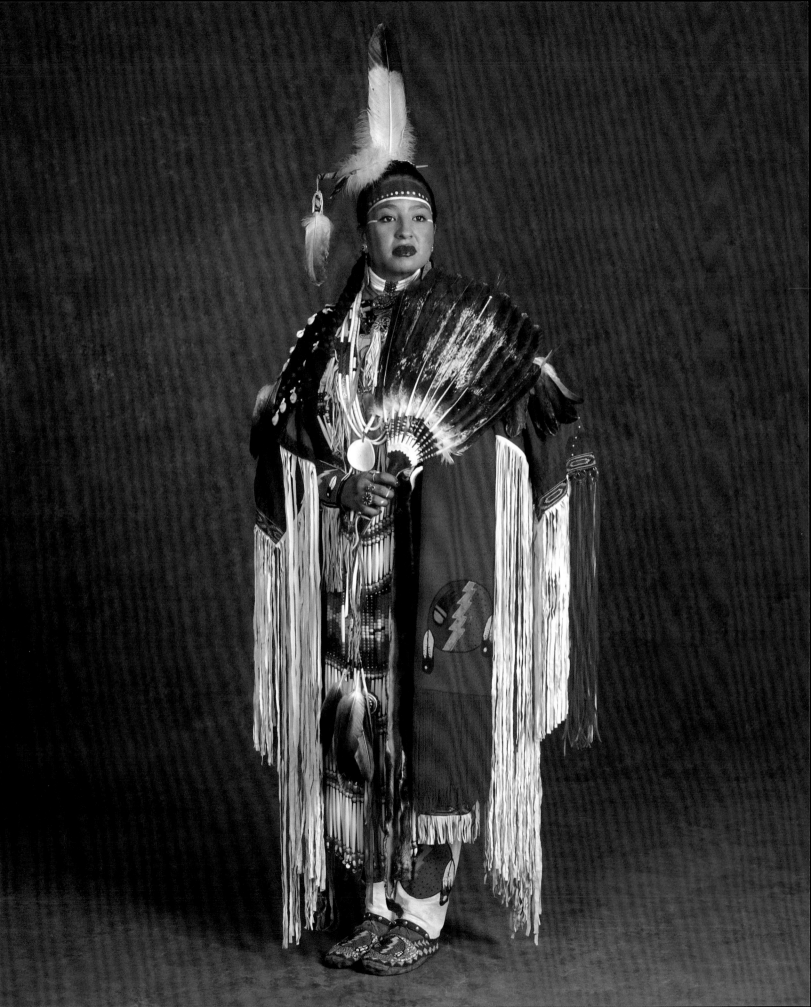

# 3

"The ground on which we stand is sacred ground.
It is the blood of our ancestors."

—Chief Plenty Coups, Crow

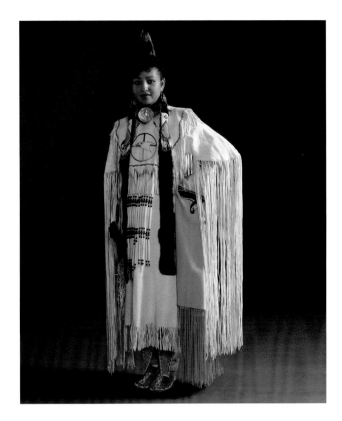

Dawn Black

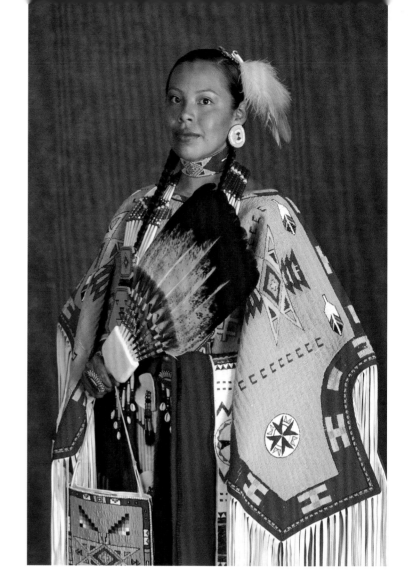

*previous pages:*

# Dawn Black

*Chippewa-Cree ⸺ Blackfeet*

I danced as a little girl because it was the thing to do, but as I grew older, so did my appreciation and respect for dancing. When I'm dancing, I feel as though nothing else matters. When I'm dancing, it's not only for God but for all the people who have inspired me throughout my travels. Most of all, my inspiration came from my parents; my mother's encouragement taught me to be the best that I can be, and my father's belief in me helped me to believe in myself.

# Delmarina One Feather, Waste Win (Good Woman)

*Oglala Lakota ⸺ Diné*

My grandmother bestowed my Lakota name to me when I was only five months old. Since an early age I have been privileged to dance the Traditional, Jingle, and Fancy Shawl styles of dancing at various powwows, school events, and social and community celebrations. I have a sincere respect for all Nations I have visited and I will continue to learn from my elders and others who have guided me to be a positive role model.

# Oliver Jones

*Port Gamble S'Klallam*

I am a descendant of the Yakama, Makah, Suquamish, Duwamish, Squaxin, and Cowichan tribes. I am proud to be honored at every powwow because of being a warrior—an Army field medic in Vietnam. The colors of my Traditional dance outfit were chosen in memory of my fallen comrades… Fallen But Not Forgotten.

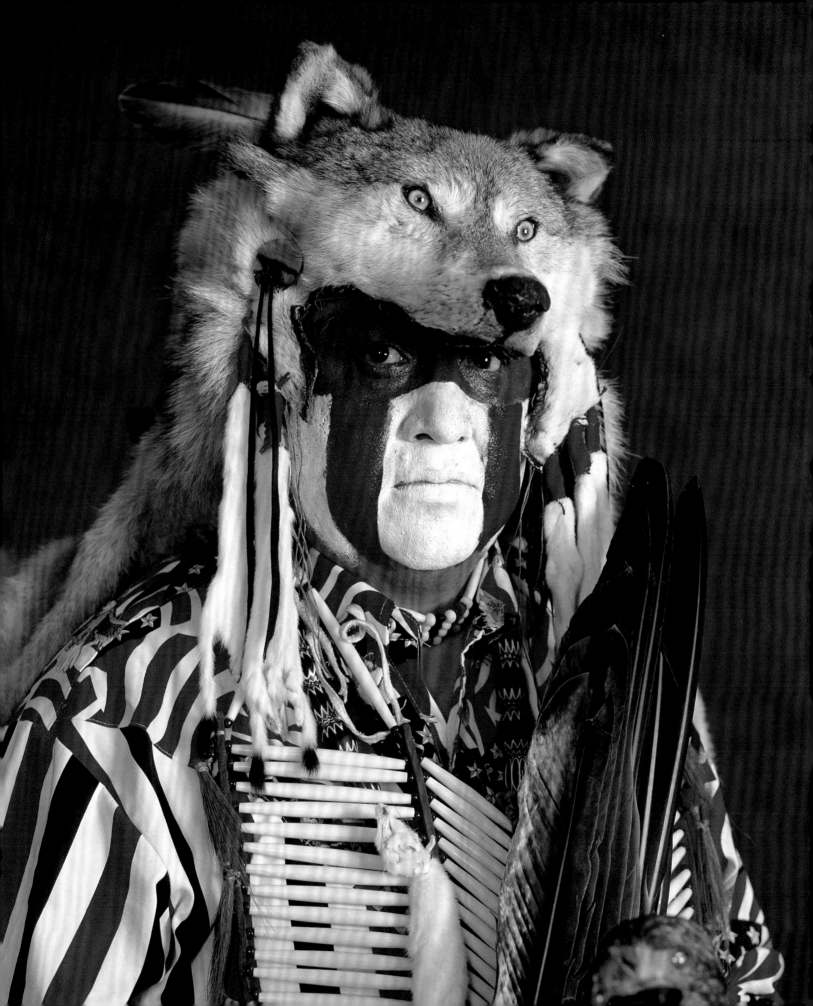

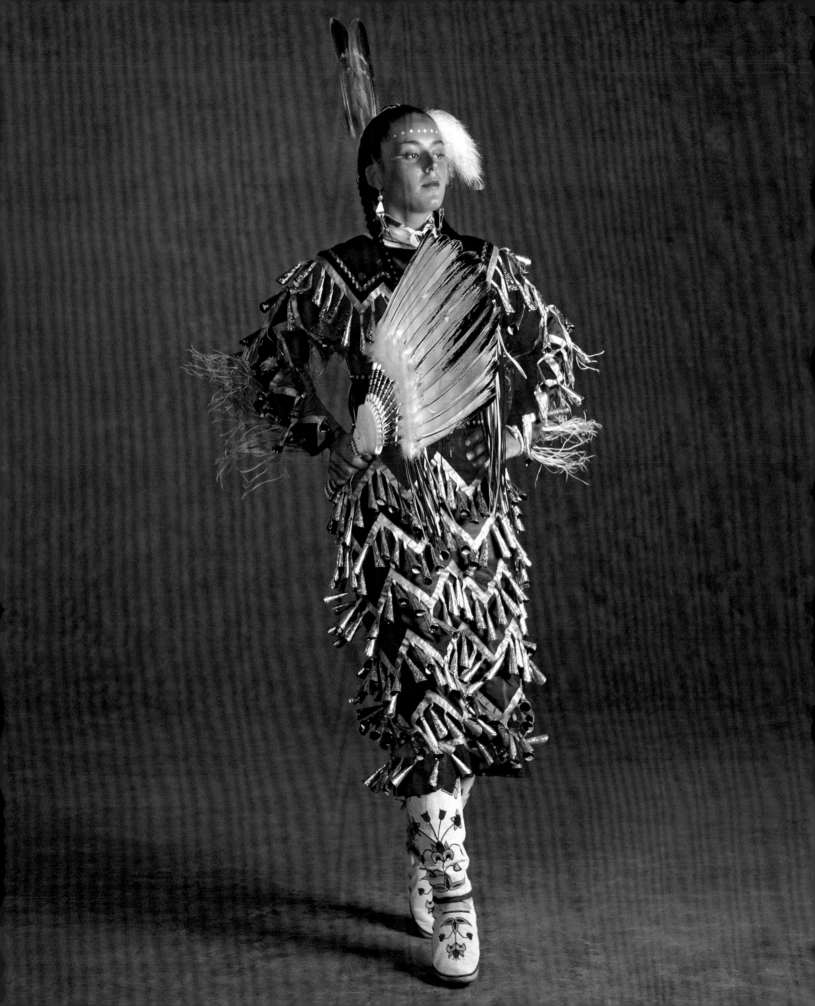

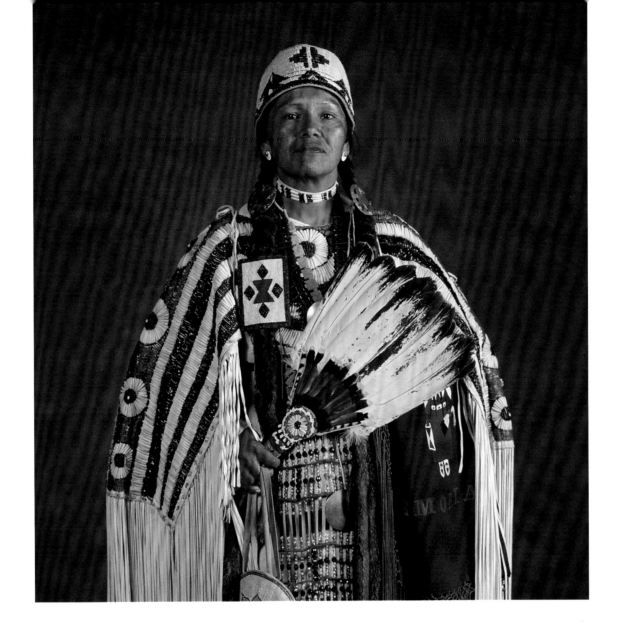

# Danielle Stratis

*Crow*

During the Grand Entry as you come out onto the floor, the emcee will announce your category. This, combined with the singers' voices, the beat of the drum, and the sound and sight of the other dancers, is really exciting. It's something you feel in your heart. I'll start dancing hard, and sometimes it's hard for me not to smile.

# Audrey Olney, Tit-Twy

*Yakama*

I am from White Swan, Washington, where I work as a teacher's aid. My dress was given to me from my grandmother and is made of old dentalium shells. In earlier times, dentalium shells were considered the most valuable ornament for trading. My husband made my hat for me, and the bag I am carrying was given to me by my niece. Although I have danced and competed in the dance categories of Jingle and Fancy, my favorite is Traditional, as pictured here.

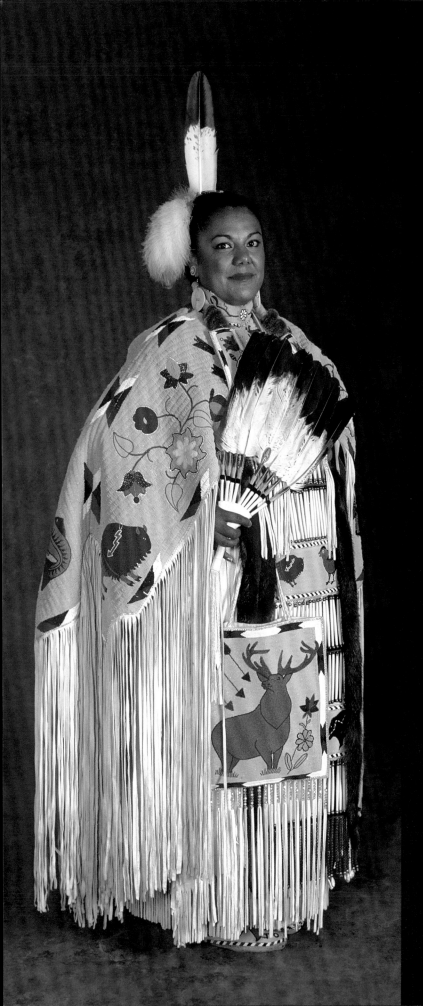

# Clarissa Cawston, Ipnasapyalonemy (She Carries a Burden for Her People)

*Colville*

My namesake was my great-great-grandmother who was in the Nez Perce War of 1877. I descend from the Chief Joseph Band of Nez Perce, Okanogan, Lakes, Wenatchee, and Coeur d'Alene. I am very thankful for having so many grandmas in my life— my Yaya who beaded me so many beautiful outfits to wear, my grandma Alvina for her spiritual teachings, and my grandma Cecelia for her support. *Ehe!*

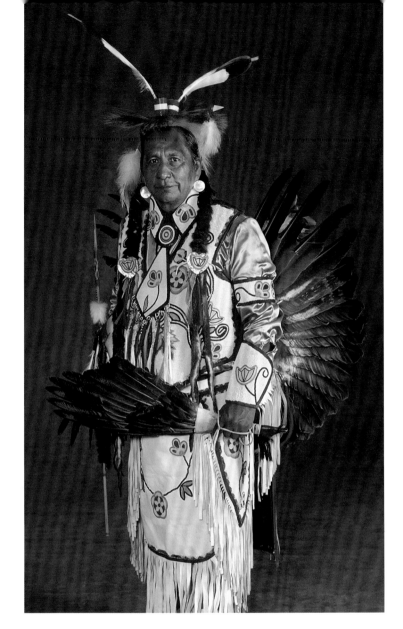

# Nakia Williamson

*Nez Perce*

I am a direct descendant of Eapaleekt He-lume Kah-wat (Pile of Clouds/Cloud Gatherer), who was a powerful Plateau warrior and prophet widely known during the period of intertribal warfare on the northern plains.

My dance style is a contemporary rendition of an earlier style of dance, *Paxam* in the Nez Perce language. I incorporate traditional Nez Perce geometric and floral designs, as well as color schemes that are Nez Perce in origin, and the Traditional hairstyle of our people, which has been passed through historical contacts.

The lives of our people were guided by examples given in nature. In traditional times, Nez Perce men were often more flamboyant in their dress than women, just as male birds are. Also, many of our songs commence at a higher pitch and descend to a lower one, just as the songs of many species of birds do. I try to remember these things, which are gifted to me by my elders, since it is through their example that we gain knowledge of the teachings of our people. *Yox kalo.*

# Phillip Paul, Snacaćene (Earring)

*Pend d'Oreille Flathead*

My family is one of the oldest families on the reservation. I am a fluent speaker of my language and I practice the traditional ways of my tribe. I've been married for thirty-two years to my wife, Debbie, and have nine children, twenty-six grandchildren, and eight great-grandchildren. My outfit was designed and beaded by my wife and daughters.

# Shándíín Spencer

*Colville ⚜ Crow ⚜ Diné*

I am ten years old and in fifth grade. I represent the Colville Confederated Tribes as "Little Miss CCT," which has given me the opportunity to travel to many pow-wows. When I started dancing, I danced Fancy, then I did Jingle, and now I am a Traditional dancer. I love to dance, because it makes me feel very proud of myself.

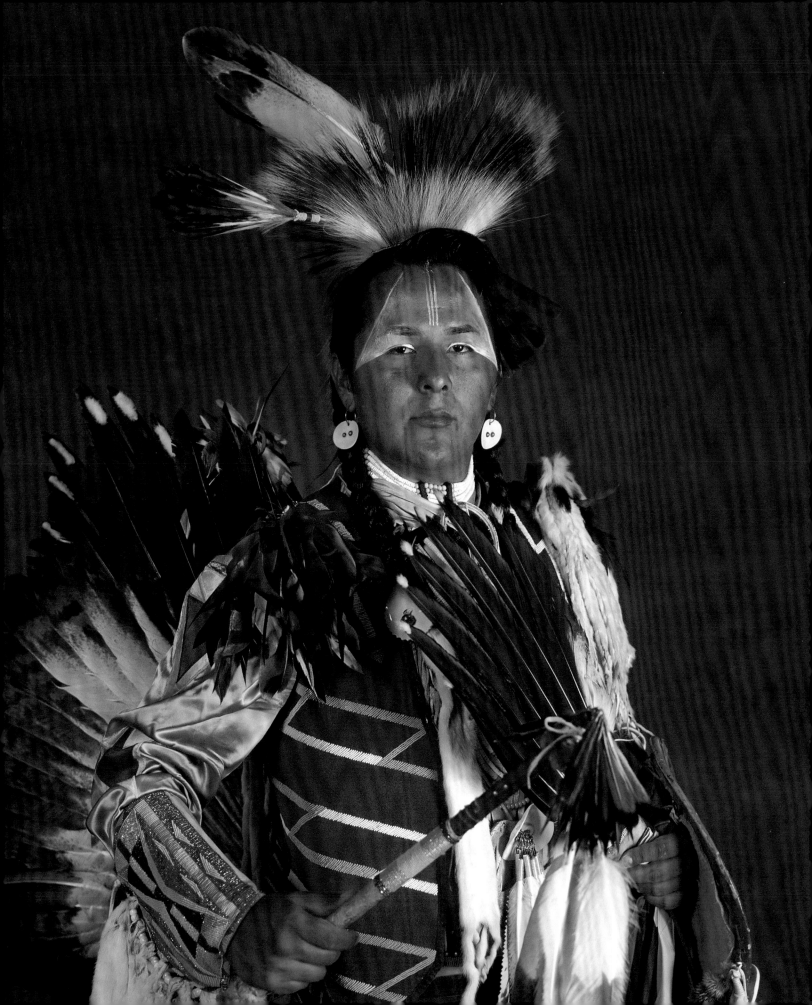

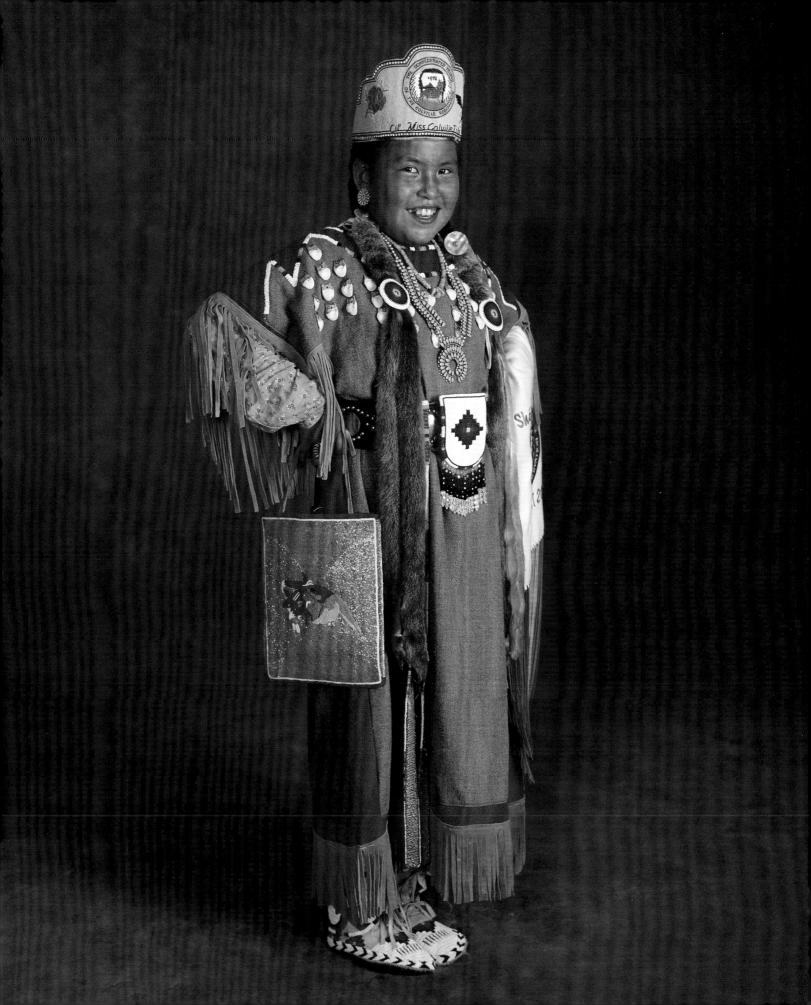

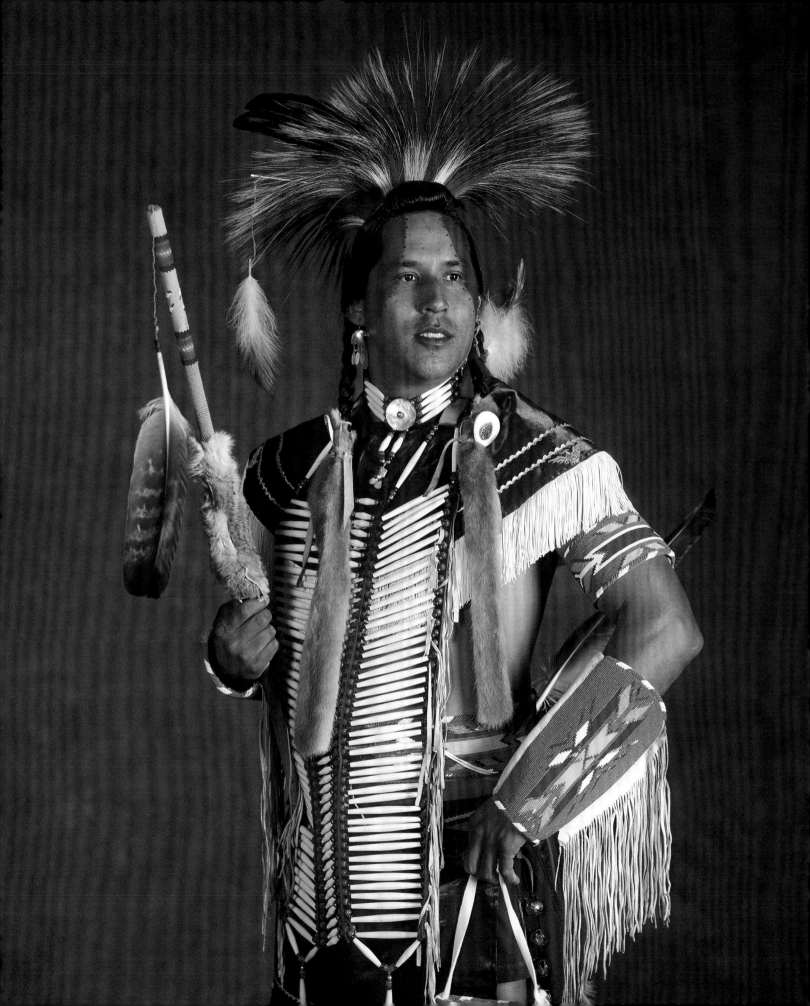

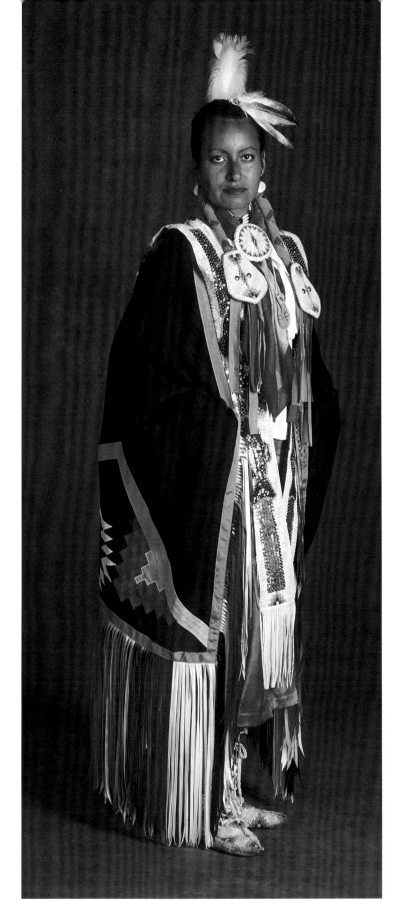

# Leon Old Elk-Stewart

*Crow*

As a Crow-style dancer, I have grown to regard dancing as a spiritual way of life—a good life. I have been taught to dance for all people and send a message of good faith, respect, pride, and friendship among all those who contribute to the celebration— drummers, dancers, spectators, and organizers. I am proud to represent my people and my family, especially my father, Walter Old Elk, Sr., who continues to teach me many traditional values, both inside and outside the dance circle.

# Melissa Campobasso

*Colville*

My Fancy dance outfit is dedicated to the salmon, which are to the tribes in the Northwest what the buffalo are to the Plains tribes. The people of the Colville Tribe lived along the Columbia River system, where salmon used to populate before the dams stunted the yearly migration. My grandpa was once able to feed his large family off the abundant salmon fishery at the confluence of the Okanogan and Columbia rivers, but that fishery, and others, are nearly gone.

My outfit serves as a prayer to safeguard and honor the salmon. I pray that one day they will return as they did only a generation or two ago— bountifully.

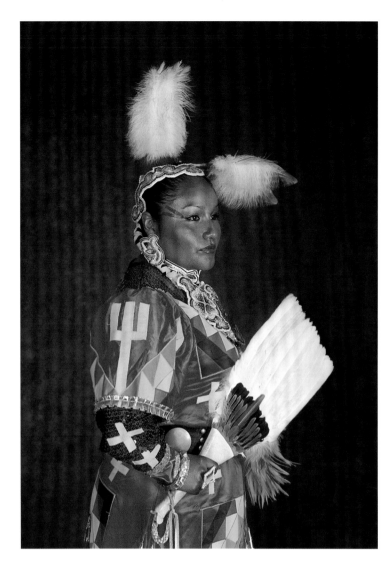

the Crazy Dog Soldier Society, which many Traditional dancers are now beginning to wear at modern powwows.

On my Arikara maternal side my great-grandfather Davis Painte composed the Arikara flag song during World War II. When I hear this sung all over the United States and Canada by drum groups from various tribal nations, it makes me feel like a part of this strong powwow circle.

I was also raised in a family that values mainstream education as a path to ensuring our tribal sovereignty and protecting our rights to live and be who we are. Both my parents have advanced degrees, and I will be attending the Institute of American Indian Art so I can further my own skills and abilities in traditional and contemporary native arts.

# Rick Wahchumwah

*Yakama* ⬇ *Nez Perce* ⬇ *Warm Springs*

My father used to tell me that my great-great-grandfather was the Nez Perce warrior Wahchumyas (Rainbow), killed at the Big Hole Battle in 1877.

This photograph of me was made when I was seventeen years old. Now I am a grown man with a fifteen-year-old son, Tyson, who dances Traditional and Prairie Chicken, and a ten-year-old daughter, Kimberley, who dances Jingle and Fancy. Dancing gives kids something positive to achieve rather than what is available on the streets. I would like to dedicate this to the memory of my nephew, Sterlin Wahchumwah, who recently passed away, and my mother, Matilda Wahchumwah.

# Lauren Frank (Good Day Woman)

*Arikara* ⬇ *Hidatsa* ⬇ *Blackfeet* ⬇ *Cree*

I am a fifth generation member of the Arikara Grass Dance Society. When I was three years old I was ceremonially painted and given an eagle plume, bestowed with the Arikara name of "Good Day Woman."

On my maternal Hidatsa side, I am a direct descendant of Two Ravens, who was painted both by Karl Bodmer and George Catlin in the 1830s. He was painted wearing a Traditional feather cap from

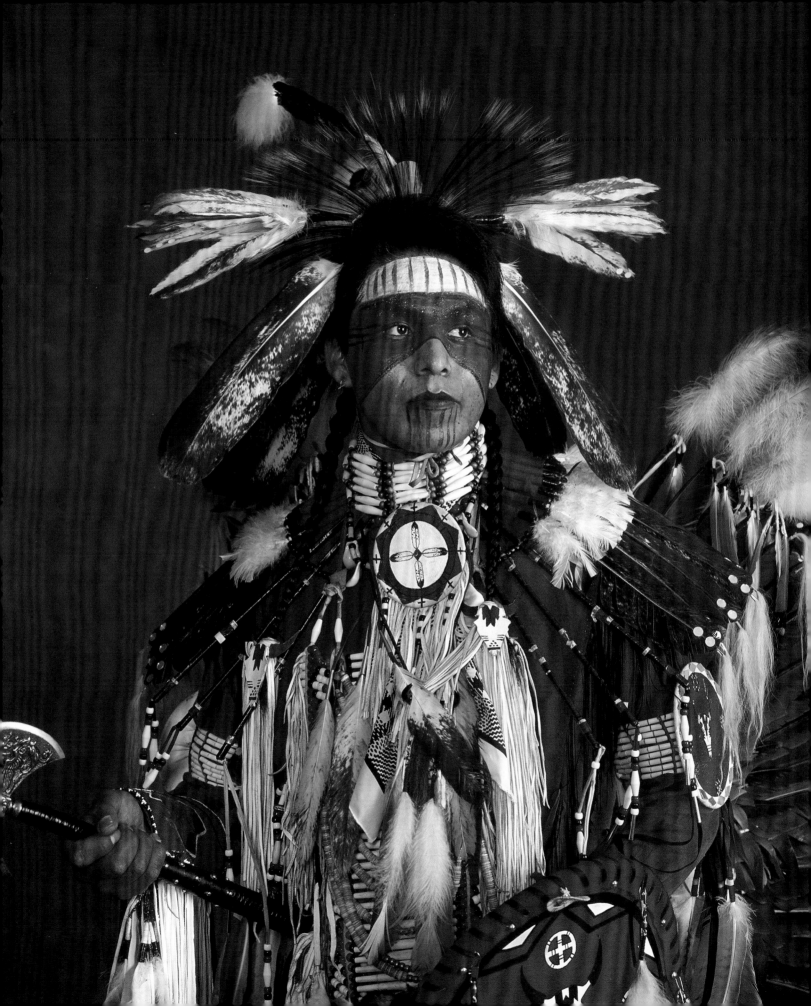

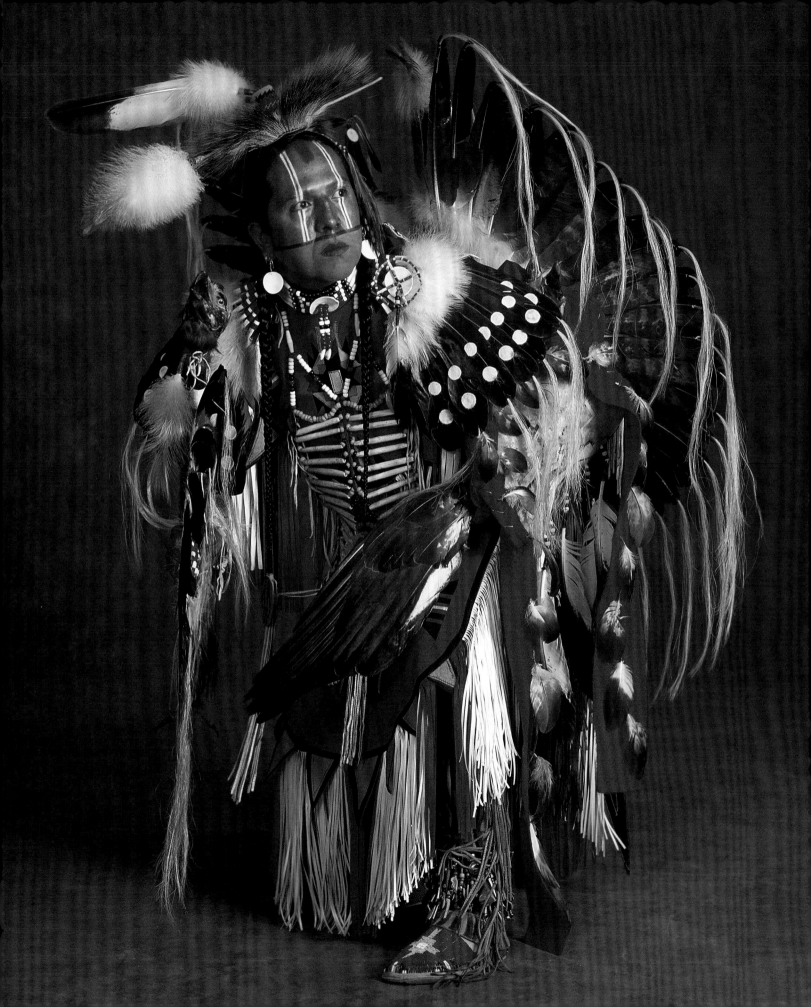

# Fabian Fontenelle
## K'ya/Nash/Ku/Li

*Zuni* ⬥ *Omaha*

Dancing and singing go together. The drummers
sing songs that stir you and make you dance,
pounding the earth with your feet while your heart
is beating with the drum.

My grandmother always told me to not be self-
ish, so when I'm praying or dancing, I try to think
of those in need of comfort and help, or a friendly
nod or smile that warms the heart. I dance to give
thanks to Great-Grandfather for giving us wonderful
things—songs and dances; animals, birds, creatures,
and insects; trees and plants and all human beings.

# Joseph F. Mellon, Jr., Su-Sep
## Spee-Le-Ya (Joseph Coyote)

*Colville* ⬥ *Coeur d'Alene*

I am a USMC Vietnam War veteran. The concept of
freedom, passed down to me through many genera-
tions, has always run through my spirit and soul. I
am a Traditional dancer who dances with, and for, all
my ancestors. I dance for all the warriors who have
not returned and have gone on to the Other Side, or
who cannot dance due to war injury. I dance for the
elders who remember a younger time.

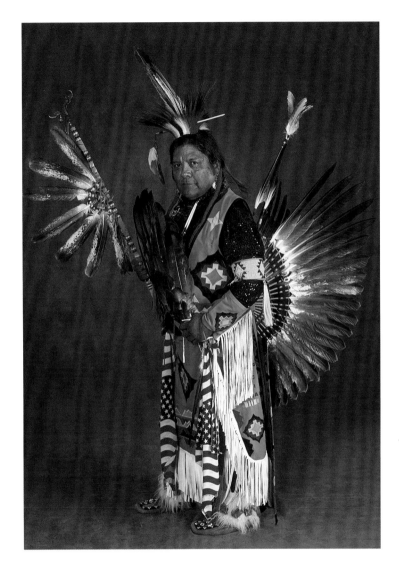

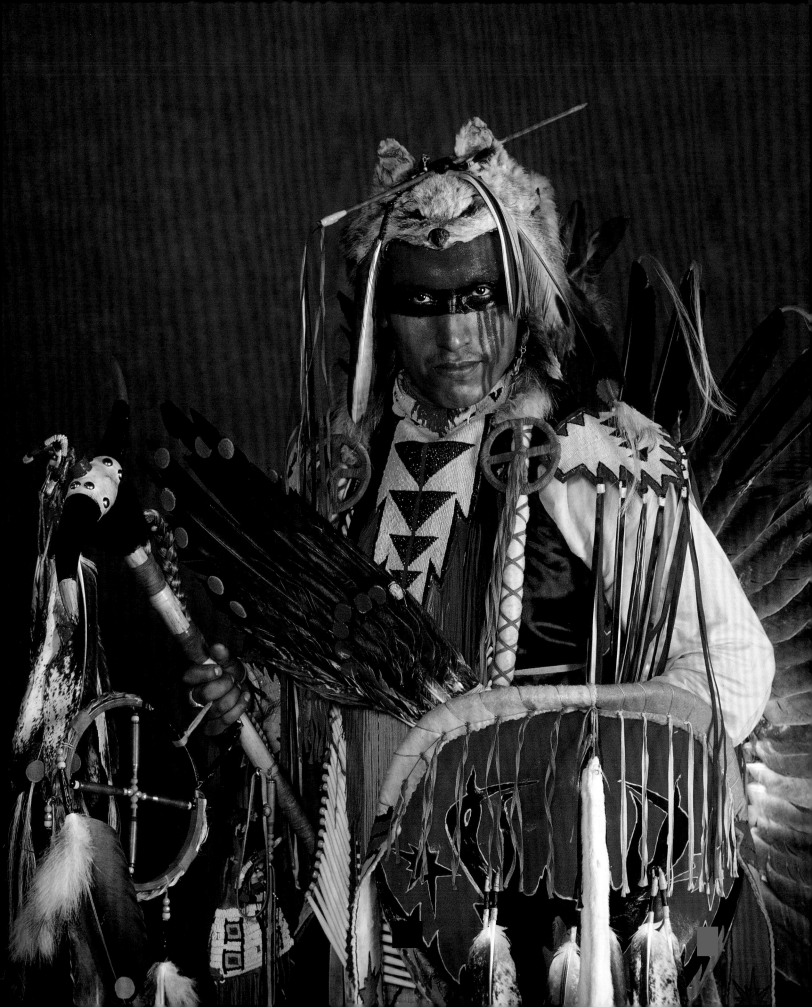

# 4

# "The many powers of inner nature are hidden in everyone, and these are identified with Wakan-Tanka."

—Blue Thunder, Teton Sioux

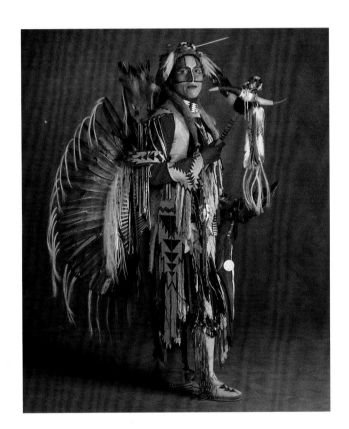

Kevin Haywahe

previous pages:

# Kevin Haywahe, Powerful Walking Wolf

*Carry the Kettle Assiniboine*

When I was a kid, there were people who told me that our past will never come back, so I should just let it fade away. We have to return to the cultural way of life in order to realize who we are and to move forward. I come here, humble, like waves of wind in the grasses, hoping people will see that they need to be reconnected with our past.

I would like to thank the Great Spirit, my family, Chief, and Council; and a special homage to my late grandfather Albert Eashappie who was a tribal healer. He gave me his blessings to be the champion Traditional dancer I am today.

# Teri and Jeffery Scott, Qoh Qoh Tse Mooque To Loo En (Raven Playing in the Soot of Fire) and son Epaleckt

*Nez Perce*

*Jeffery*: When I was a little boy living with my grandparents, we had to cross a field to the sweat house. My grandfather led the way, dancing, with his grandsons dancing behind. As a man, I have my own sweat house, and friends and relatives come to my house to sweat. As a little boy, I used to help my grandmother tan hides. As a man, I carry on these teachings, and tan the buckskin myself that my wife, my children, and I wear. So, in my dance and style of dress I truly know that through me my grandparents live on. Our religious leader and relative, Horace Axtell (pages 42–43), presented me with an eagle whistle, with all the rights and responsibilities that go with it. His words I hold in my heart, for I earned this in my own land, doing the things of a warrior for my people.

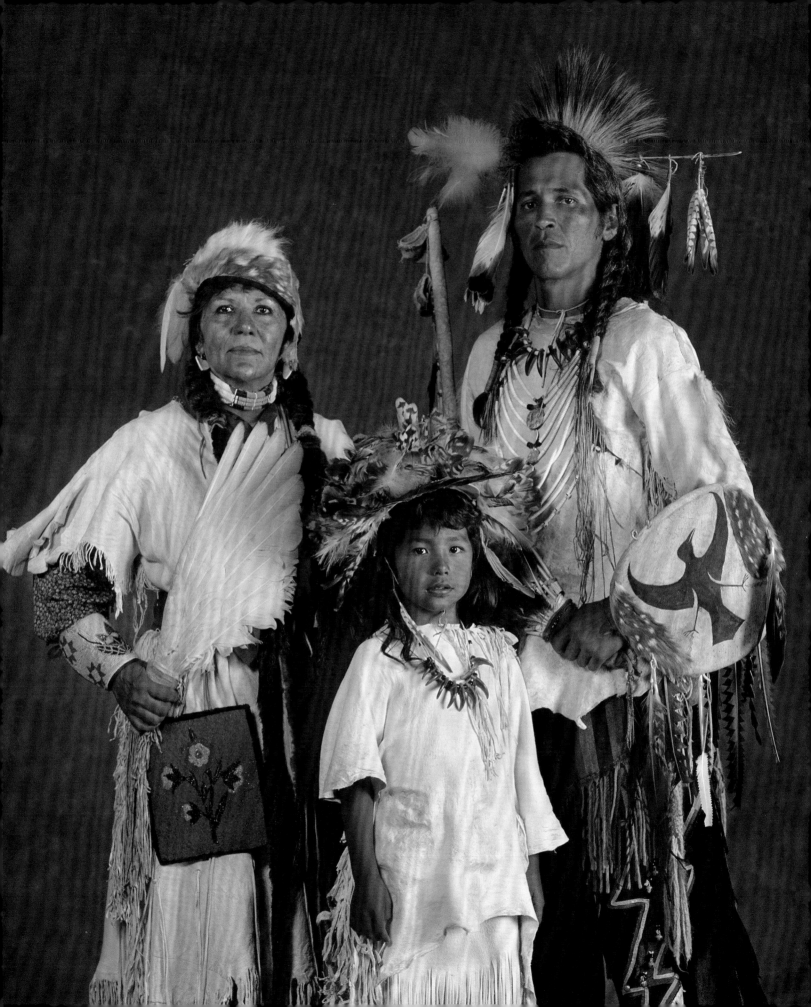

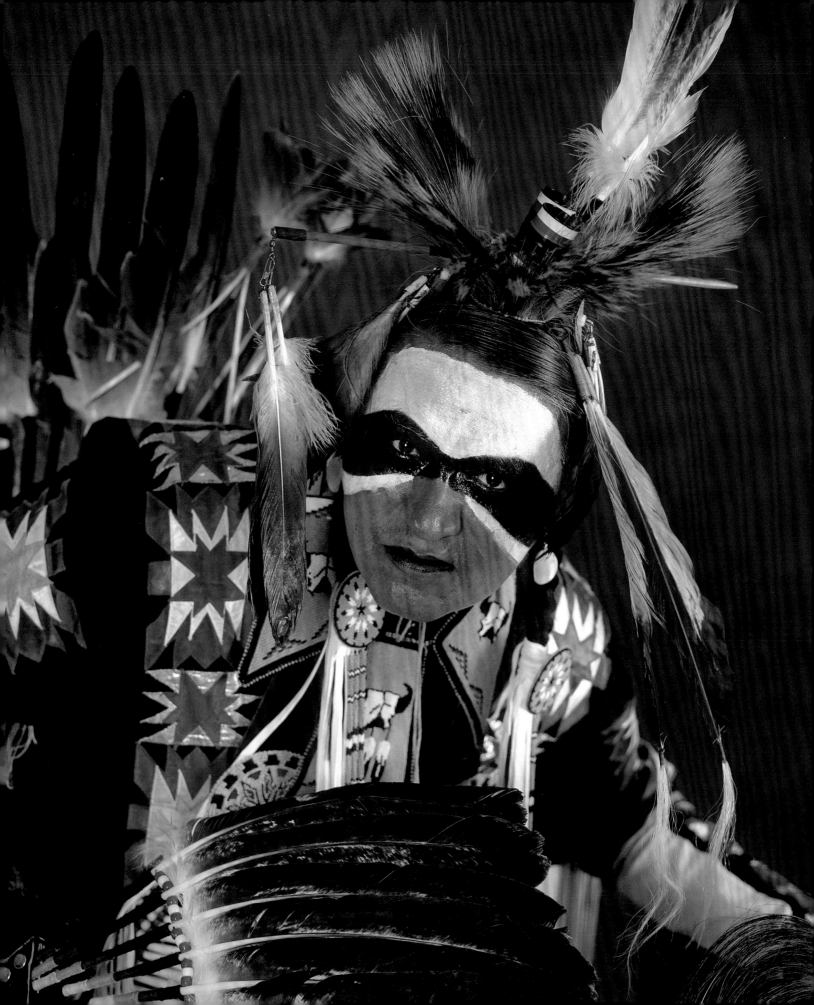

# Harvey Thunderchild

*Plains Cree*

I am Plains Cree of the Thunderchild First Nation, Saskatchewan, Canada. I currently dance Northern Traditional style.

I dance for the strength to continue to guide my children and grandchildren along the Red Road; to care for all human beings in a healthy and unconditional manner; to continue to be of service to the Creator, my family, community, and Nation, by demonstrating the healing power found within a small piece of the First Nation's culture.

# Kellie Mae Down Wind, Waa-bi-gonce (Little Flower)

*Red Lake Anishanabe*

I belong to the KingFisher Clan of the Minnesota Red Lake Band of Anishanabe.

Look at me. Watch me dance. I am proud, I walk with dignity, I walk with pride. I dance with all my relations, and for all my relations. I am also dancing with the elk, the otter, the horse, and the eagle, which are featured in my regalia. Look at me. Watch me dance.

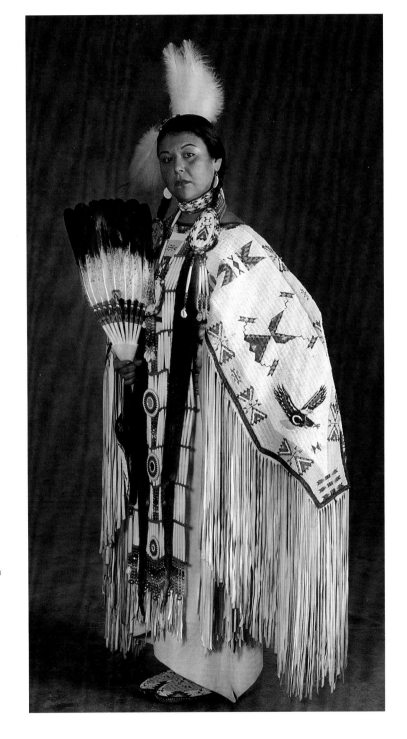

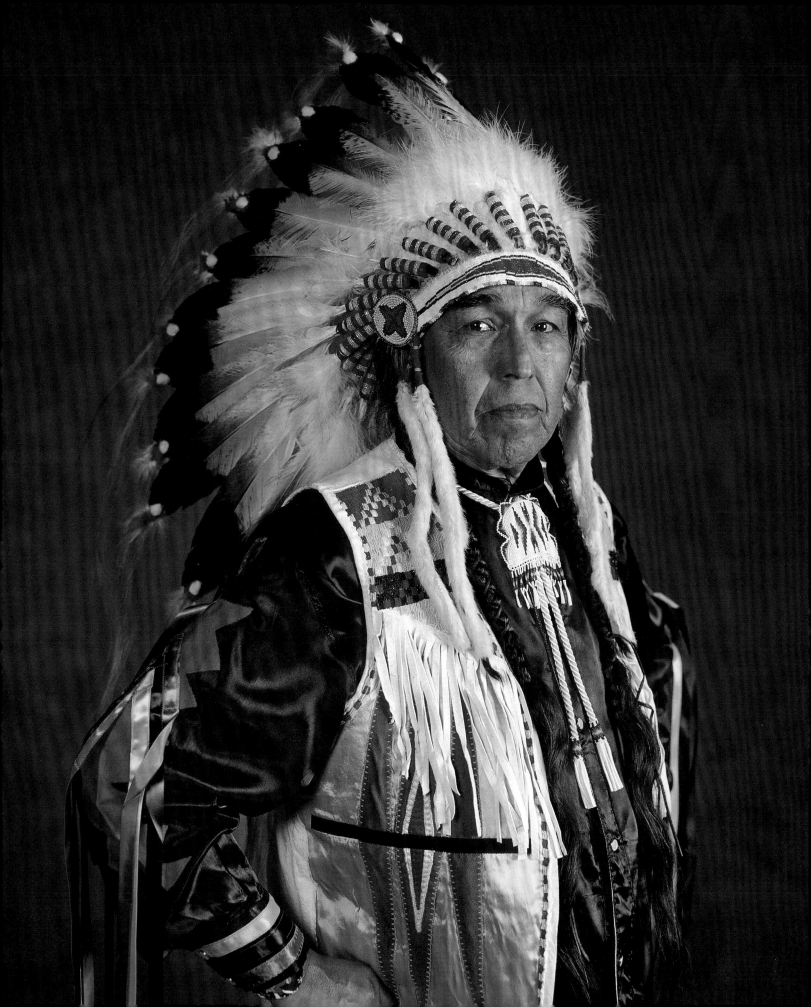

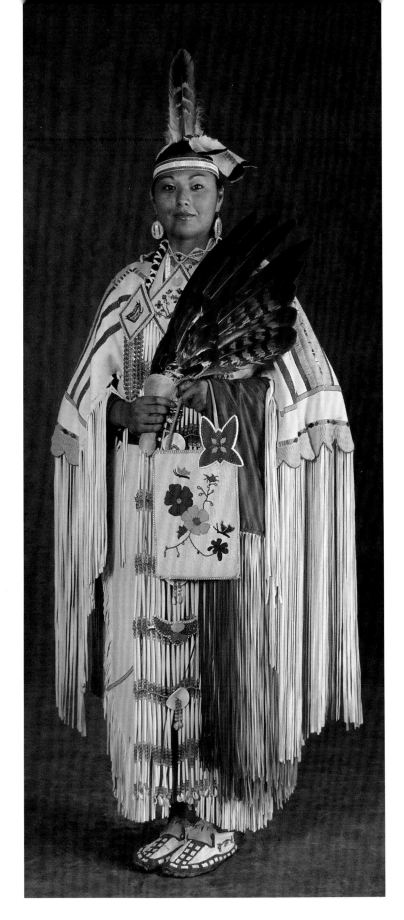

## Wilferd Yallup

*Yakama*

I was born on Christmas in 1931, at Rock Creek Longhouse, near the Columbia River. I was taught to fish as my people had for centuries before me. Then Celilo Falls, where I lived, was flooded in 1957 when the Dalles Dam raised the water level. Although we continued catching, selling, and drying salmon—preserving what was needed for off-seasons—the dynamics of the Columbia had changed. I served on the Columbia River Inter-tribal Fisheries Commission, and today advise what is needed to protect our resources. I was elected to serve on the Yakama Tribal Council, which I did for fourteen years.

My prayer for all: "A gift of peace to you and your families. Knowledge and understanding to all the children. Live with traditional values always. May the Creator be with you for many years to come."

*Wilferd Yallup passed away on March 31, 2004.*

## Teresa Bear

*Goshute*

My Grandma Pearl W. Sammaripa (see page 125) always tells me that if you want something, you must do it yourself because you will appreciate them more. Although she made my dress, I made everything else I am wearing. Grandma is right. While dancing in the arena arbor, I feel that nothing can touch me: I am protected. When I dance, I feel as though time stops and everything goes away. Dancing gives me time to think and to clear my mind.

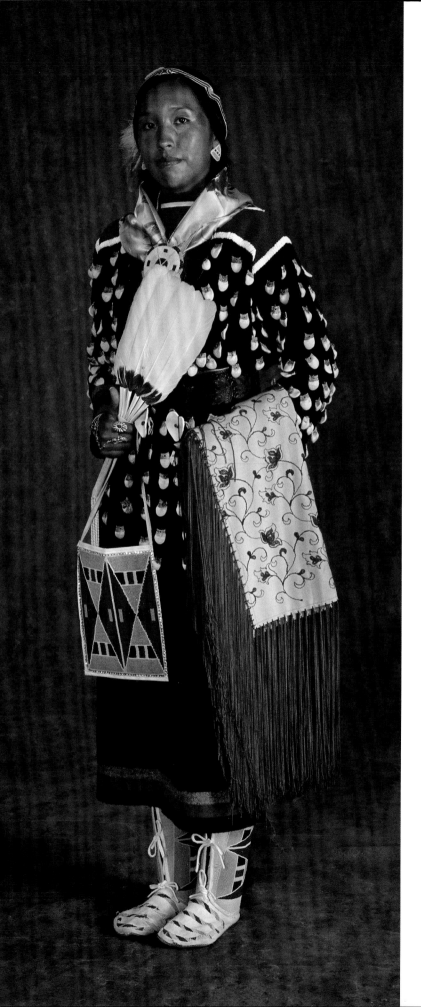

# Ashley Blacksmith

*Crow ⟡ Oglala Lakota*

I was taught how to dance by my older cousins, whom I looked up to since I started dancing. Everything I know about my culture and the powwow grounds was taught to me by my grandfather, who is still teaching me to this day. My love for dancing came from my parents who taught me to cherish everything I have. The inspiration that has kept me going came from my younger siblings and cousins who look up to me. And last but not least, my strength, knowledge, love, and pride for dancing has taught me so much about myself and the healing power dance has among the Crows.

# Terry Tsotigh

*Kiowa*

I'm thankful for the opportunities dancing has given me. It has taken me many places over the years. I have met and made friends with people of many different Nations. I have seen and heard many dancers and singers of different tribes—male and female, young and old—whom I admire very much.

I would like to give thanks to all of our veterans who sacrificed so much so we can practice our ceremonials, cultures, traditions, and celebrations.

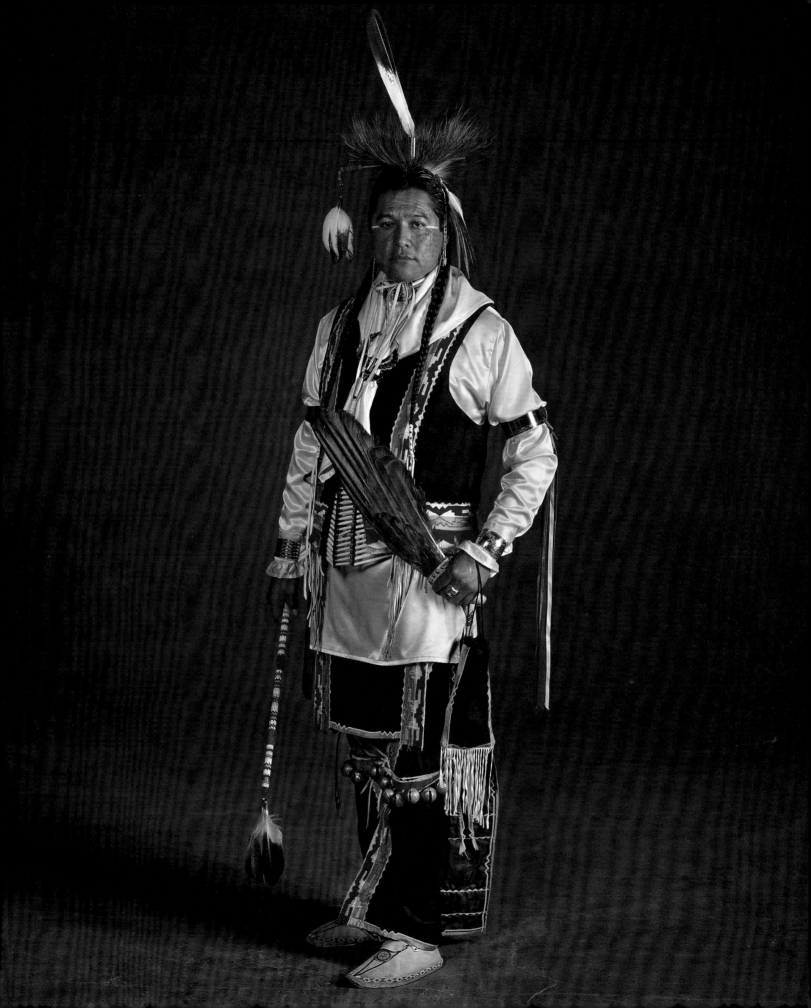

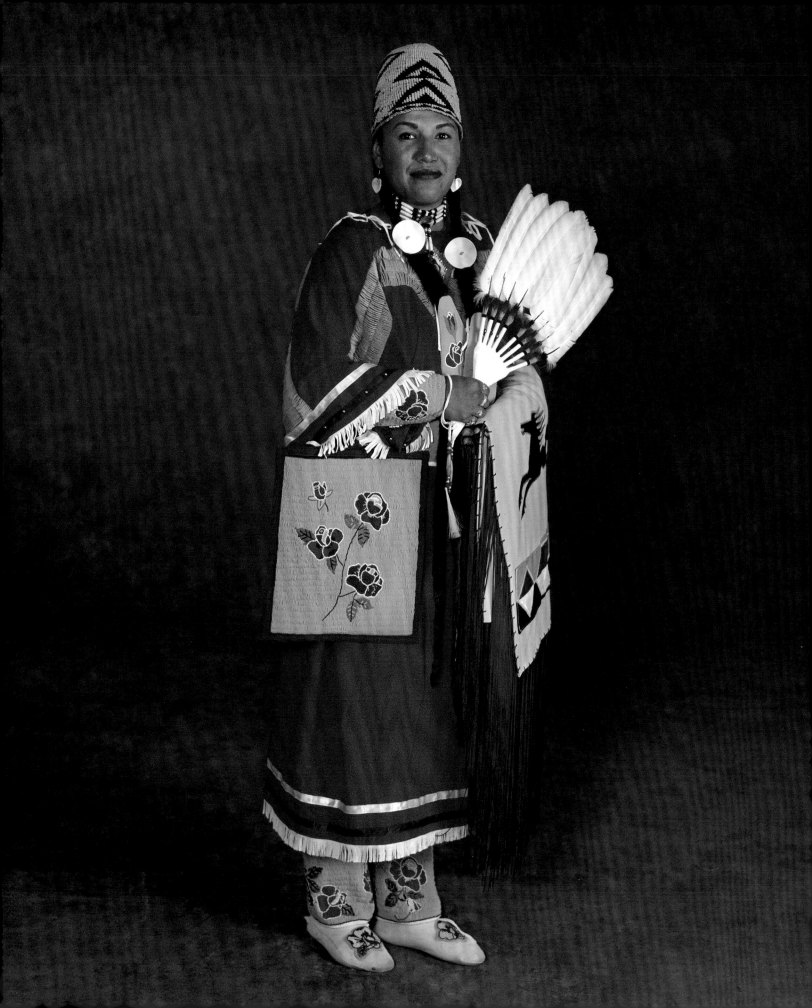

# Leanne SiJohn, Kwl ts'aw (Red Fringe)

*Coeur d'Alene* ⬇ *Colville* ⬇ *Nez Perce*

*Khwe ch'ntswinsh hi'nukum khwe guL hnt'ik'ut.*
(When I dance I am one with my elders.)

To dance is to honor your past and secure your future as an Indian person. To dance is to keep a part of our tradition alive and preserve a part of our culture, which reminds our children of who we are and where we came from. That is why dancing is important.

*overleaf left:*

# James Walsey, Pas-ta-xit

*Warm Springs* ⬇ *Wailaki* ⬇ *Yakama*
⬇ *Shoshone-Bannock*

I started dancing when I was about one year old, and at five I began singing at powwows. With the help of my uncle and my grandpa, I became the lead singer for the Eagle Spirit Singers from the Yakima Valley. My Indian name was passed down from my great-grandfather who was a spiritual leader. Then, it was given to my grandfather, who gave the name to me. We now share *Pas-ta-xit* together. The outfit I'm wearing was made by my father (see pages 158–59), mother, and oldest sister.

*overleaf right:*

# Janet Billey

*Grand Ronde* ⬇ *Paiute*

I'm the great-granddaughter of chiefs who fought for our lands and signed treaties. I grew up among rodeos, powwows, and generations of queens. I am very proud of my family, most of whom are still active in the National Indian Rodeo, and give thanks to my ancestors, "the horse people"—a generation of great cowboys.

I am a Traditional dancer and elder who earns honor at the Grand Entry of the powwow line. Entering the Great Circle fills you with strength; and the beautiful regalia of peoples, personalities, and creatures is like a flashing rainbow before your eyes.

My hat is a replica made by many coastal tribes and shows the story of our tribe's basket lady. It is cedar-covered with tiger shells, cowries, little white clamshells, abalone shells, and dentiliums that were once used as wampum.

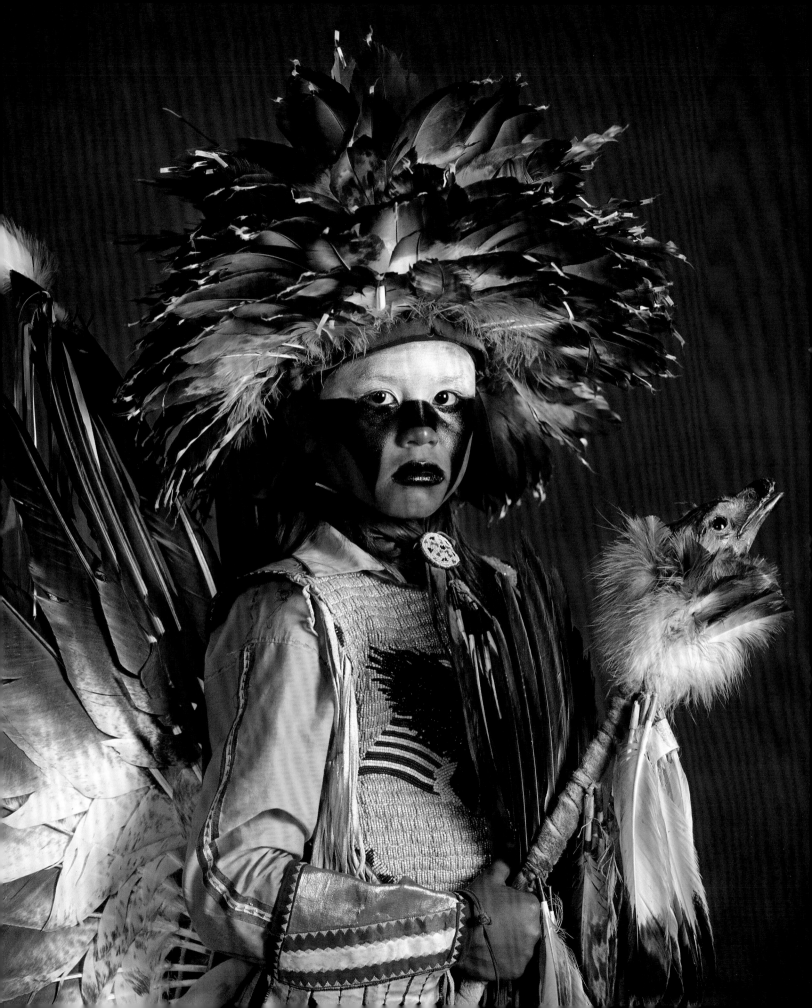

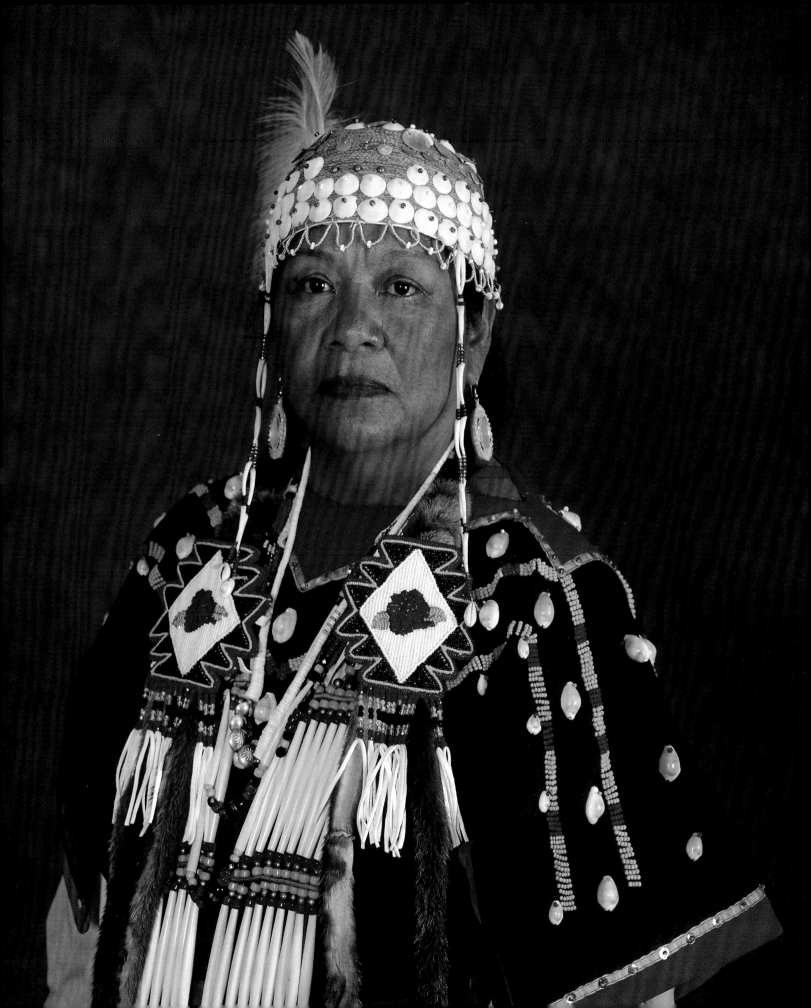

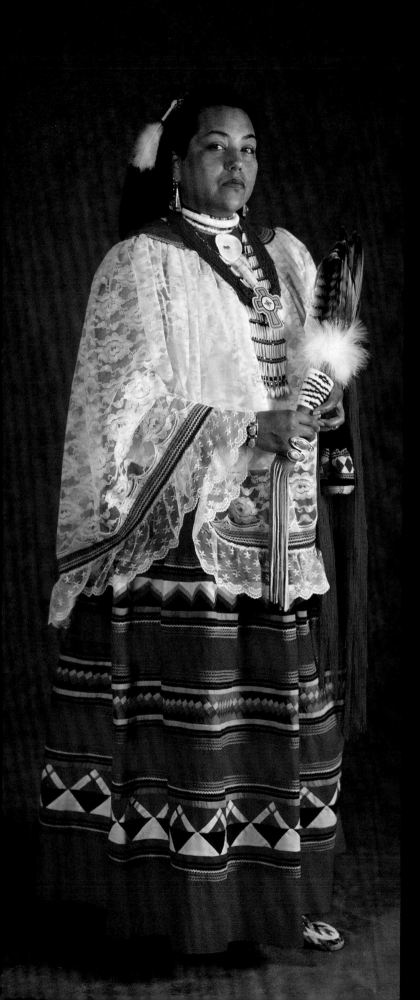

# Leila D. Spencer

*Umatilla ✦ Seminole of Oklahoma*

The dress I wear tells my mother's family history like a coat of arms. The top row is a friendship band; the middle row is our Nurcup Harjo family band; the bottom row represents our Sweet Potato Clan; blue stripes represent my mother's children and the yellow stripes represent my father and mother.

The strength in this dress comes from my mother, who is the embodiment of protective and supportive power. When I wear this dress I feel her strength, pride, and love. As my mother is a prayer warrior, I also wish to continue on in her steps to help the healing and empowerment of all of our Native people.

# Taunie M. Cullooyah

*Kalispel*

My family and I go to powwows throughout the Northwest. I think powwows are a great tradition and a perfect gathering. They show our spectators how much our religion and our culture mean to us. But most of all, the powwows bring all the tribes together as one.

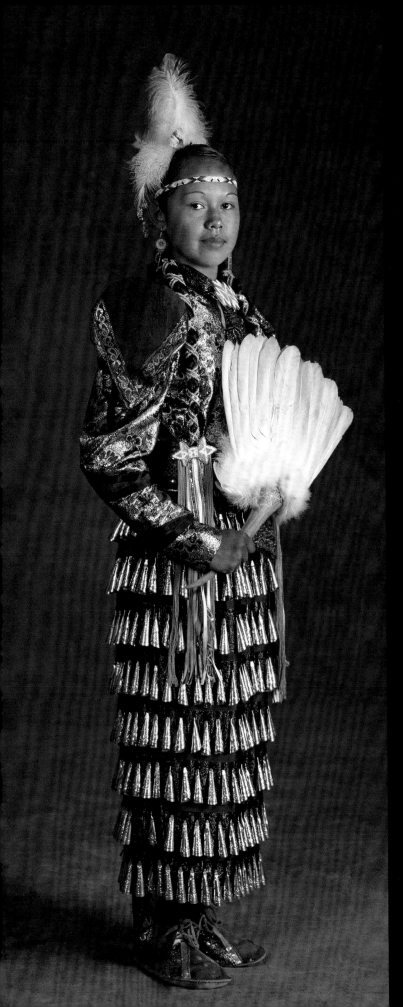

overleaf left:

# Derwin Velarde

*Jicarilla Apache*

One day my grandmother chuckled as she recalled how as children we would gather, decorate, and wear sunflowers as regalia and imitate powwow songs and dances. Although I was too young to remember, I've always felt the spirit of the drumbeat. Traditional dancing strengthens my spirit. Good blessings can come from respecting our Creator, Mother Earth, the heartbeat, and the circle of life.

overleaf right:

# Marty Whelshula, nc'icen (Wolf)

*Sanpoil Band of the Colville Confederated Tribes*

I love dancing, especially when my children and family are on the dance floor with me. Something powerful happens when you join the Circle and celebrate life with your relations. I think most dancers would agree that one of the most powerful moments on the floor is when a drum kicks out a song that connects with the spirits of all the dancers. It's moments like that when I thank the Creator for my children, my family, my ancestors, my outfit, my feathers, and for being Indian.

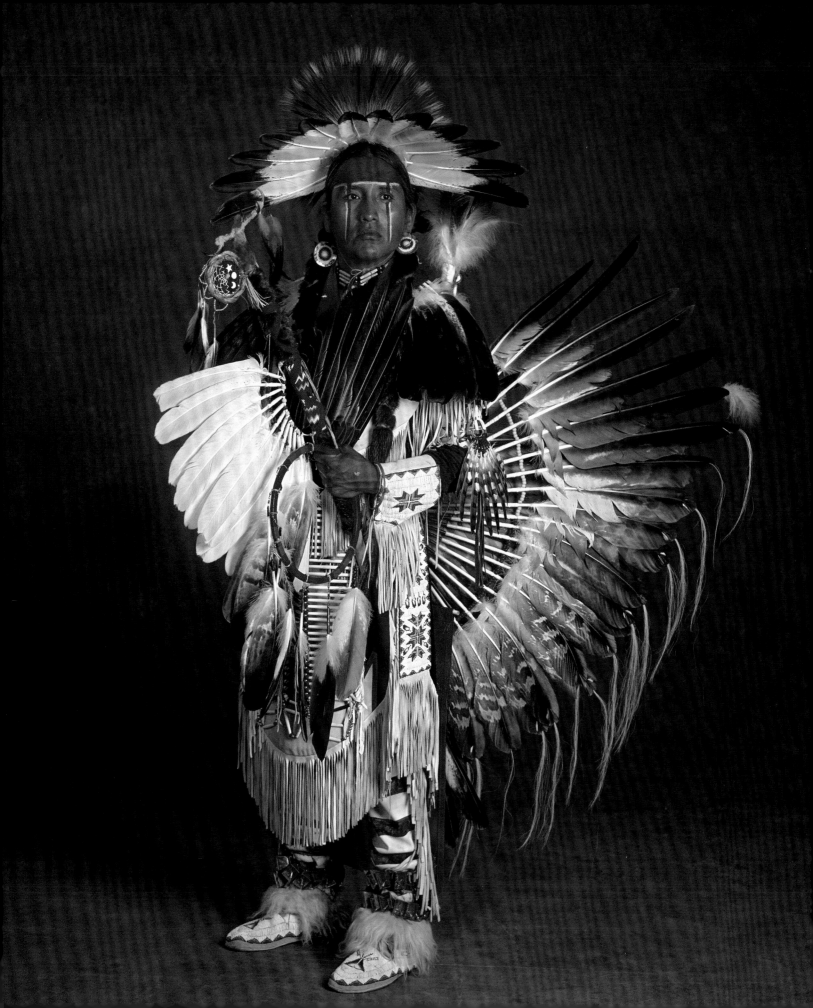

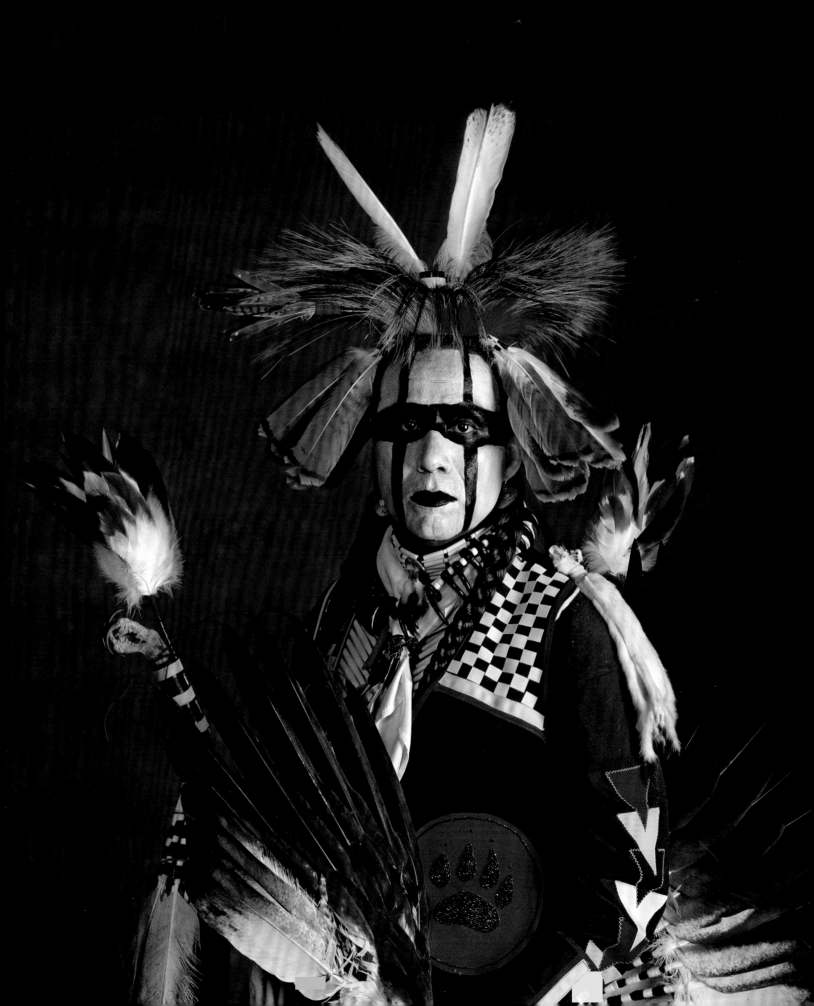

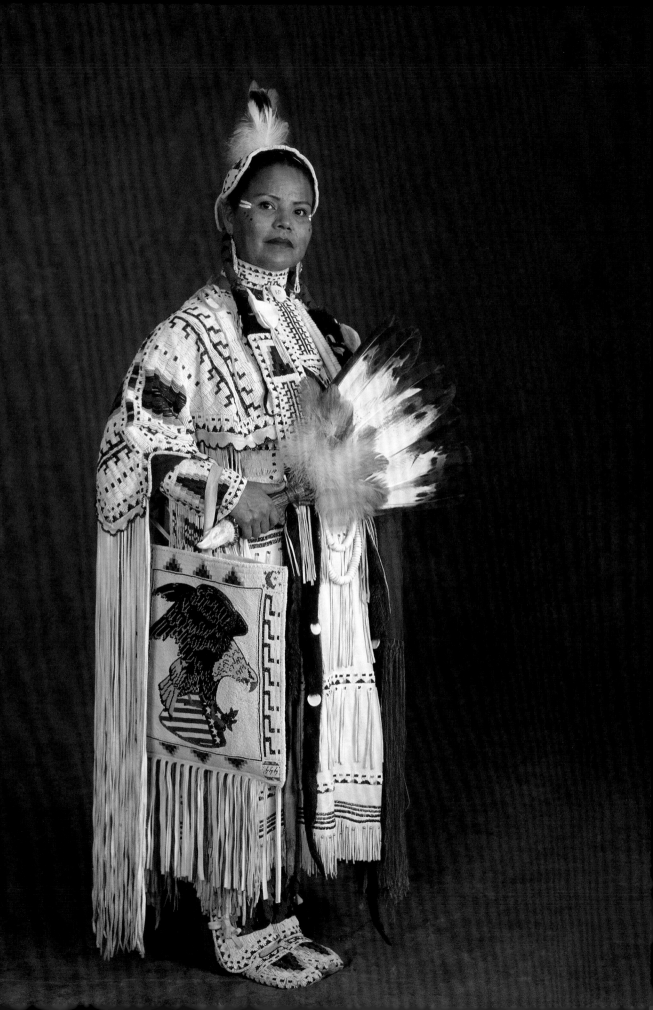

# Leona A. Ike, Mi-twi

*Warm Springs ⟱ Wasco ⟱ Yakama*

My mother is the great-granddaughter of Chief Toh-sympt, a great Indian warrior and Wasco chief who signed the Treaty of 1855 on behalf of the Ki-gal-twal-la Band of Wascos.

My Traditional beadwork made by my mother, with a few beads sewn by me, represents our Creator and His creation of life, and respect for our spiritual beliefs, our sacred foods, and my chiefs. I have had medicine people and elders approach me to shake my hand because the medicine of my regalia touched their spirit.

I work in the criminal justice system. Every day I start my job with hope that I can help one person on that day, and my faith keeps me coming back the next day. In my eyes, if I can help one person to stay sober or free of drugs for one minute or one hour or one day, then we both are a success. Powwow keeps my spirit strong.

*overleaf left:*

# Tashina Crom (Eagle Lodge)

*Chippewa-Cree ⟱ Blackfeet*

This photograph was made when I was ten; I am now eighteen years old. Powwows have always been a huge part of my life. I remember my mother (see pages 56–58) and me dancing together, and my grandmother looking on with satisfaction as we floated gracefully across the floor to the sound of the beating drums. With my grandmother's passing I've put my powwow days aside for a while, but I hope to return to the Circle one day to dance in her memory.

*overleaf right:*

# Dan Nanamkin, K'oup? lus enim k'la (Thunder and Lightning)

*Colville ⟱ Nez Perce*

I descend from the Chief Joseph Band of Nez Perce, and from the Okanogan and Lakes Bands of the Colville Tribe. I work as a teacher and love to work with the youth.

This dance, this powwow, is only one small aspect of our heritage. Yet, just like our ceremonies, language, sweat lodge, and pipe, this is our remaining link to our past. This is our ancestor's gift to us, given to them long ago, from our Creator. *Lem Lempt.*

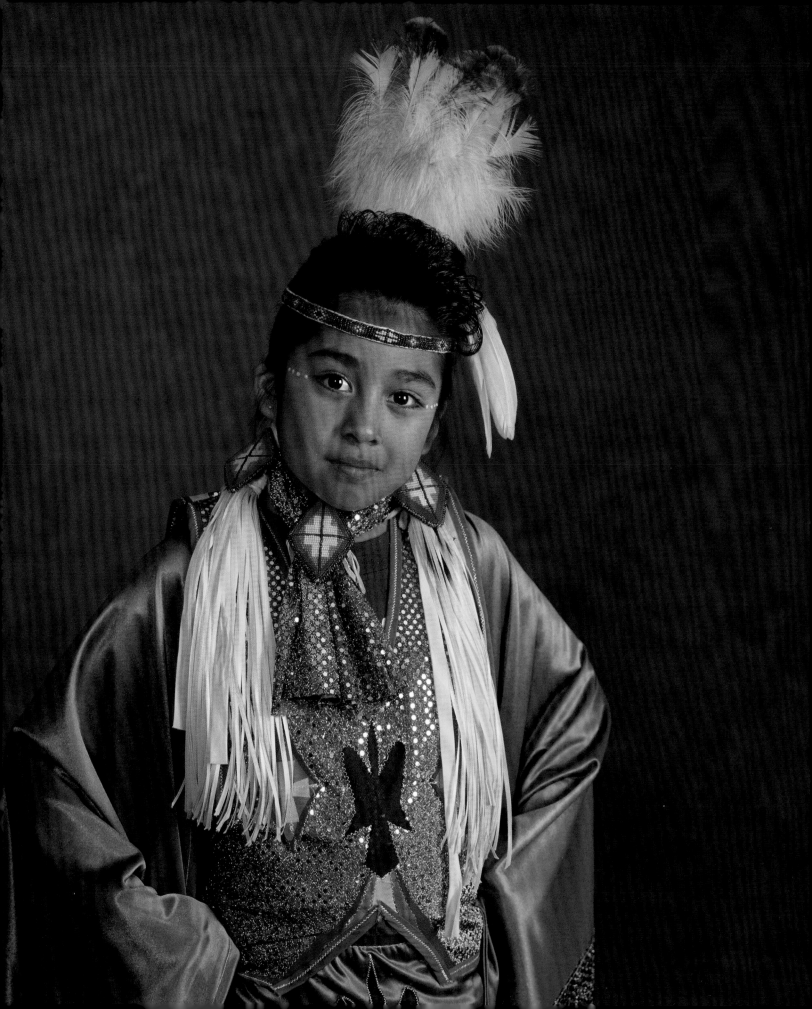

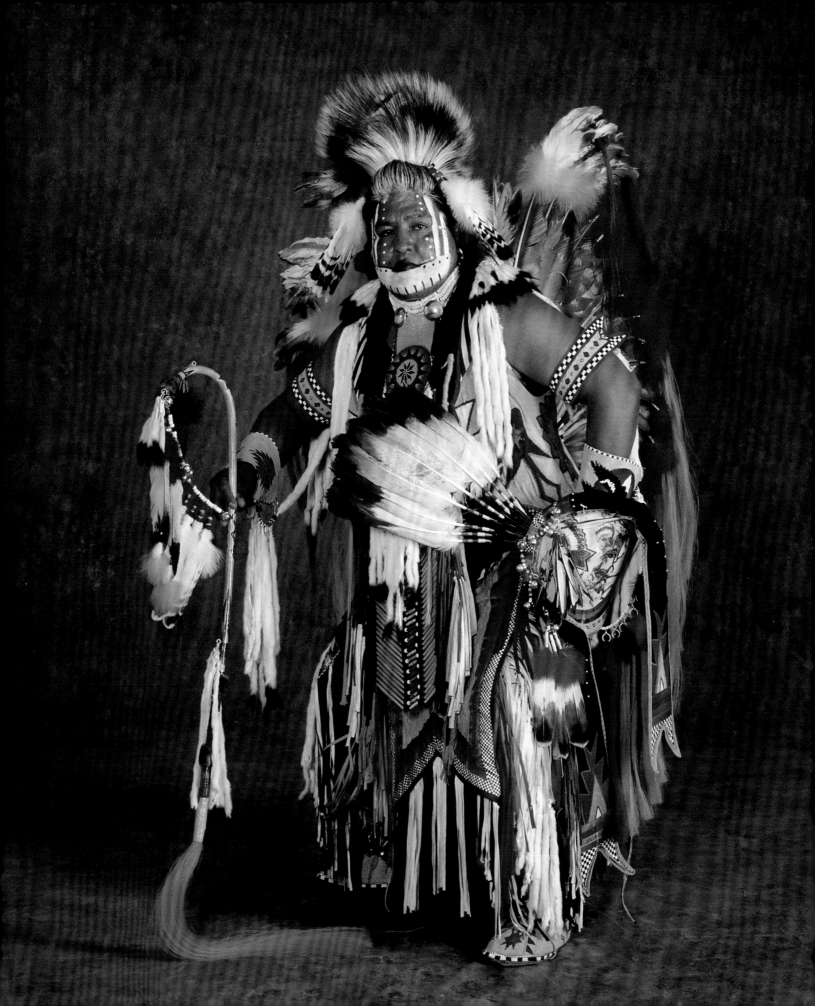

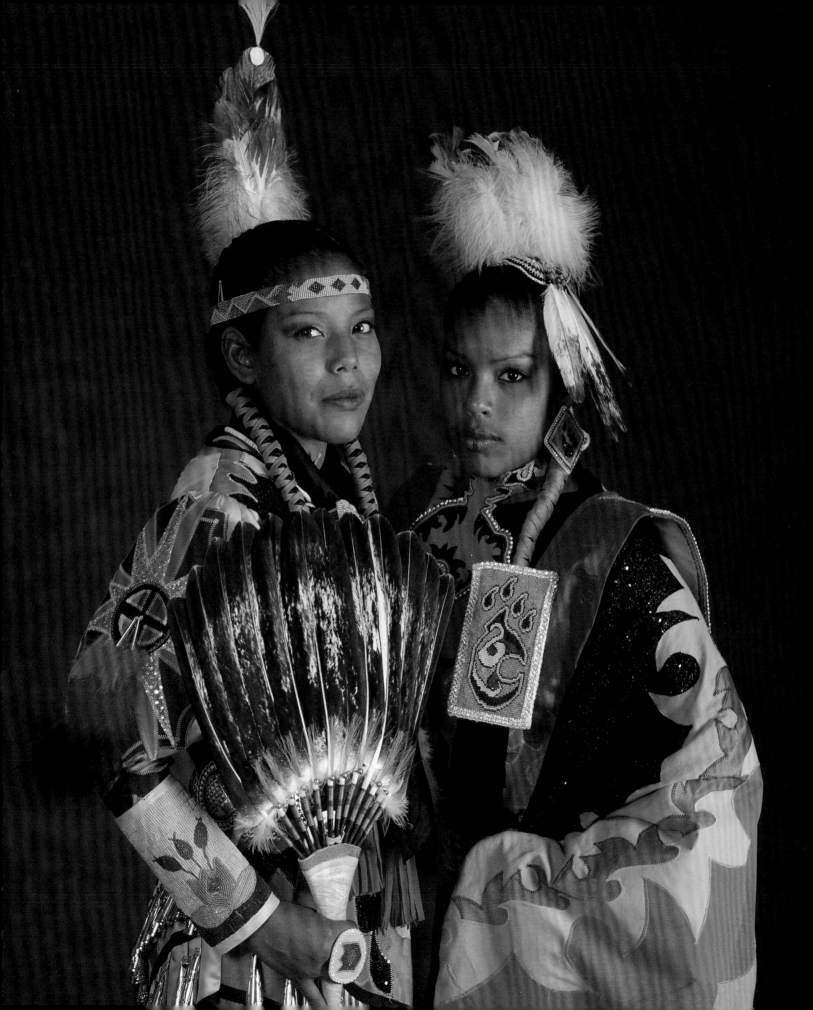

# 5

"We had only asked to be left in our homes;
the homes of our ancestors. Our going was with heavy hearts,
broken spirits. But all this is now placed back of us."

—In-who-lise (White Feather), Nez Perce

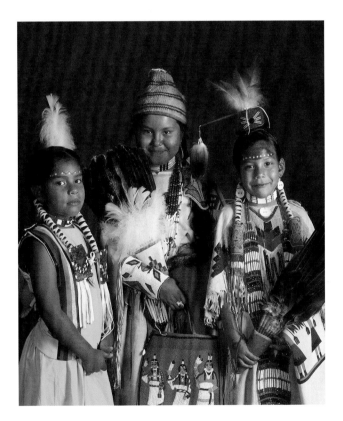

Wetalu Henry, Tamara Arlene James, Lolita Henry

Lolita and Wetalu Henry

previous pages:

# Lolita and Wetalu Henry

*Nez Perce*

*Lolita:* My sister and I have been dancing since we were two and three years of age. We were originally all-around dancers, but our main styles of dancing are now Fancy and Jingle. Plus, we sing backup for the Redtail Singers. My sister and I first began to bead at the ages of eight and nine. There are many different styles of beadwork and we know a few— but we are still learning.

# David Mills

*Blood*

I was brought up traditionally and taught to respect my elders and their ceremonies. They taught me the songs and the ways of our people: how to do bead-work, make drums and dancing outfits, and keep our own language. I left all this for a while when I was sent to a boarding school for ten years, but I never forgot our ways.

  I've been dancing for about seventeen years, and I am a member of the Sun Dancers on the Blood Indian Reserve in Standoff, Alberta, Canada. My out-fit is black and yellow, like that of a bumblebee. The

overleaf left:

# Justus Cree

*Assiniboine ₩ Cree*

My dance style is very Contemporary and is full of the colors and movement of the new generation. My regalia was made by my family as a symbol of the love and pride they have for me. The eagle feathers I wear help the Great Spirit guide and protect me. The colors of my beadwork represent the Fire Thun-der (the fire colors). My great-grandpa said when the Fire Thunder touches the earth, the sky and earth come together and create a sacred place. To me, this is the dance arena.

overleaf right:

# Vincent Rain

*Cree ₩ Stoney*

*Aho* Creator,
I thank you for all you have given me in song and dance as I walk this road in life. I also give thanks for my wife, my mom, and my dad for all their support that helps me with my steps through life. I know who I am.

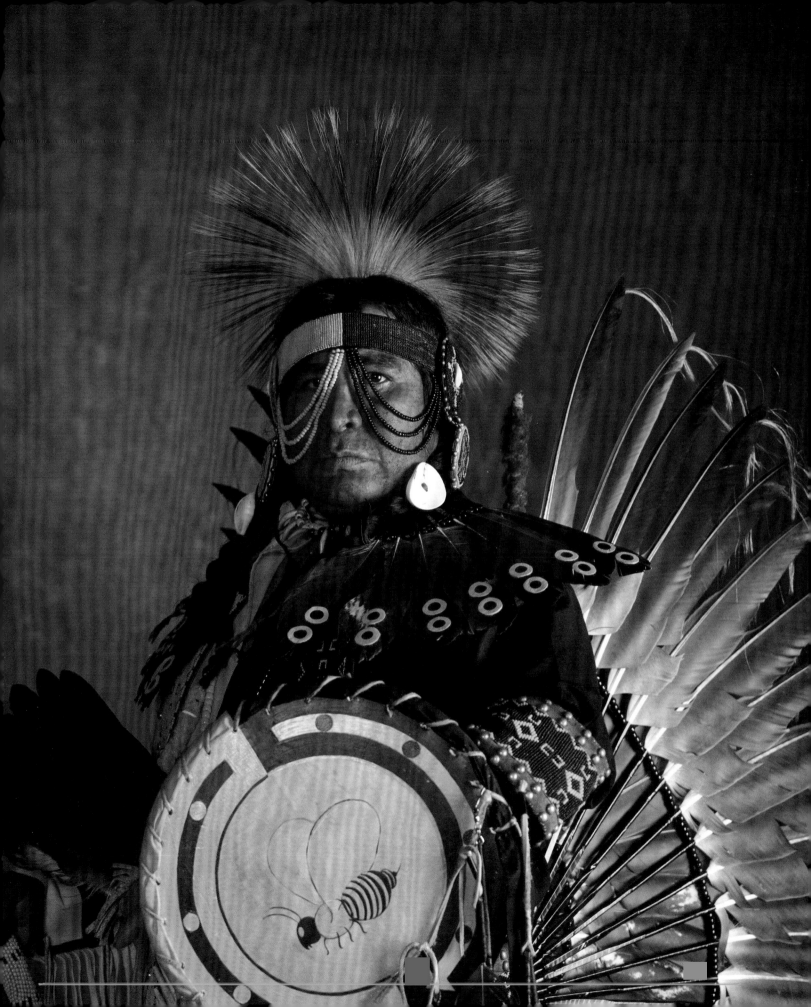

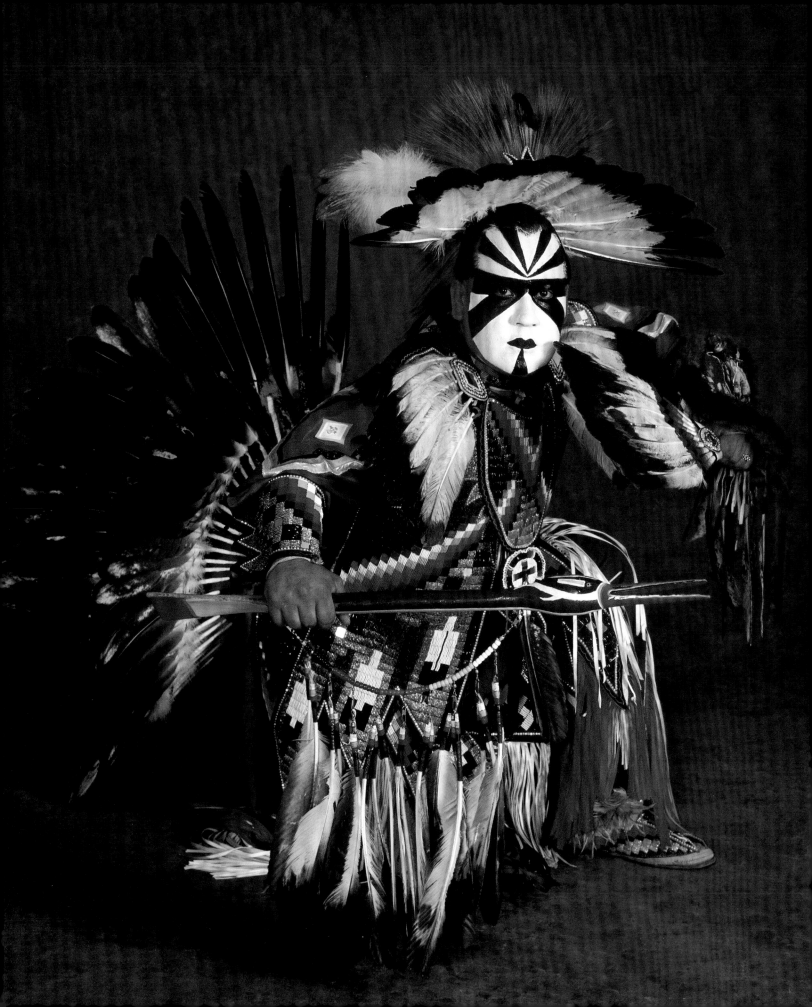

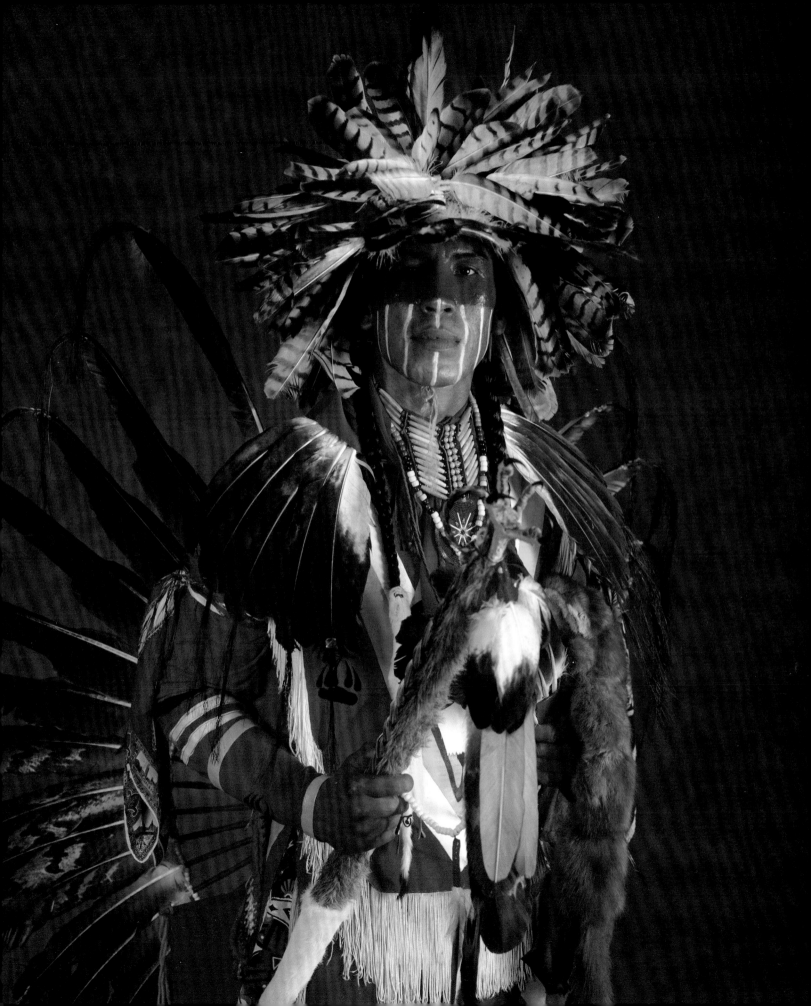

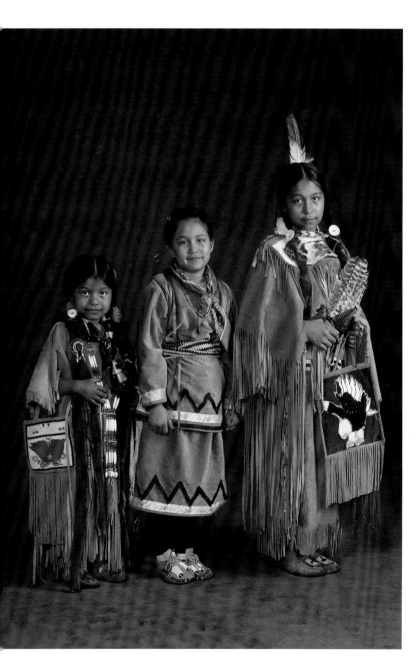

# Mary, Jennifer, and Joyce Everybodytalksabout

*Blackfeet ⚶ Colville*

Our cultural heritage is shared between the Colville and Blackfeet tribes—Plateau and Plains Indians. We come from a large, proud family often seen at powwows. We love to dress in our finest regalia and dance as often as we can.

# Alex Williams, Jr.

*Nez Perce ⚶ Umatilla ⚶ Assiniboine*

The picture you're looking at is one of many prayers and a great deal of effort on the part of my family as well as myself. The outfit I wear was started by my aunt "Cash" when I was twelve years old. It was later added onto by my grandma Aurelia Stacona. My stepmom did my shirts, and my father and I did my featherwork. The fan I hold actually belongs to my sister, Liberty Cree.

Life has dealt me some hard knocks, but along with that came many blessings. All of it has made me the man I am today. Descended from warriors, chiefs, and medicine, strong men and women who persevered over all, it is my duty to carry on with fortitude in the face of my adversity. Anything and all is possible.

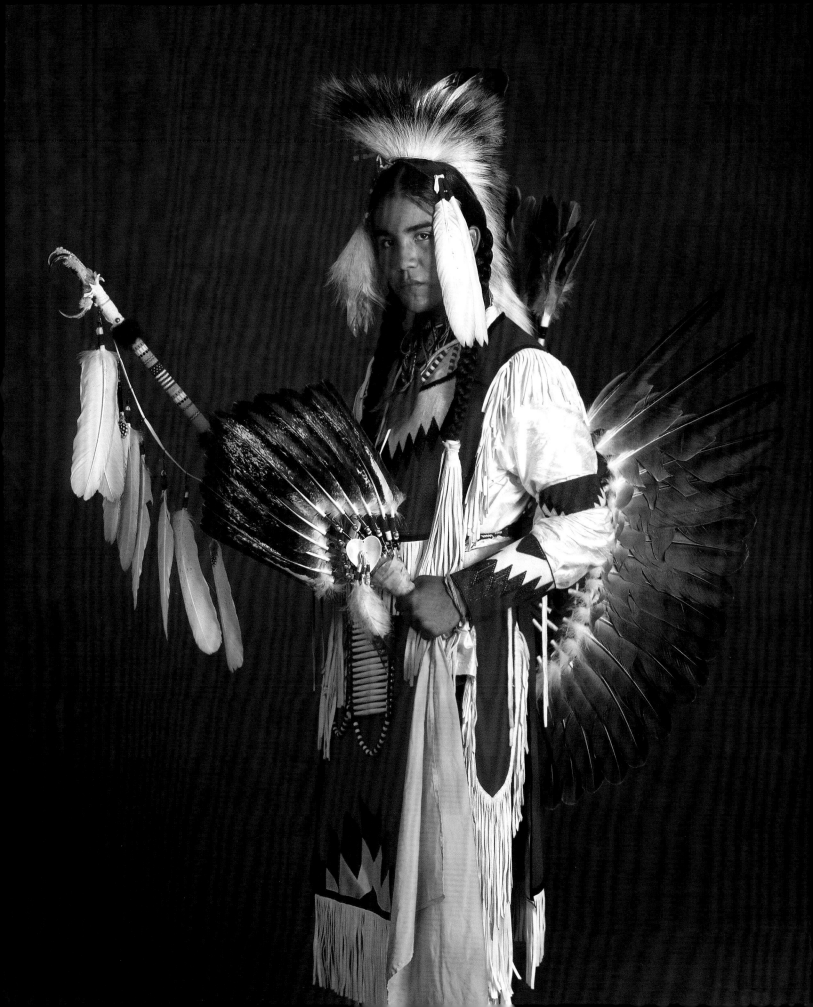

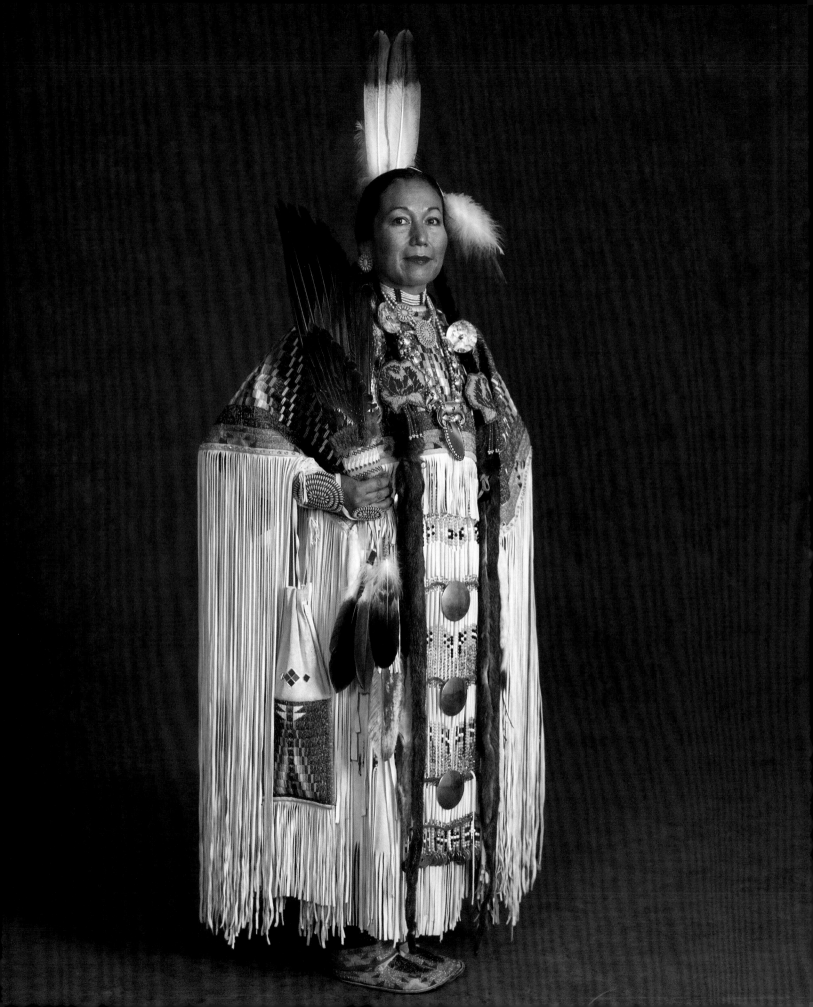

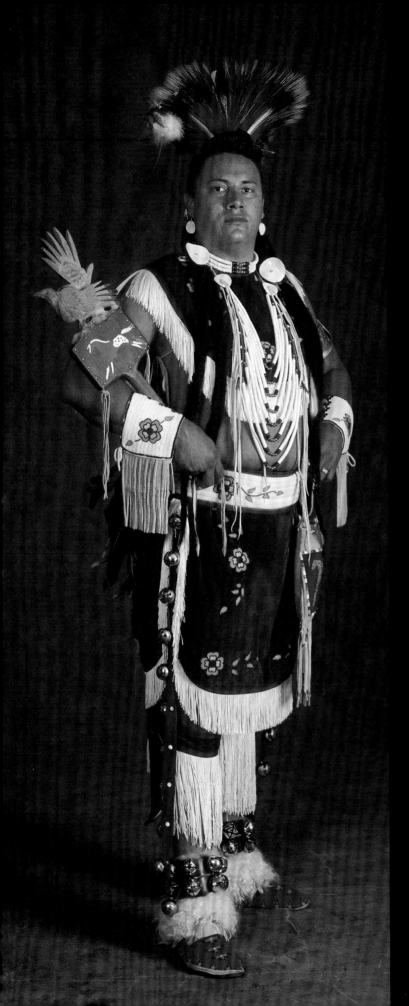

## Rose Olney Sampson, Cahsooteah

*Yakama*

I live on the Yakama Reservation with my husband, the tribal council chairman of the Yakama Nation. We have four children and four grandchildren. I have a degree in psychology and own a Native art store.

Powwows are a celebration of life. It's a fun time and a good place to teach our young people respect for themselves as well as respect for all people young and old. When I am dancing I feel close to the Creator because it is in the dance circle where I do my best praying.

## Francis "Frenchy" SiJohn, u-ch-kwl-a'lqs [h]n-ch'es-u'lmkhw (Red Bird in the Brush)

*Coeur d'Alene ❧ Spokane ❧ Colville*

My regalia reflects the Plateau-style flower design, beaded by my wife, Leanne (pages 82–83). I dance the Prairie Chicken style of dance to honor my grandfather Andrew "Red Bird" SiJohn. He was a traditional Coeur d'Alene man who lived during the era when the federal government and Jesuit missionaries prohibited our traditional practices. However, he and other traditional Coeur d'Alene men still danced this style to honor the prairie chicken and keep their traditional beliefs alive. My family and I follow Andrew's values and practices to ensure they carry through my family for generations to come.

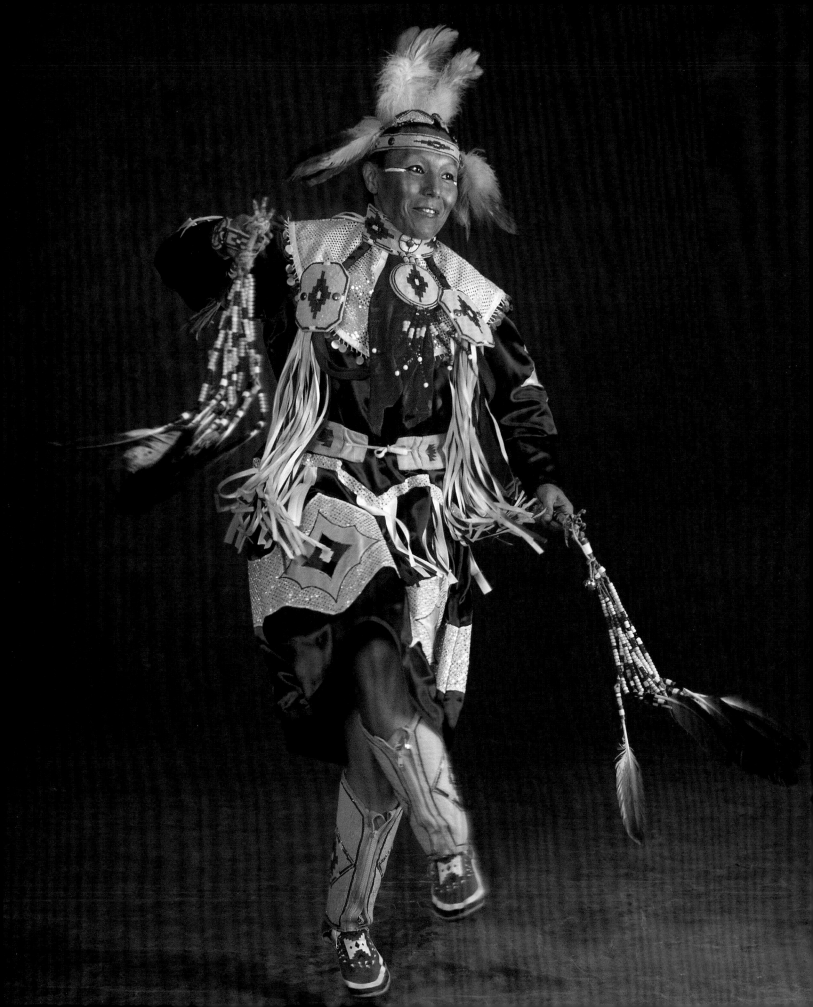

# Patricia Young Running Crane

*Flathead*

I am an enrolled member of the Confederated Salish and Kootenai Tribes. I am a Fancy Shawl dancer and have danced throughout my childhood and into adulthood with a style that is unique. I give all credit, with appreciation of their support, to my parents, husband, and children.

I live and work on the Blackfeet Indian Reservation as director of the Blackfeet Child Protection Investigation Unit. I have obtained my education from the University of Great Falls, Great Falls, Montana, with a bachelor of science and a master of science in criminal justice administration. I will continue to support and encourage our children and grandchildren to carry on the respect and livelihood within the circle of dance.

# Joyce Hayes

*Shoshone-Bannock*

I am a Women's Northern Traditional dancer and when I was a young child, my grandmother Marie Hardy told me "If you want a buckskin dress, you have to make it yourself." She then taught me how to brain-tan deer hides to make buckskin and how to sew with beads. I love and appreciate my grandma for her words and guidance because now I am able to create the beautiful beaded dance outfits that I wear.

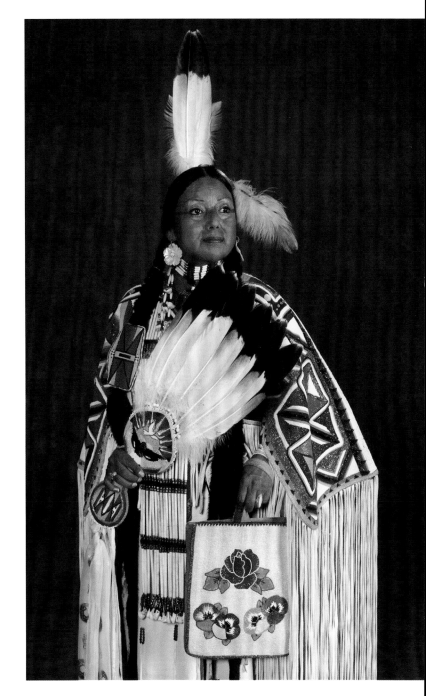

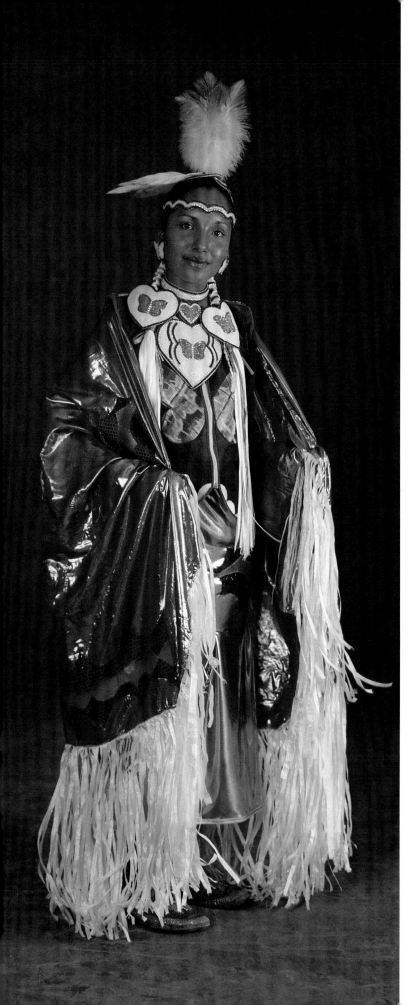

# Crissy Kipp (Holy Beaver Woman)

*Blackfeet ⚜ Oneida*

My Blackfeet name was given to me by my grand-mother Beaver Spirit. Dancing and ceremonies are our gift from the Creator. No one can ever take them from us. I will continue to dance as long as Old Lady Dancing Spirit gives me the will and strength to carry on.

# Duane "Dewey" Gopher

*Chippewa-Cree*

My beadwork comes from my mother, Ruby Big Knife. The floral design has been in my family for many generations and I am honored to be able to wear it with pride. I hope that my grandfather Big Knife, who passed on before my birth and was a renowned dancer, can look down from the heavens and smile.

I dance for my little brother who is handicapped due to cerebral palsy. I dance to keep the tradition alive, and most importantly, I dance for the feeling it gives me when I hear a good song.

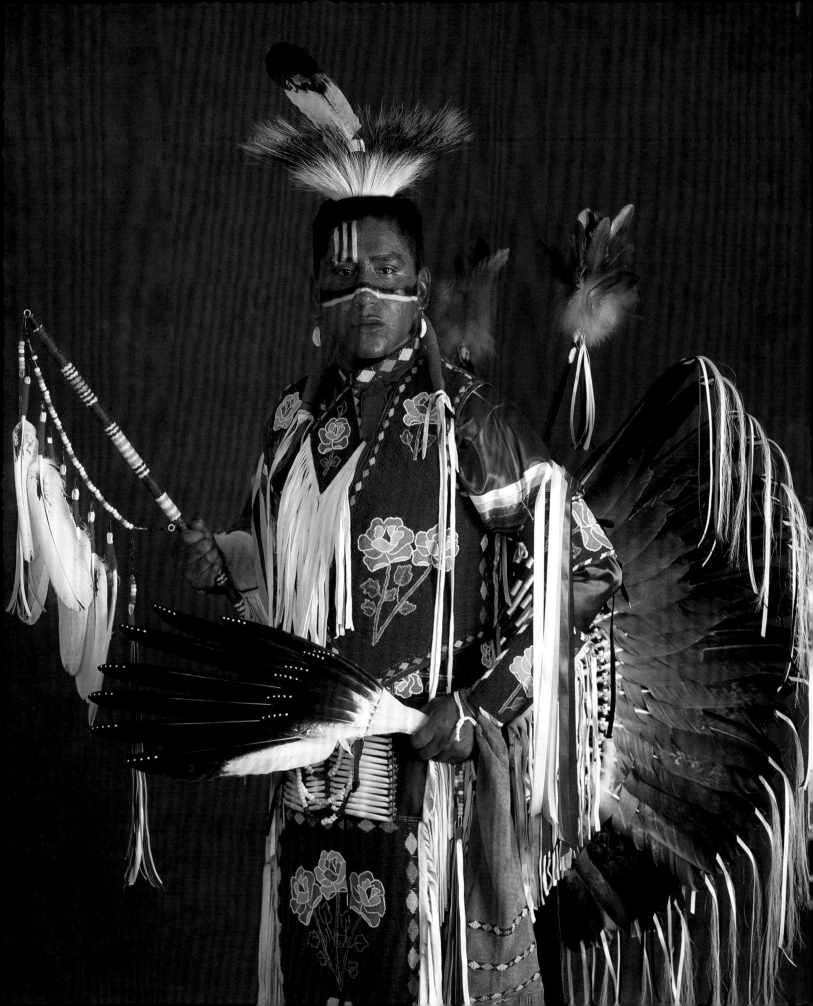

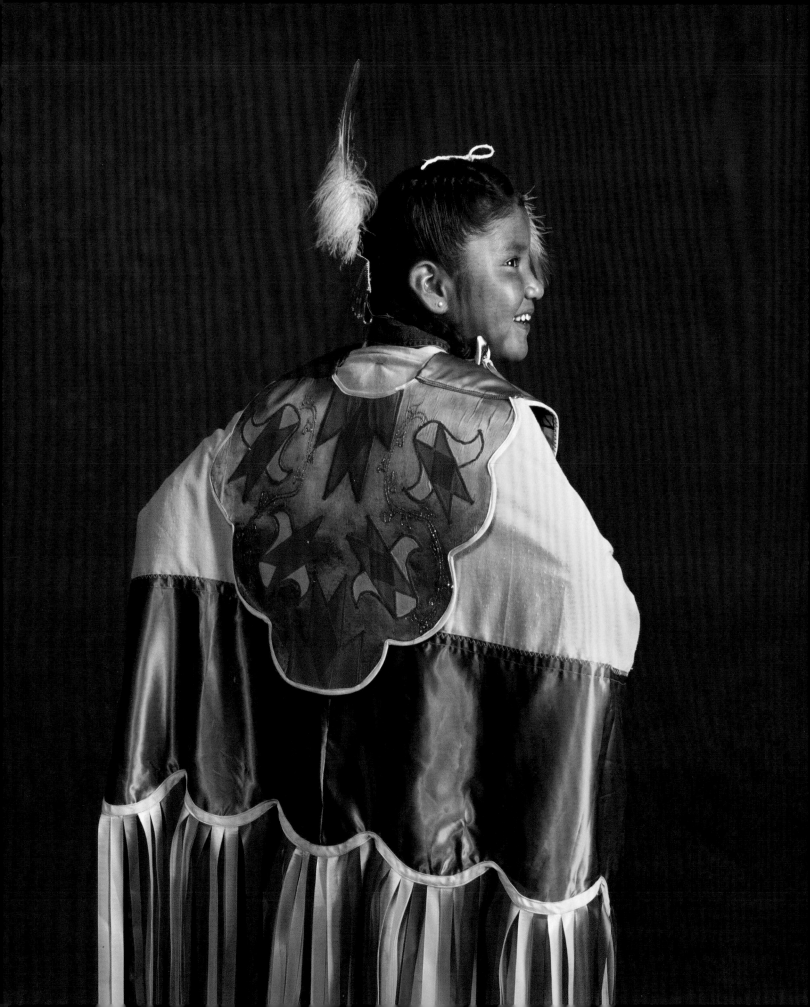

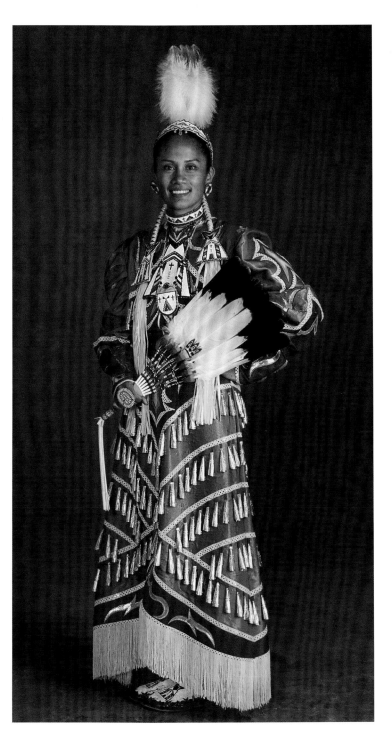

# Lena Meninick

*Yakama*

I wear a Fancy Shawl outfit my stepmother made me with contemporary cloth appliqué and ribbon work. Ever since I was able to walk, I followed my older sister onto the dance floor. Now I am ten and my three-year-old sister follows me onto the floor. It's just another piece of the dancing circle.

# Henrietta Scalplock

*Diné* ⧓ *Mescalero Apache*

One story of the origin of the Jingle Dress style is that of an Ojibwe medicine man whose daughter was very sick. One night the Creator came and gave him the vision of a dress made with shells (jingles), one for every day of the year. He was told to make this dress and have his daughter dance in it. The next day he made the dress, saying a prayer with every shell. His daughter danced in it and was cured.

As for me, the reason I dance is to feel good about myself and to give my children, whom I raise with my husband Ardell (see pages 154–55), a head start in living their lives in their culture and heritage. I hope that when people see my dancing, that they too may get a good feeling, knowing that Native American cultures are alive and strong.

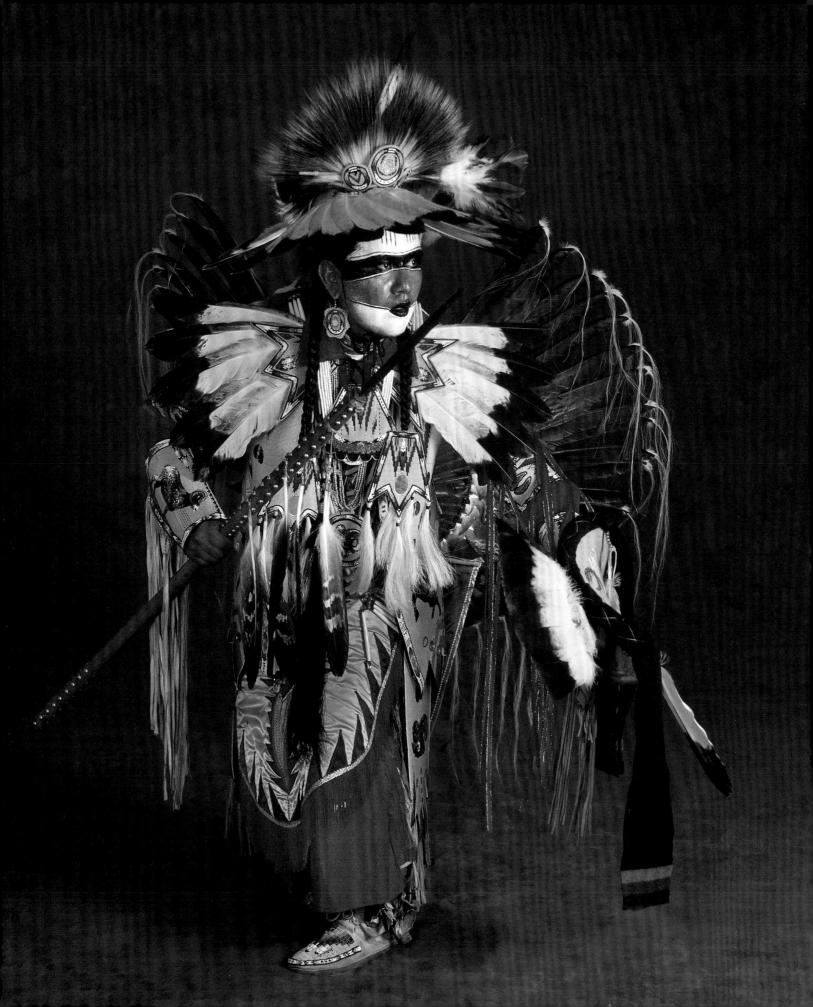

# Merle Eagle Speaker

*Yakama ⚜ Blood*

- ⚜ Powwows...
- ⚜ Traveling throughout Indian Country...
- ⚜ Making new friends and seeing old friends...
- ⚜ Dancing and having fun...
- ⚜ Getting that good feeling inside when I'm in the dance circle...
- ⚜ Listening to the Heartbeat (the drum)...
- ⚜ A celebration of the Indian way of life.

*overleaf left:*

# Norton "Bubba" Becenti, Jr.

*Diné*

I began to dance at the age of four as a Grass dancer, then my interests went toward the Fancy Feather dance and the Northern Traditional style of dance. Currently, I compete in the Teen Boys Northern Traditional category. My hobbies include going to school, playing basketball, riding my bike, and powwow singing and dancing. All of these activities are very important to me.

I would like to thank my parents for allowing me to travel with my grandparents Norman and Phyllis Largo; my uncle Nathan Largo (see pages 2–4); and my aunts Theresa Jim and Tina Paddock.

*overleaf right:*

# Toni Lee Tsatoke

*Kiowa*

The leaf design on my buckskin dress is my regalia's most prominent feature and represents my tribe's origins to the north; the horse designs represent my great-great-grandfather Huntinghorse, and the Tsatoke and Horse families.

My main source of strength while pursuing doctoral studies at the University of Oklahoma is participating in traditional tribal gatherings, including Gourd dances. I hope that through all of the blessings that have been bestowed upon me, I can

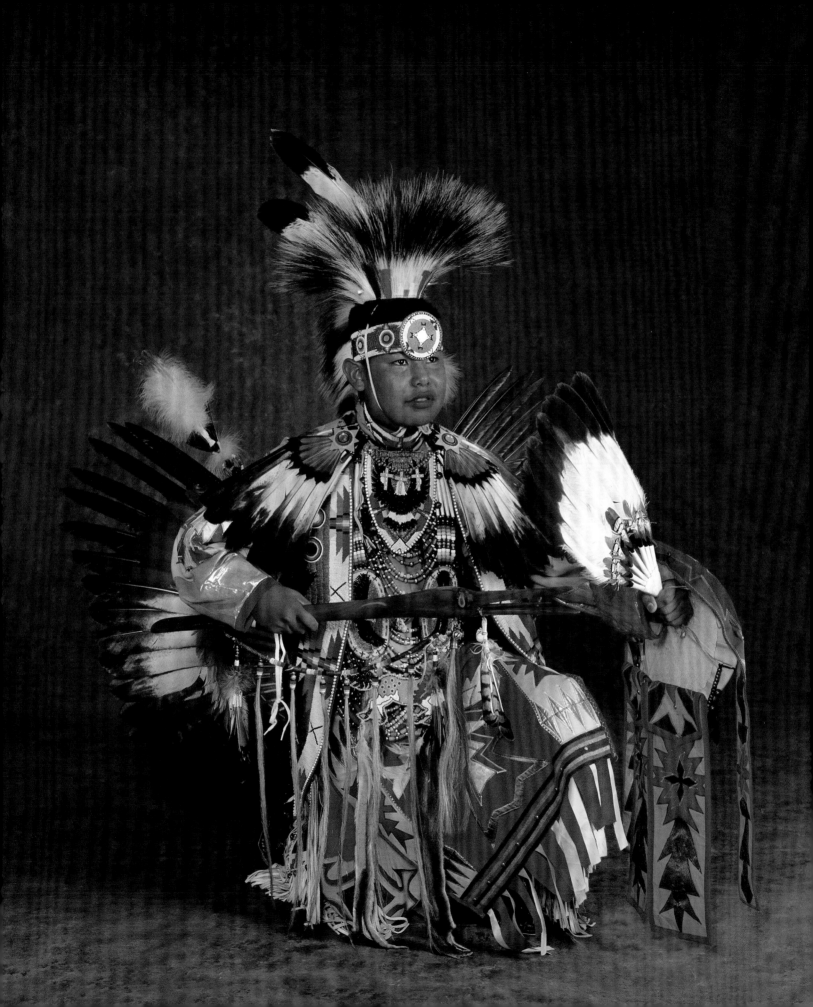

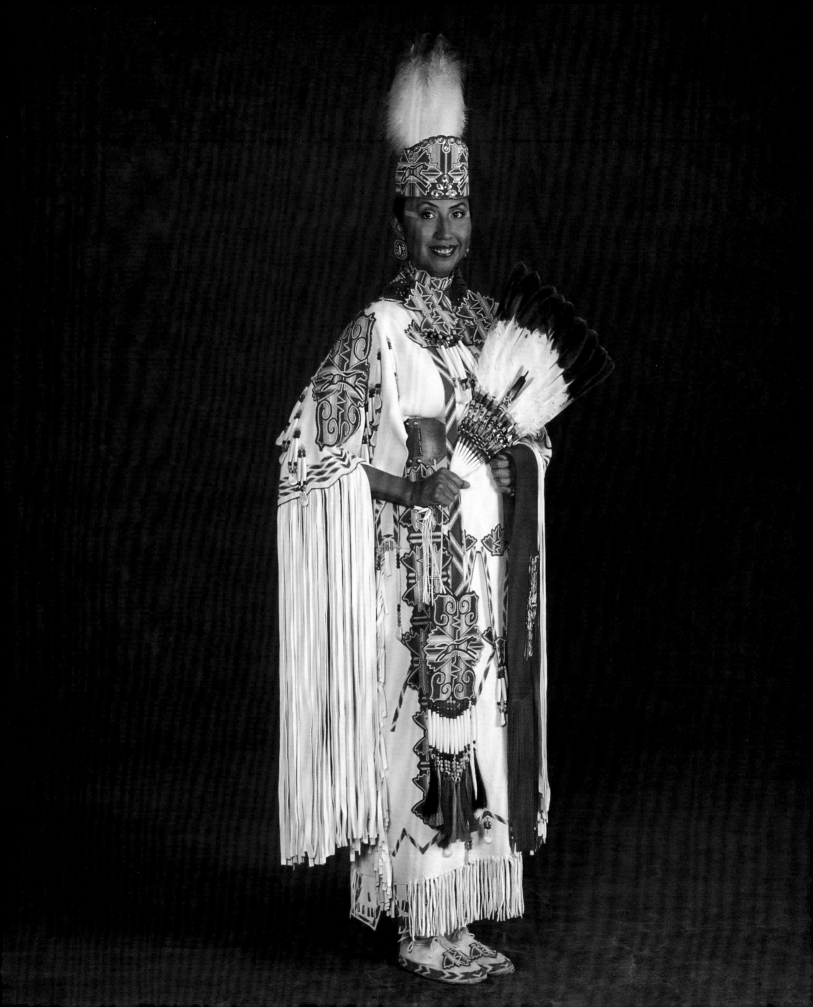

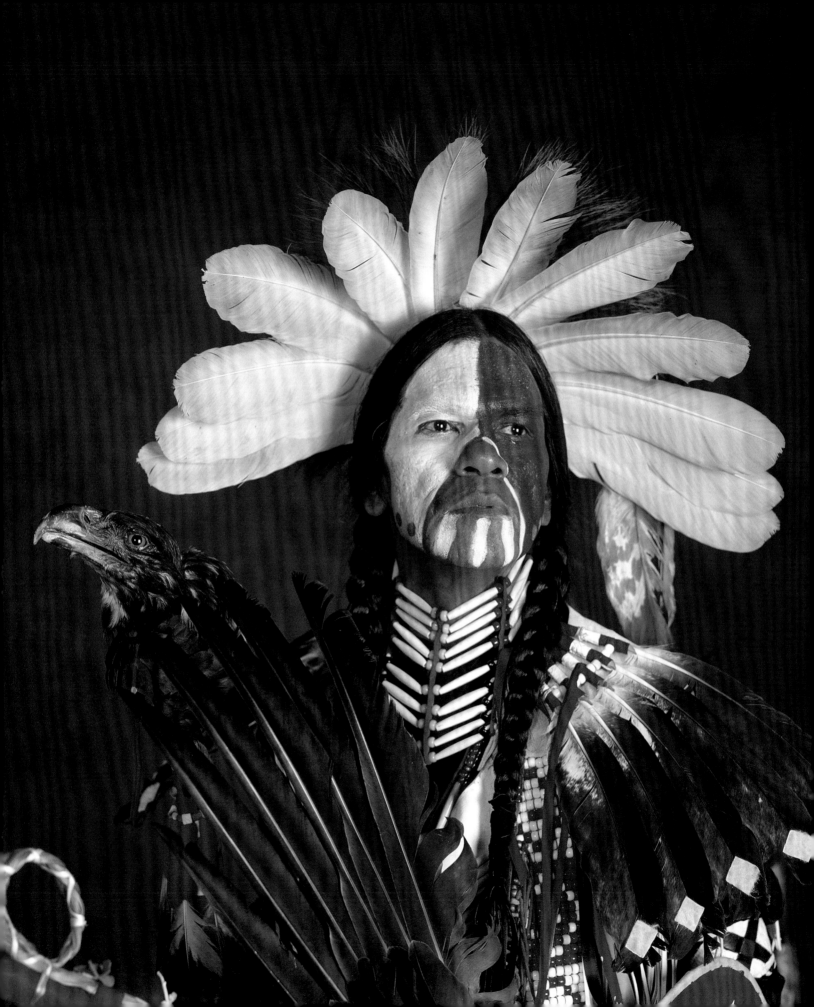

# 6

"I was not brought from a foreign country and did not come here. I was put here by the Creator."

—Chief Weninock, Yakama

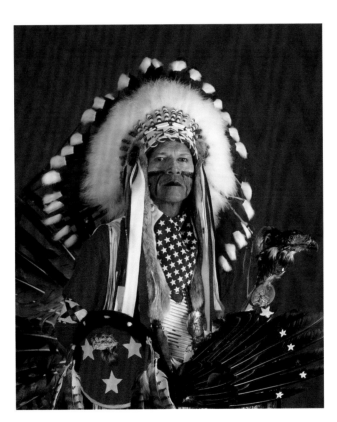

Raymond Cree

previous pages:

# Raymond Cree

*Umatilla ⚊ Yakama ⚊ Cree*

I live near Pendleton, Oregon, where the Tamástslikt Interpretive Center arranges their gallery exhibitions within a theme that gives me so much pride: "We were, We are, and We will be..."

I dance for the Creator, my people, and my family. I dance for sobriety. I'd like to thank my son, Jacob, for always staying to help, and Rattling Thunder and all the other drum groups across this Turtle Island. I'd like to acknowledge my Umatilla elders and all powwow people.

# Loretta Seaman

*Shoshone-Bannock*

As a child, I was greatly inspired by my mother who showed me the beauty of creation through her beadwork. I, in turn, have created my own dance outfits, which I wear with pride, knowing that my inspiration has come from a very great teacher. And when I dance, I feel a spiritual connection to Mother Earth, as she is the creator of all beauty around us. Now, as a mother and grandmother, I hope to be a teacher to our children and grandchildren so we may continue to create and carry on the beauty of our Native American culture.

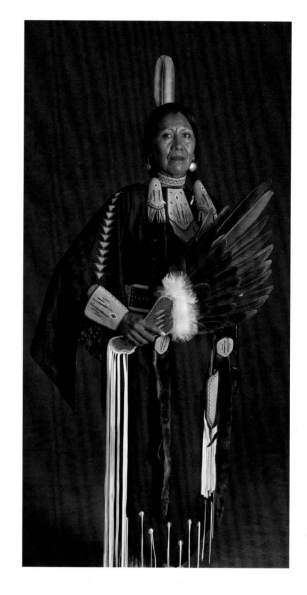

# Mike Peters

*Shuswap*

I live in Kamloops, British Columbia, Canada. My dance regalia is inspired by dancers of the past and from stories that I have heard from my home area. My inspiration to dance comes from the friends I have made, and from those people who enjoy just watching the dance.

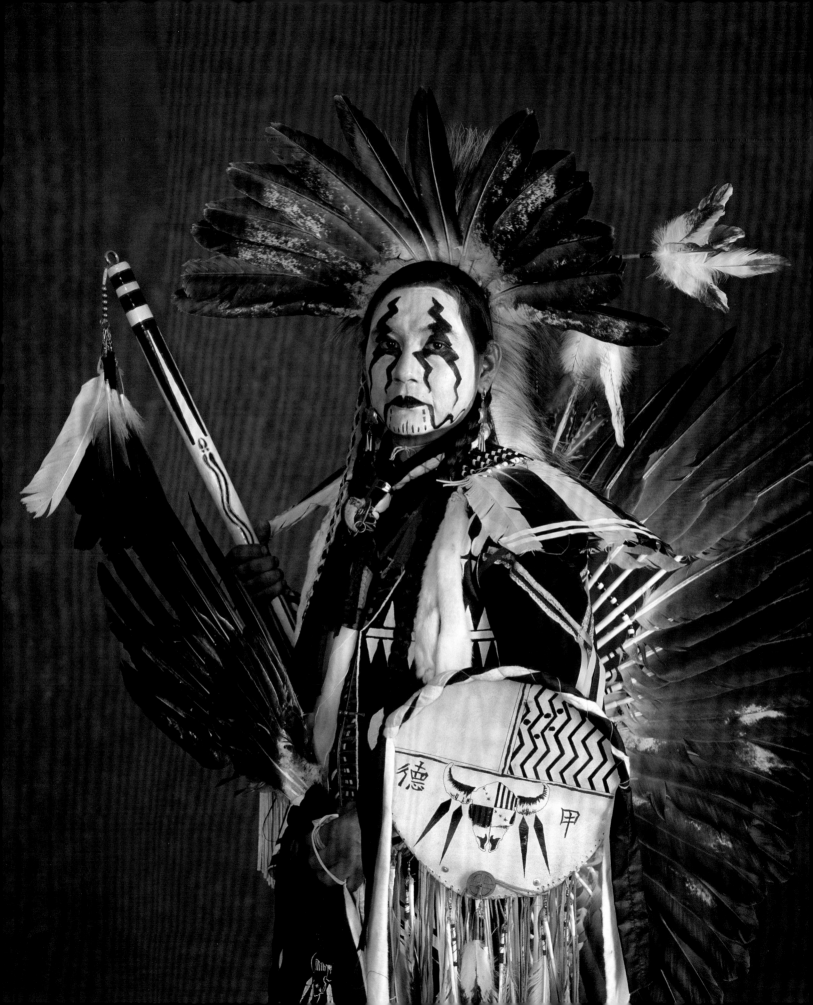

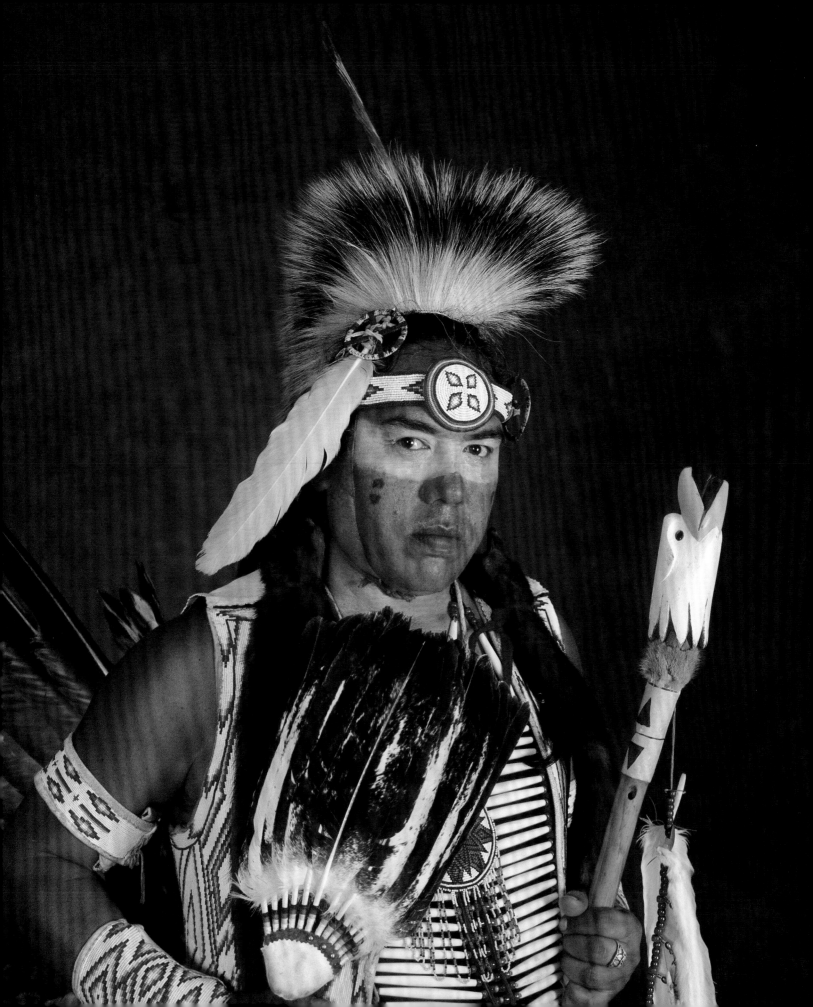

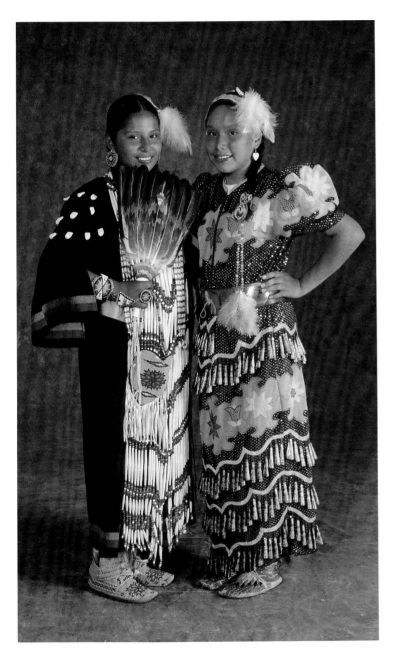

# Mark Stanger, Ka Ten Hoy Ten (Many Tracks or Many Paths)

*Arrow Lakes and Okanogan Bands of Colville ⚶ Coeur d'Alene*

Dancing is mainly prayers for my people—that is why I dance and sing. We have come a long way since surviving the Termination Act and the slaughter of past relations, who gave up their lives in order for us to live today. I believe our children are our future, so take care of them today and tomorrow by showing them the way and helping them make good choices!

# Jazmin and Shanice Abbey

*Dakota Sioux ⚶ Hidatsa*

*Jazmin:* We are enrolled members of the Three Affiliated Tribes and belong to the Alkali Lodge of the Three Clan. I started off dancing Fancy Shawl when I was four years old, but I have found more of an interest in Girls' Northern Traditional. I am honored to have my picture taken with my older sister, as I look up to her for guidance.

Shanice: I have been dancing since I was five years old in the Tiny Tots category. Now I dance in the Teen Girls' Jingle category. My younger sister and I have had the same teachings about dancing in the sacred circle from our grandma and papa.

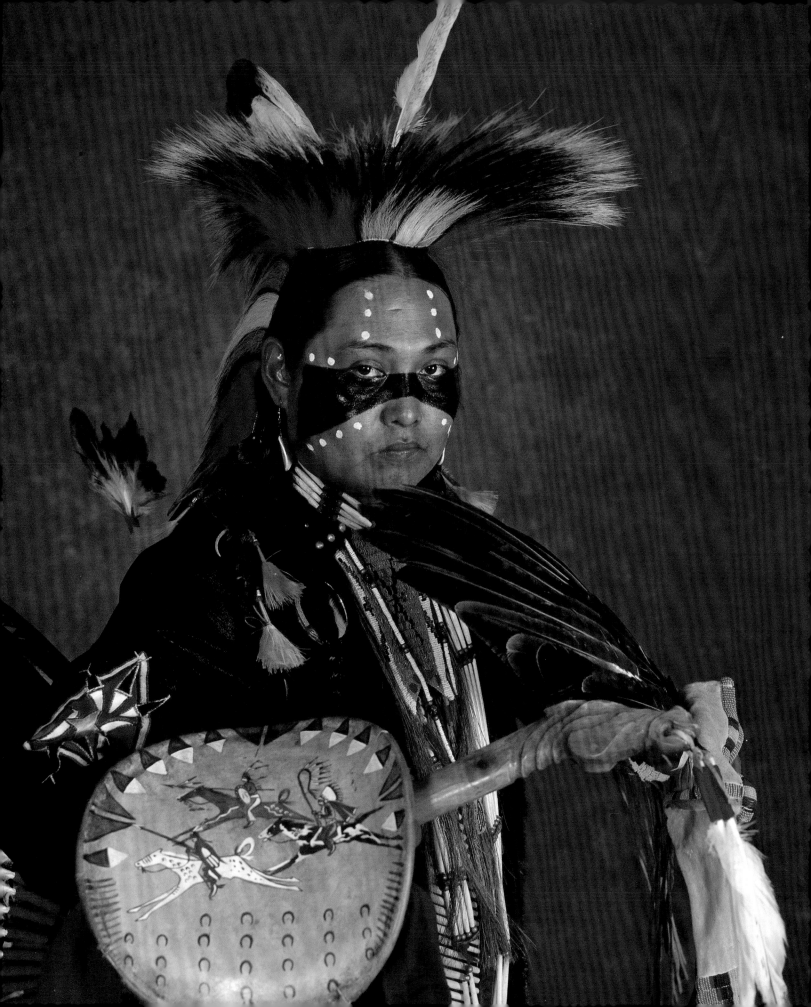

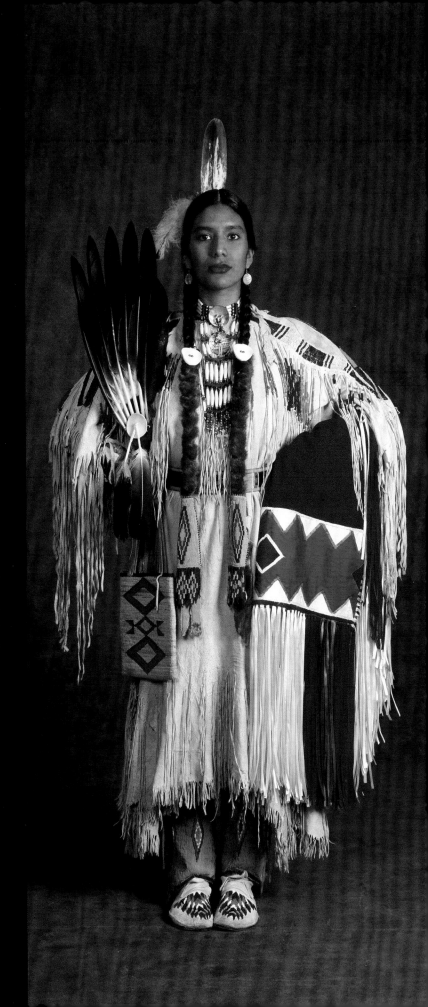

# Sheldon Bitahni Shebala

*Nabahe Diné*

My lineage comes from the Chorizo mountain range in northern Arizona. I am proud to say that my family on my mother's side as well as my father's side was always a step ahead of Kit Carson and the U.S. Cavalry. My father's people escaped from Fort Sumner, and my mother's people always eluded the enemy. We never suffered the horrors of the Long Walk. From the teachings of the past I was taught to refer to myself and my people as *Nabahe Diné*, or "Warrior People."

# Angel McFarland-Sobotta

*Nez Perce*

I am *Niimíipuu*, the people also known as Nez Perce. As a University of Washington graduate I now coordinate the Nez Perce language program. I wrote the Nez Perce Lolo Trail script, and wrote and narrated videos, produced by LCSC and the Nez Perce tribe, that won the Aurora and Telly awards. I am a family member of the M-Y Sweetwater Appaloosa Horse Ranch, which owns the largest herd of horses for a Nez Perce family.

This picture was taken in 1999 shortly before I married my wonderful Nez Perce husband Bob Sobotta. God blessed us with beautiful children, Payton Francis, Glory Rose, Grace Victory Joy, and Faith Mae Angel. In the spirit of what my ancestors taught, may peace be with you!

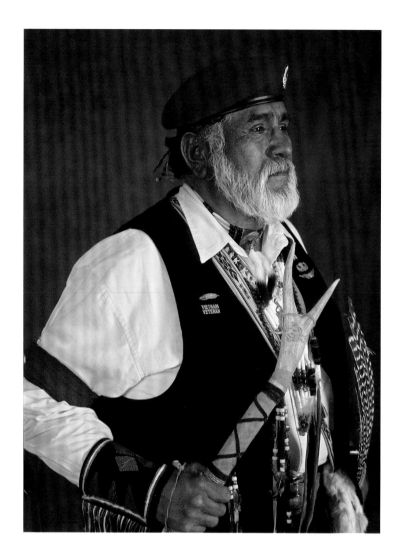

# Ignacio "Nacho" Domingo Martinez

*Yaqui*

My people came from El Rio Yaqui, Sonora, Mexico. In our tribe, religious, traditional ceremonies consist of Christian and soldier societies intertwined with Catholicism and Yaqui beliefs. I served in the U.S. Army with the 82nd Airborne Division as a helicopter mechanic, crew chief, and door gunner from 1967–70. I proudly wear the military insignias to honor all veterans from my hometown, especially the three who died in Vietnam. Powwow is full of the grandeur of color, dancers, singers, spectators. The drummers echo the heartbeat of Mother Earth, unlike the emptiness when you lose a loved one.

# Gerrod Moses Goudy, Win-Wy-Tit (Great Hands in Battle)

*Yakama*

My style of dancing is Traditional. My outfit was made by my father and me. The bustles are eagle feathers; the other parts are cloth, beaded cloth, ermine skins, buckskin, and various materials. When I dance, I feel pride and gratitude to our Creator for being who we are: His creation. Although the government attempts to destroy our heritage to make us the same as the dominant societies, our ways have survived. I believe one cannot destroy the Creator's purpose.

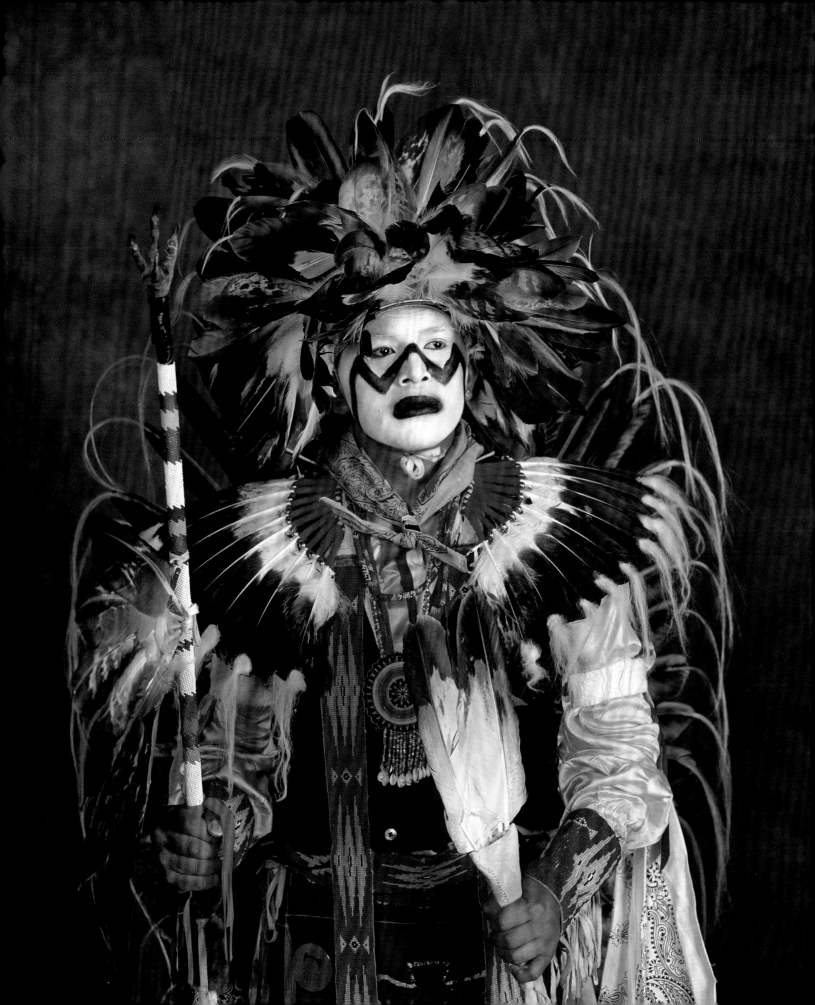

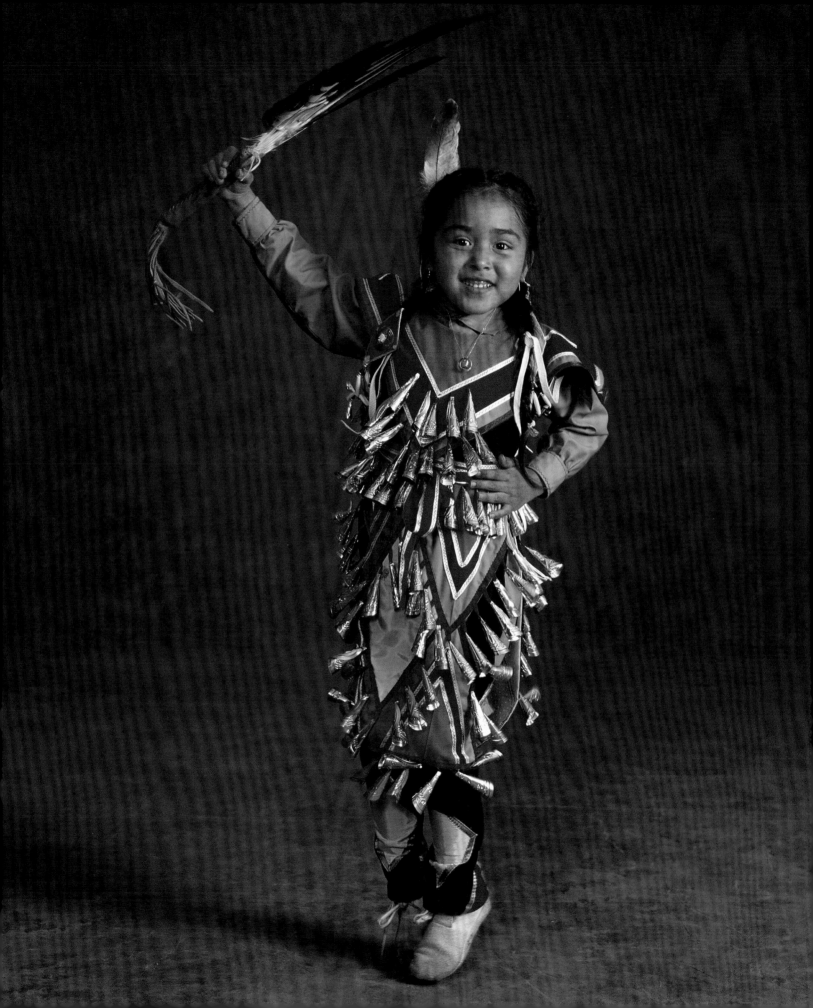

# Kayla Johnson

*Warm Springs* 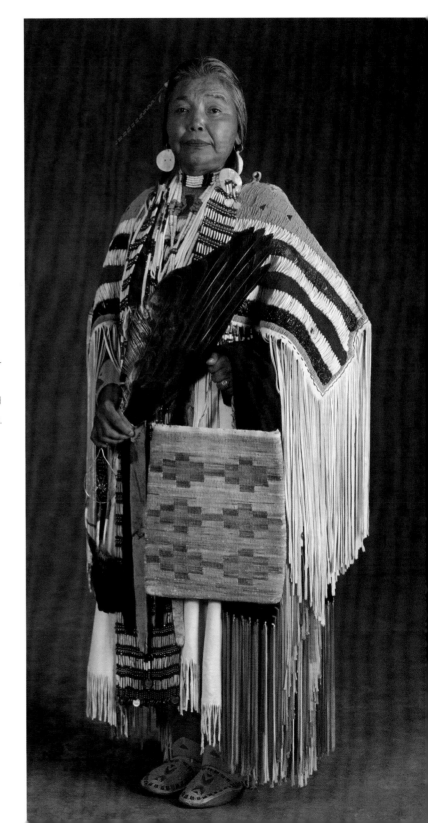 *Samish* ✦ *Lummi*

With the support of my parents and family, I have been dancing since I could walk. I dance Jingle, which is my father's tribe's way. I have also learned about the spiritual dancing in the winter from my mother's Lummi tribe. I love to dance!

# Pearl W. Sammaripa, Niê-Aye-ð6lh Wike Wike

*Colville*

To be with my relatives brings to mind the many stories of my grandmother Madaline Moses Covington, my grandma Cleveland and grandpa Chief Cleveland Kaminakin, and numerous aunts, uncles, and cousins. We were taught to hold our heads high no matter what one says or does to us. No one can take what we love best: our language, the songs, and especially the dance. All of these things are combined with *Washet*, which is our belief. *Lem Lem.*

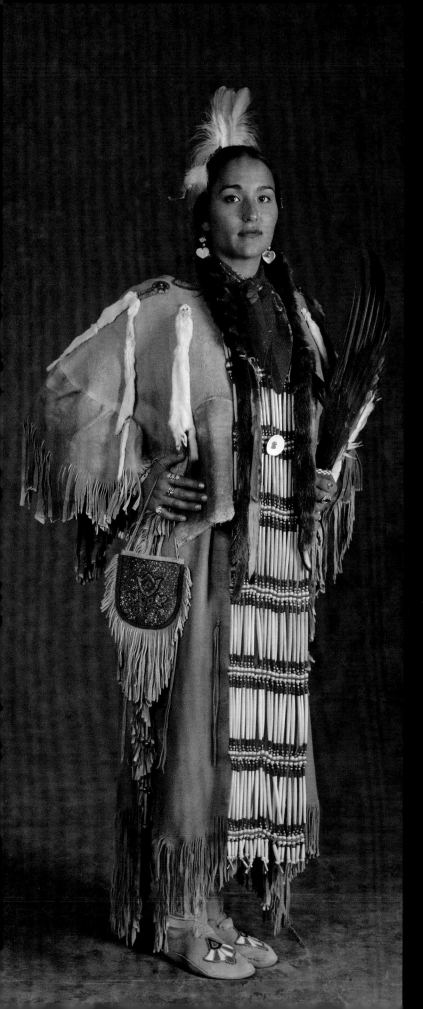

## Rachel CrowSpreadingWings

*Blood*

I am from the Blood Reserve in Southern Alberta, Canada. My mother made my Women's Traditional outfit for me when I was twelve. It is made from hand-tanned deer hide, and the breastplate is made out of real bone, brass, and glass beads.

I am currently in college where I am studying to be an interpreter for the deaf. I think that First Nations people need to be seen more in the public as strong and surviving in today's world.

## Alden Pompana, Jr., We yca Ota Hokseda (Many Eagle Feathers Boy)

*Dakota Sioux*

My family is from Sioux Valley, Manitoba, Canada. I began dancing as a Traditional dancer when I was five years old, when my dad and my grandfather initiated me into powwows. I remember my grandfather Thomas Pompana, who was a singer with Sioux Valley Old-Timers, and my grandmother Susan, who influenced all of my family. Sometimes when I dance, I feel they are watching me.

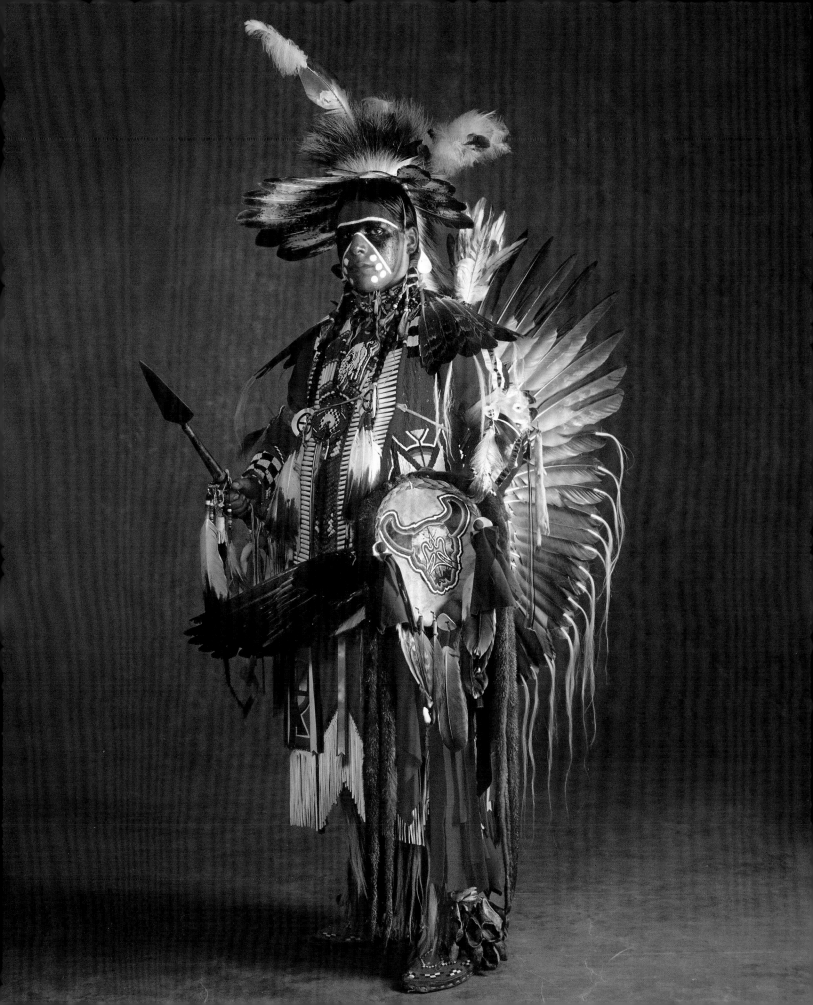

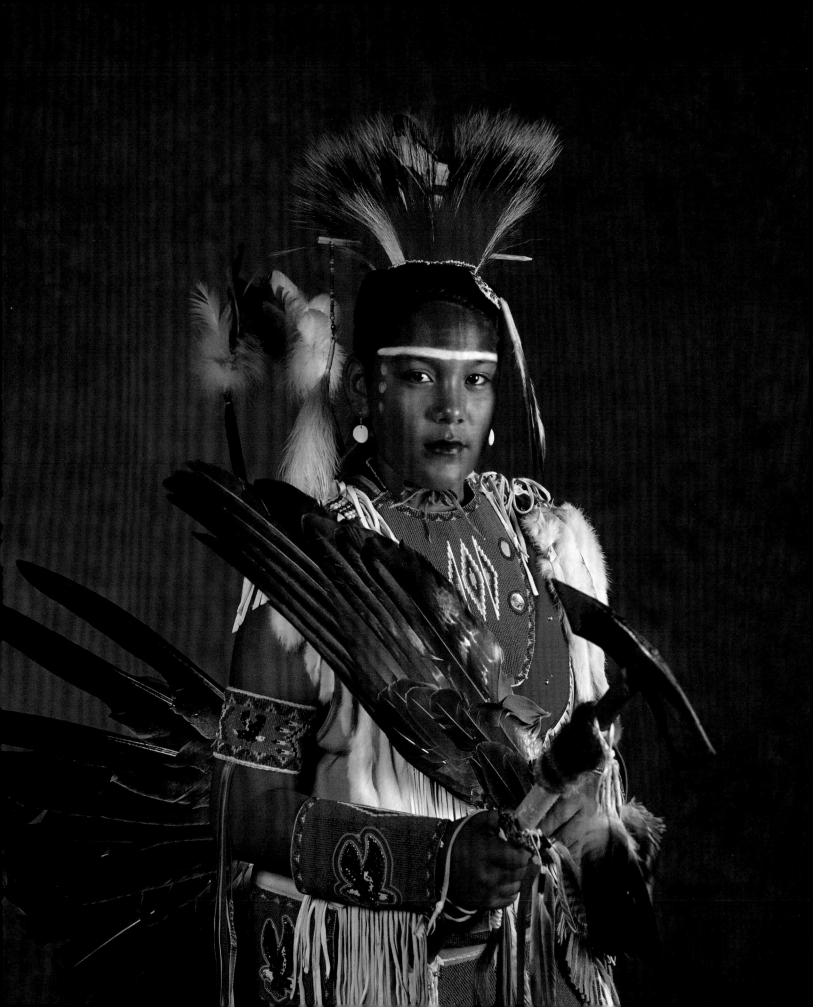

# Preston Tom

*Paiute*

I am a member of the Paiute Tribe in Warm Springs, Oregon, and have been dancing Traditional for nearly eleven years. The oral teachings have always taught me to enter the Circle with great respect. It is my elders for whom I dance. They have taught me to dance, and more importantly, they have taught me to always give credit to our Creator.

# Vanessa Gayton, Ghante Waste Win (Good Cedar Woman)

*Hidatsa ⚜ Arikara ⚜ Sioux*

I have been dancing since the age of one, and I have a son, Zayden, who will be dancing soon. I feel such pride in being able to go out there alongside my brothers and sisters, mothers and fathers, and feeling the beat of the drum, knowing that it gives us strength and makes us happy.

It's not always about winning, but being able to go out there, have fun, feel good about yourself, and feel the pride of being an American Indian—knowing the struggles we as a people have gone through in the past and still go through today. I am so blessed that the Creator chose this way of life for me.

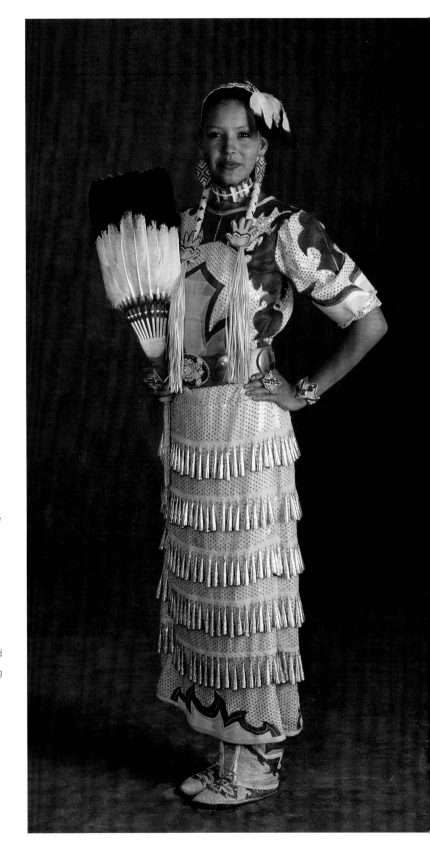

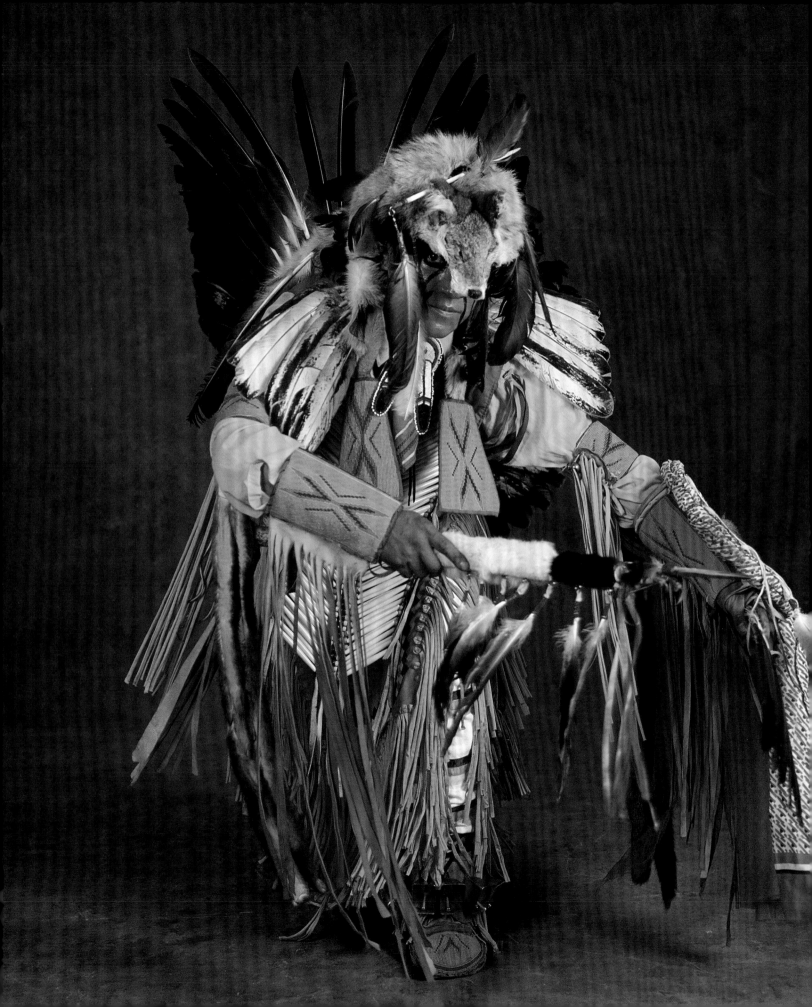

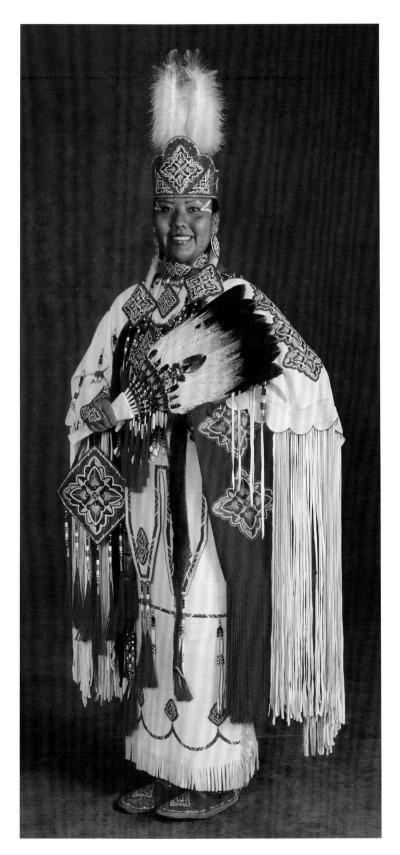

# Zack Cailing

*Yakama* 🜚 *Squamish*

I am a Coast Salish carver and artist who earned my diploma in Fine Arts from Emily Carr School of Art and Design. I had my "coming out" as a Traditional dancer at the People of the River Powwow in Chilliwack, British Columbia, Canada. My mother and I designed my outfit and did all the beadwork. I also make fans and bustles for other dancers.

I found the powwow trail after committing myself to sobriety. I find the powwow trail is the best medicine for Native people on a healthy journey.

# Raetava "Tate" Lyne Yazzie

*Diné*

I belong to the Towering House Clan, born for the Edgewater people. My late maternal grandfather was of the Bitter Water people. My paternal grandfather is of the Salt Clan. I started dancing in the Southern Buckskin Dress at the age of fifteen. It was a great honor to be adopted by my Kiowa family—the Cozad family—and to be given the right to dance in my dress, made by my mother, with featherwork done by my father. *Ah-ho!*

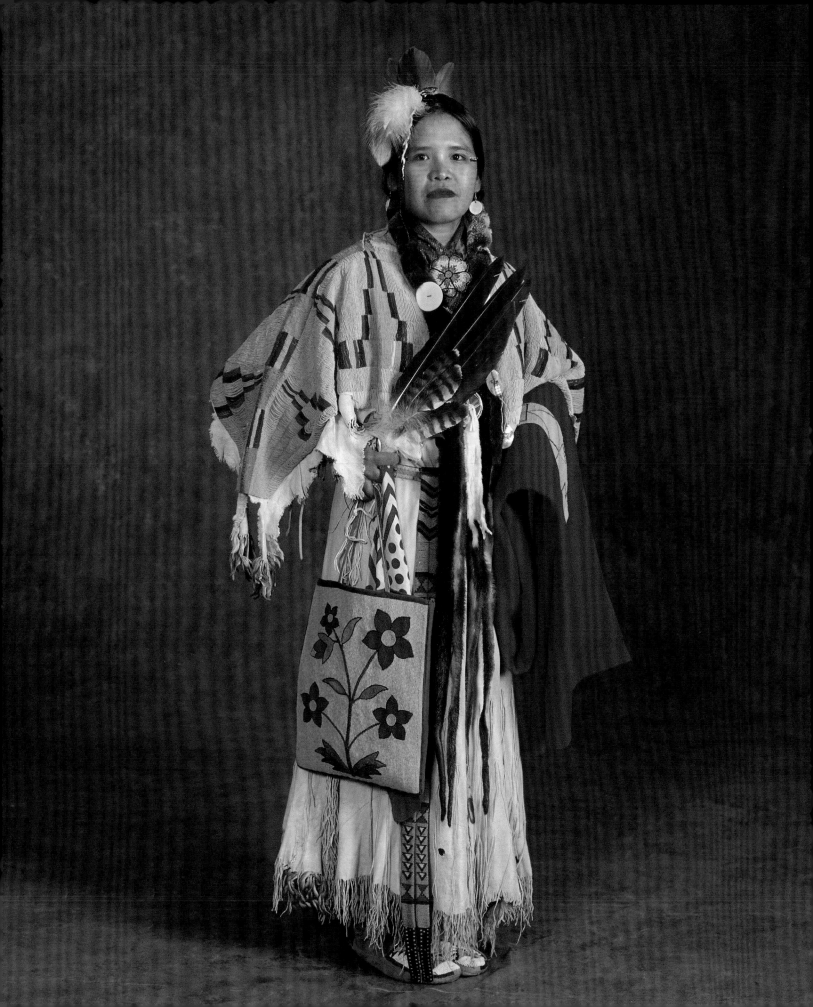

7

# "The Great Spirit, in placing men on the Earth, desired them to take good care of the ground and do each other no harm..."

—Chief Young, Cayuse

HollyAnna CougarTracks Decoteau Pinkham

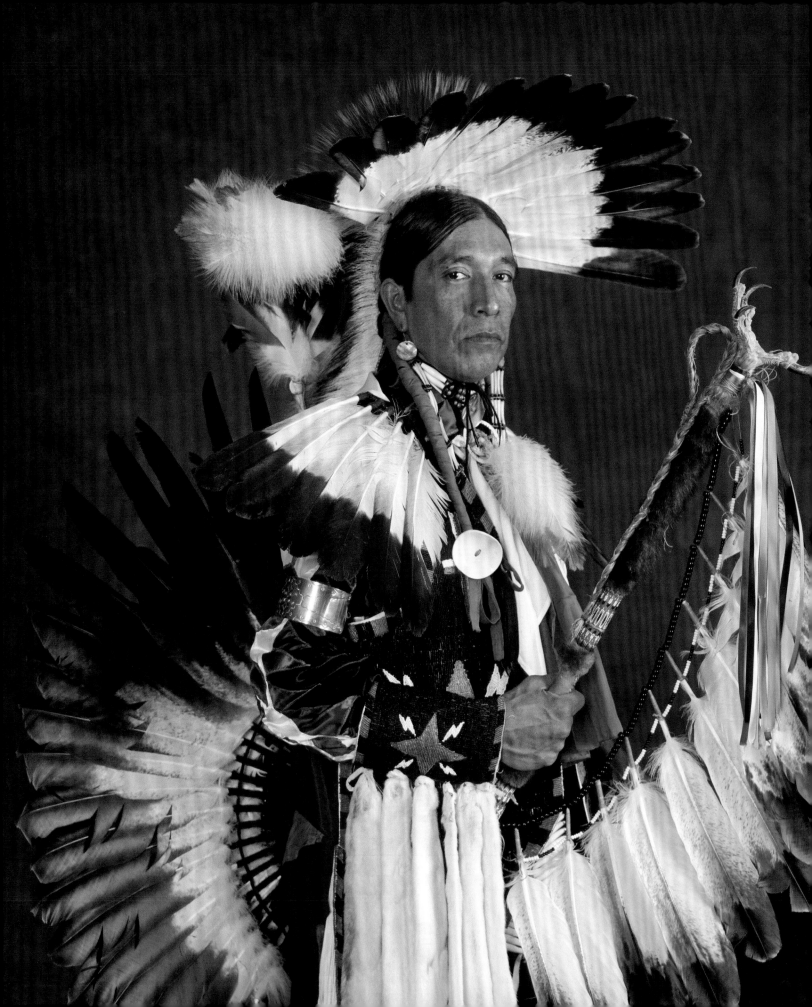

*previous pages:*

# HollyAnna CougarTracks Decoteau Pinkham, Timał (Sound of a Woman Working)

*Yakama ⚜ Nez Perce ⚜ Cayuse ⚜ Umatilla*

I believe there is a lot the world can learn from a powwow. There are dozens of different nations represented—all peacefully dancing, drumming, singing, and observing. There are many different people representing different religions, beliefs, traditions, and native nations. It is a time and place where friendships are born. Families are brought together, and you watch them grow or you share their losses.

Even though people may not understand the language of the verses being sung, they are moved by the emotion to understand the meaning through the songs. Despite our differences outside of the Circle, inside the Circle we share the love of the songs and dancing.

# Al Blackbird

*Omaha*

The designs and colors of my regalia all have a very special meaning to me. My Indian name simply means "star" and I am from the Thunder Clan. I use the Four-Point Star design. Each point represents one of the sacred four directions. I would llike to acknowledge my Omaha ancestors for giving us the Helushka War Dance. It makes me very proud to be a part of this tradition.

My grandfather Theodore White, Sr. and my uncle Rufus White were an inspiration to me. I was able to learn from them about my culture and background. My grandfather passed away when I was very young. I can still remember dancing with him in the sacred circle. I dedicate all my dancing to my grandfather.

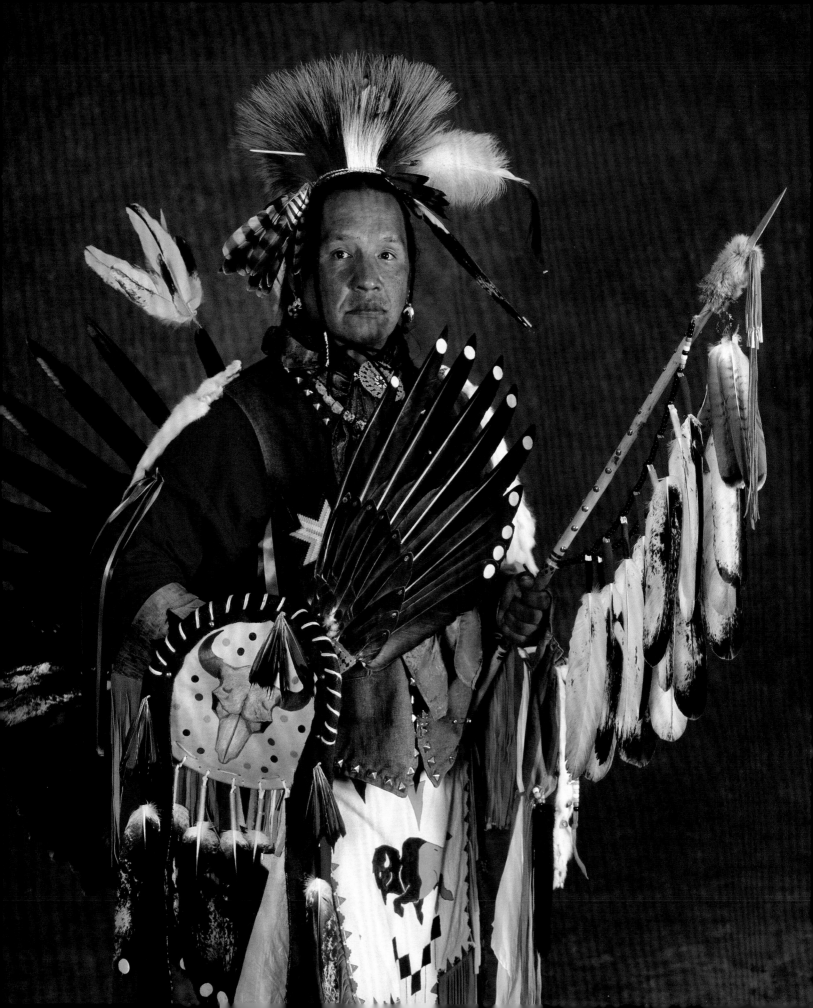

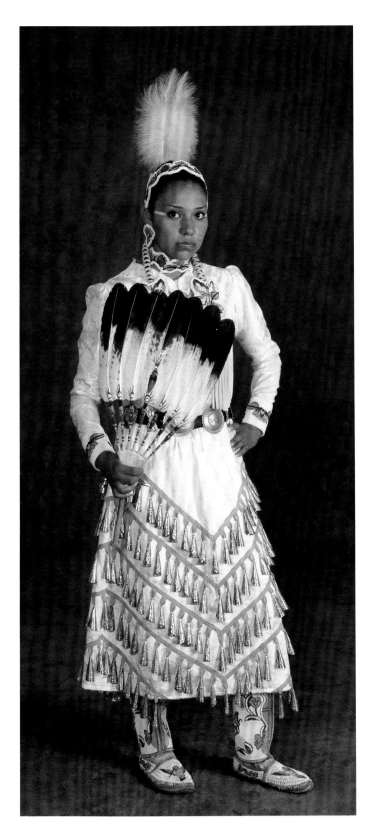

# Guy LaVerne Ford

*Spokane (Spokan)*

Dancing for me means more than just placing my feet correctly on the ground with the beat of the drum! It's who I am; the drum is in my heart. My grandma used to come watch me dance. She had a hard time getting around then, but the dance was important to her as it is with me now. In my memory, I can still see her sitting and watching us dance. I still dance for her today.

# Talissa Abeyta

*Eastern Shoshone ⚊ Northern Arapaho*

Dancing is literally part of me. Without it, there wouldn't be a completion of who I am. It connects me spiritually to my background and the traditional ways of my people, like my father, George Abeyta (see pages 165 and 167). Whenever I dance, I do all I can to be part of that beauty. There is an indescribable feeling when someone comes up to you to tell you how good your dancing made them feel. I live for those moments.

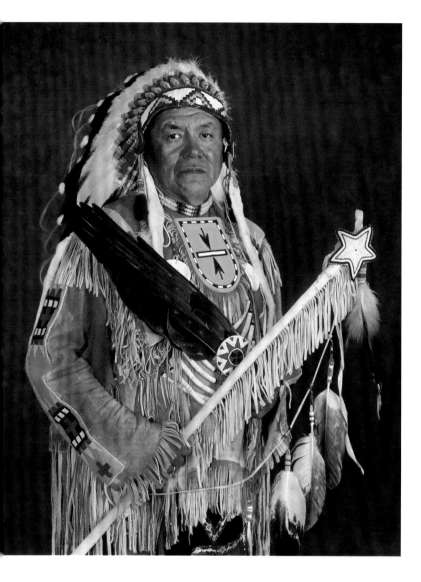

# Gary Burke

*Umatilla ⬇ Walla Walla ⬇ Cayuse*

I am Chief Tuk-Lu-Key Gary Burke, the son of the late Chief Wish-Lau-Tu-La-Tin Raymond Burke. I was at the sweat house with my father before he died and he told me what to expect about certain things. I stopped him to say I didn't know if I could accomplish what he's done. He said, "I don't want you to do what I've done; I want you to do it better."

# Utania Ceyshé Nelson

*Diné*

I am eleven years old and currently in seventh grade. The day I began dancing was when I took my first steps. I began with Fancy Shawl, and later I enjoyed dancing Jingle Dress and Southern Cloth. Now I dance the style of Northern Traditional.

I've listened to my adopted uncle and my parents converse about how important it is to educate the youth about culture, respect, and discipline. I feel this is very important because the youth of today are faced with many challenges and decisions.

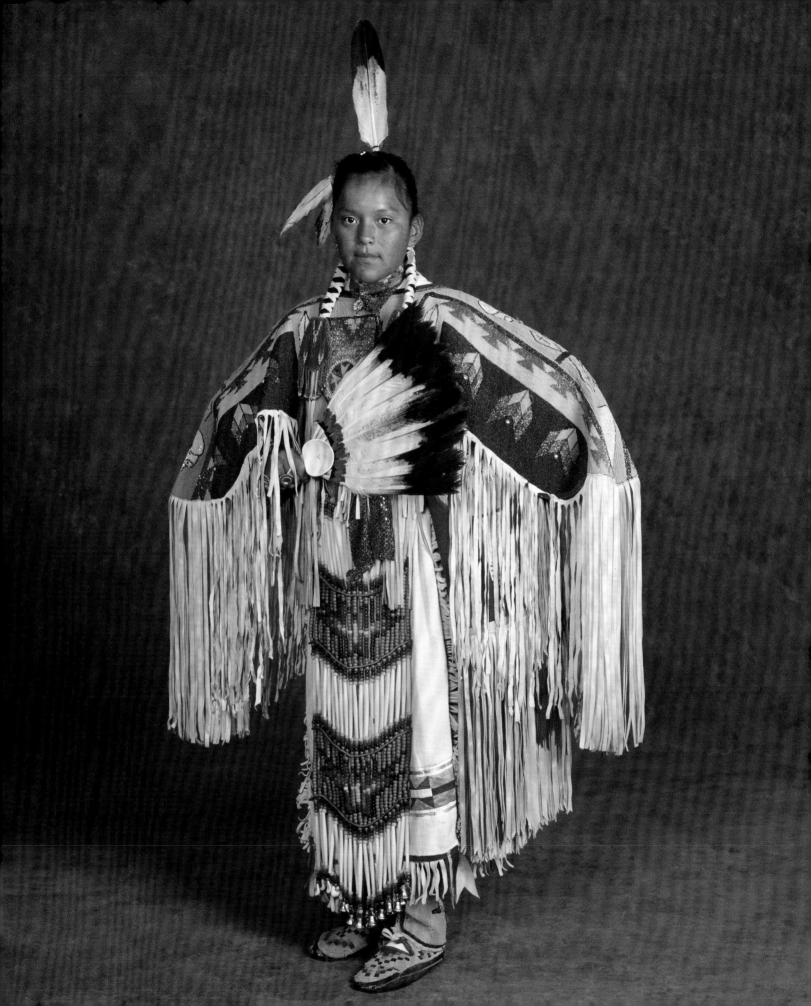

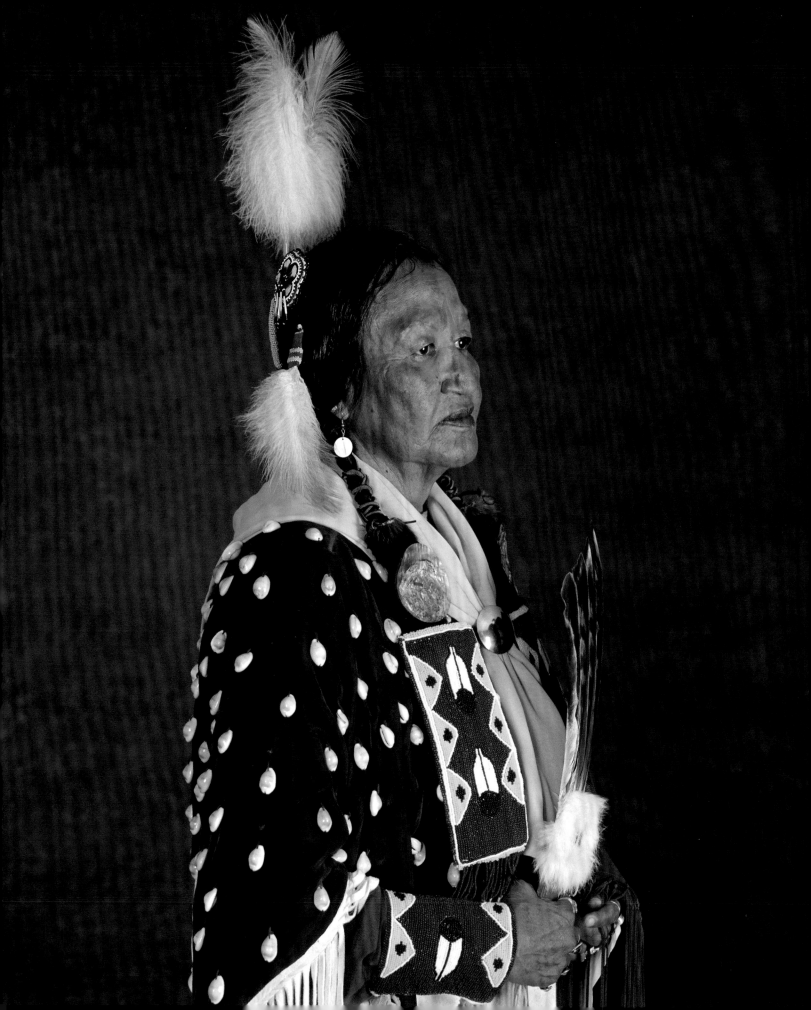

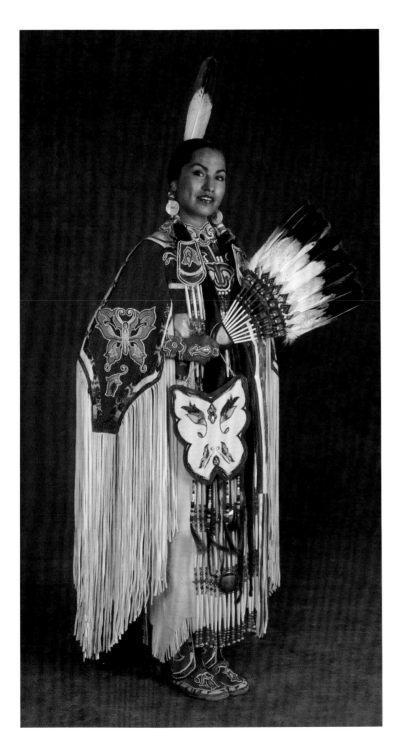

# Ernestine Gopher

*Ojibwe*

I am a direct descendant of Chief Rocky Boy. I was born and raised on Hill 57 northwest of Great Falls, Montana. We had no running water or electricity, but we were happy because of our family. My grandmother Mary Gopher taught me my traditional and spiritual ways. She taught me to make beadwork as a small girl; I would thread her needles.

I missed out on powwows for many years because life was a struggle, but my son and daughter-in-law got me into it about twenty years ago. It feels so good to be inside the Circle; I feel like a different person—like my body's been spiritually uplifted. Now I am a traditional woman and I live my Indian ways. I do all my own sewing and beadwork, and my daughter-in-law, Mary Ahenakew (Cherokee), made the buckskin dress I am wearing.

# Amber Buffalo, Mikwan Awasis (Feather Child)

*Plains Cree*

I am Plains Cree from the Samson Cree Nation of Hobbema, Alberta, Canada. My Indian name was given to me by Joe Roan of Pigeon Lake, Alberta, Canada. I dance Women's Northern Traditional, and have been dancing since the age of two. I am very fortunate and thankful that I was raised in the powwow circle. I thank the Creator every day for blessing me with my culture and my life. *Hai Hai.*

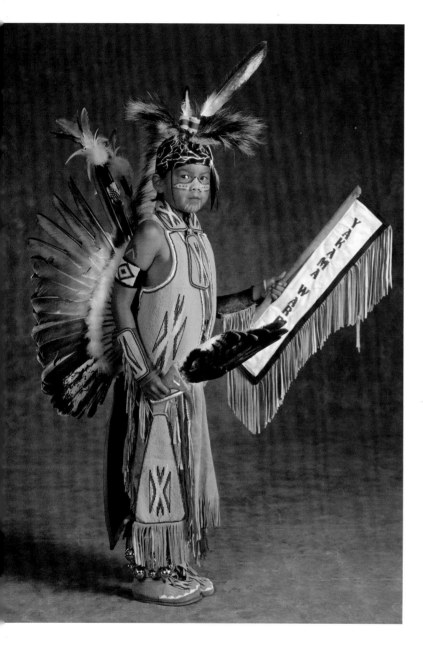

## Kevin Smartlowit, Kwel-Kwel-Lish

*Yakama* <span>ᗑ</span> *Spokane*

My relatives are teaching me the ways of the pow-wow trail: how I am to carry myself on and off the dance floor. My father and mother encourage me in everything I want to do. My uncles and aunties praise me for my dancing and this makes me even try harder. I am told that the powwow trail is a good road to follow; you can't go wrong if you dance with a prayer in your heart.

## Lisa V. Fourd, Hakikta Win (Looks Back Woman)

*Oglala Lakota*

I am a full blood Oglala Lakota from Pine Ridge, South Dakota. At seven years old, I was honored in a ceremony we call the *Hunka*. At this time I received my first plume and my Lakota name. Afterward, my grandmother started putting the two red lines down my forehead and I do so now every time I dance. When I hear and feel the singing and drumming, my heartbeat quickens. Dancing gives me a strong sense of identity and pride.

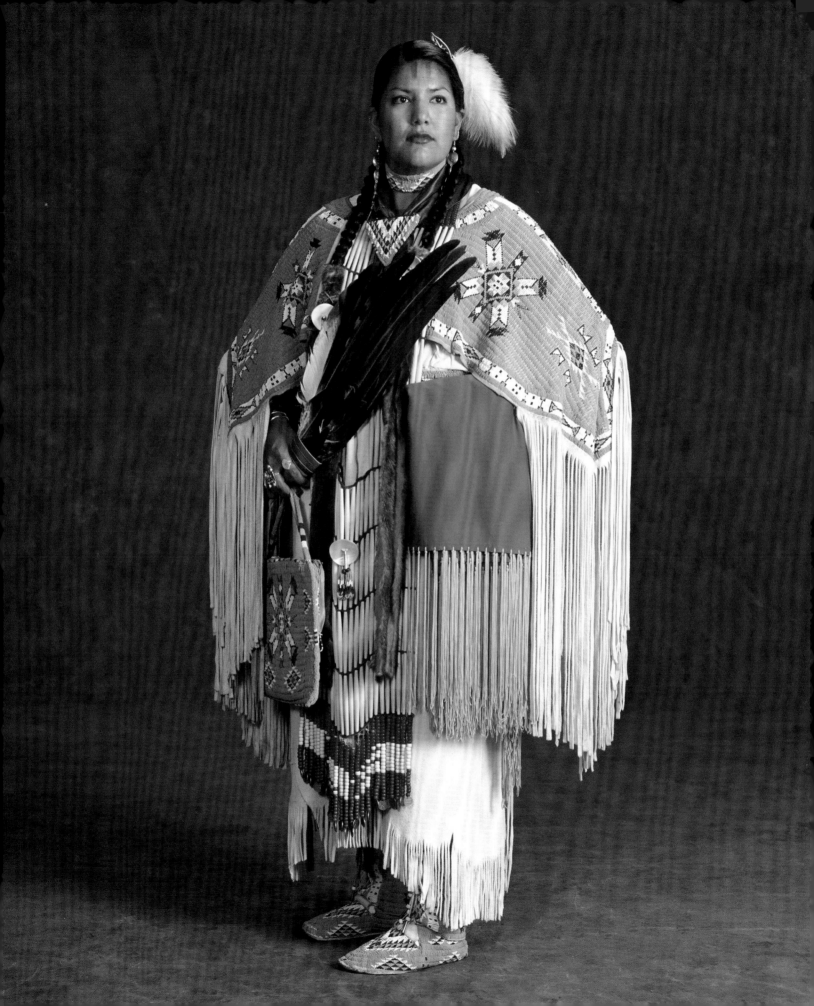

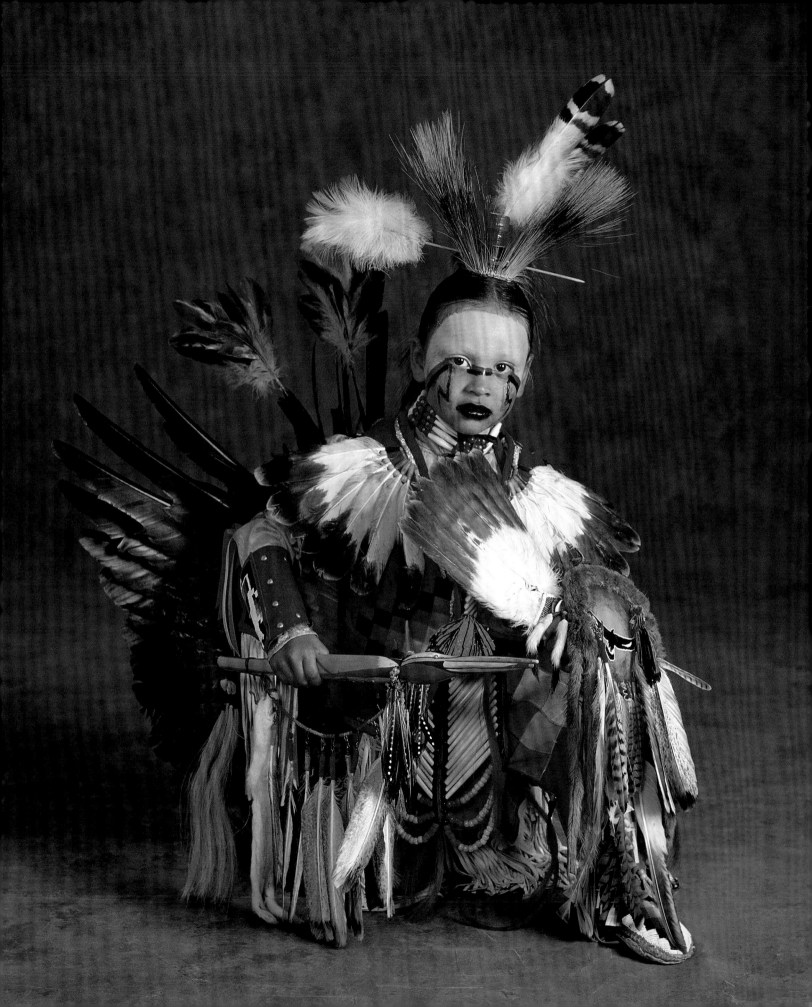

# Marquis Channing Leighton, Maksum IIIp-IIIp (Red Mountain)

*Nez Perce*

I am blessed to be an Indian and to be taught so much about our culture and way of life. It makes me proud to be *tetoken*. I've been dancing since I could walk. My *Totah* (dad), Paris Leighton, Sr. (see pages 20–21), had an outfit ready for me as soon as I was standing on my two feet. Now I'm fifteen years old and am in the ninth grade. This way of life has taught me about the different tribes, states, reservations, tribal relations, ceremonies, and all the types of songs from certain tribes. But most of all, it has taught me respect and kindness.

# Guy Fox

*Gros Ventre*

I am a renowned Chicken dance champion of the northern Great Plains and have developed my own style of dance and dress, which has inspired many other Chicken dancers. My regalia was put together by my mother, Gloria, my sister, Tina, and me. My beadwork was a gift by Beverly Large and family. My thanks to all the family and friends who have supported me throughout my years of dancing.

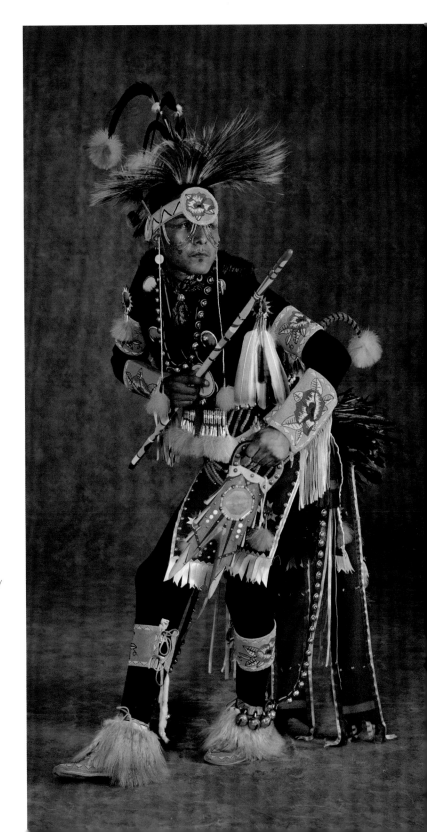

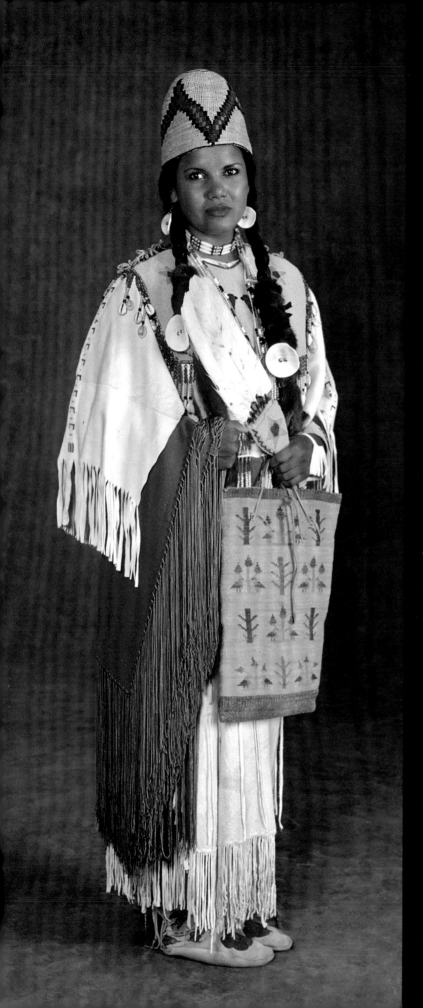

# Nicole Santos, Whe-lee (Meadow Lark)

*Coeur d'Alene*

My regalia was made in the 1940s by my great-grandmother Lucy Garry and has been passed down through three generations. Through the work of her hands, she created beautiful Plateau-style outfits that have been worn by her daughters and sons—my grandmother, great-aunts, and uncles. I feel fortunate to have this rich legacy as part of my life. The design on my yoke is bluebirds and stars. Lucy—the wife of the last chief of the Coeur d'Alenes, Ignace Garry—used birds, which serve as a family crest, in her work. My grandmother Celina Garry-Goolsby worked during the winter to add new pieces to this outfit.

# Shannon Ahhaitty

*Kiowa ⚜ Comanche ⚜ Cherokee*

The dress I wear is Kiowa style. The peyote fan I carry and the feather in my crown belonged to my grandpa Walter Ahhaitty. When I was eight years old my dad was very ill and not expected to live. My grandpa prayed over my dad in the tepee, using both this fan and this feather. When I turned sixteen my dad gave them to me. I have three other brothers that this fan could have gone to, so I feel especially blessed that he chose me to carry this medicine.

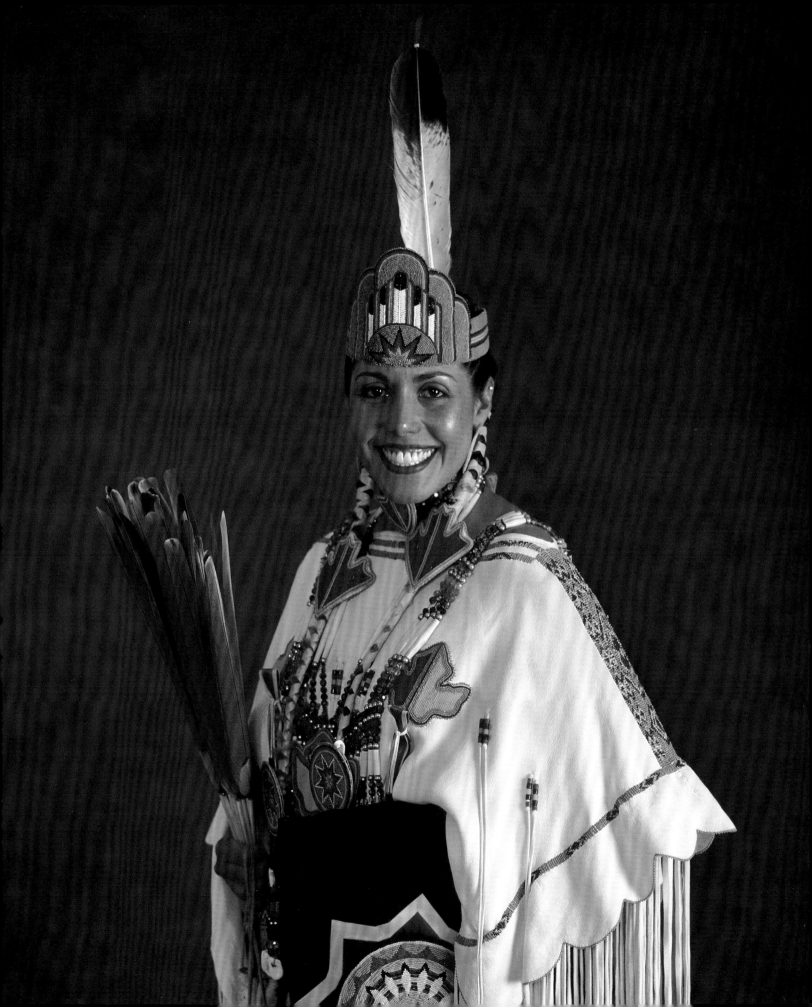

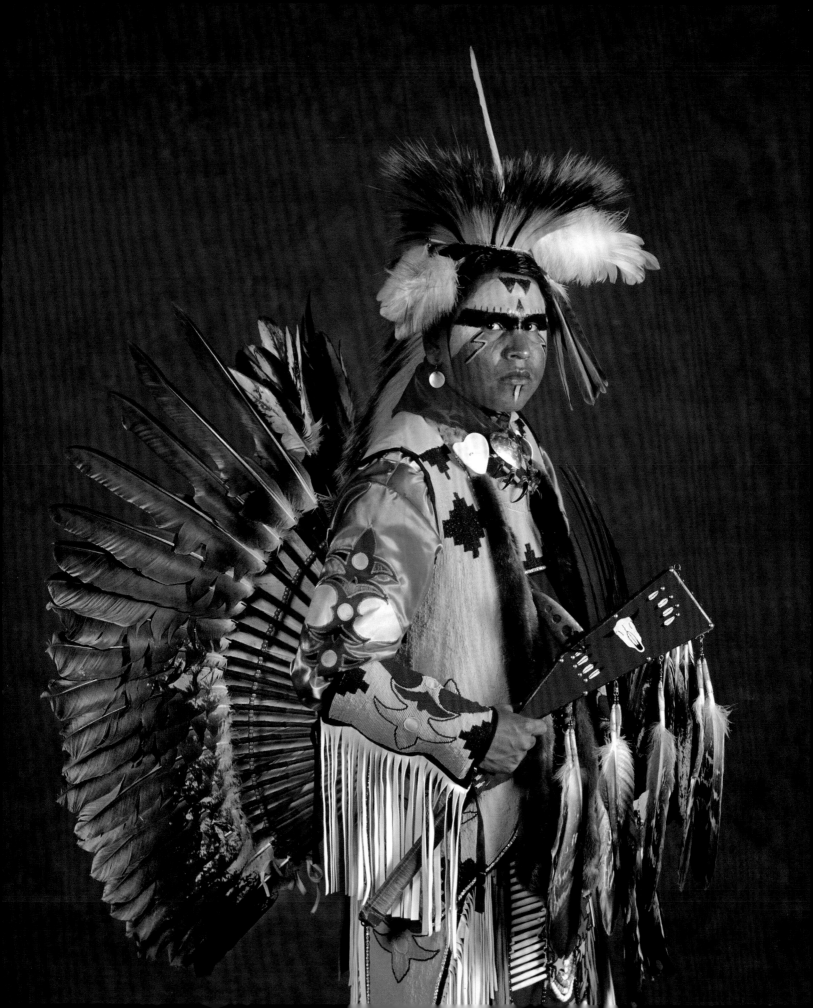

# Steve Hunt

*Blood*

I am a Northern Traditional dancer of the Blackfoot-Blood Nation from Standoff, Alberta, Canada. I began dancing at the age of eight, but stopped after a few years. My grandfather Alex Hunt, Sr. is the one who prompted me to begin dancing again. I dance for a lot of reasons, but most importantly because I wanted to honor my grandfather's wishes.

*overleaf left:*

# Sydney John, Pusha Kow

*Umatilla ❦ Yakama*

My outfit is an old family design beaded by my aunt Elaine Hoptowit, with seamstresses and extra beaders Roberta "Tootsie" Danzuka and my wife, Robin.

I consider myself a modern-day warrior. I work in public education as an administrator on the Yakama Reservation. My career choice echoes an old familiar song, "Go my son, get an education," which was instilled in me from my beloved parents. I work with all youth, but it makes my heart happy to see our Native American youth succeed in school and still maintain their cultural identity.

*overleaf right:*

# Virgil Mountain, Buffalo Warrior

*Dakota ❦ Anishinaabe*

Buffalo Warrior is my spirit name. I am a third-generation whistle carrier for the people. The whistle came to me in a sacred way five years ago. It is my responsibility to honor and protect the teachings and traditions that were passed on to me.

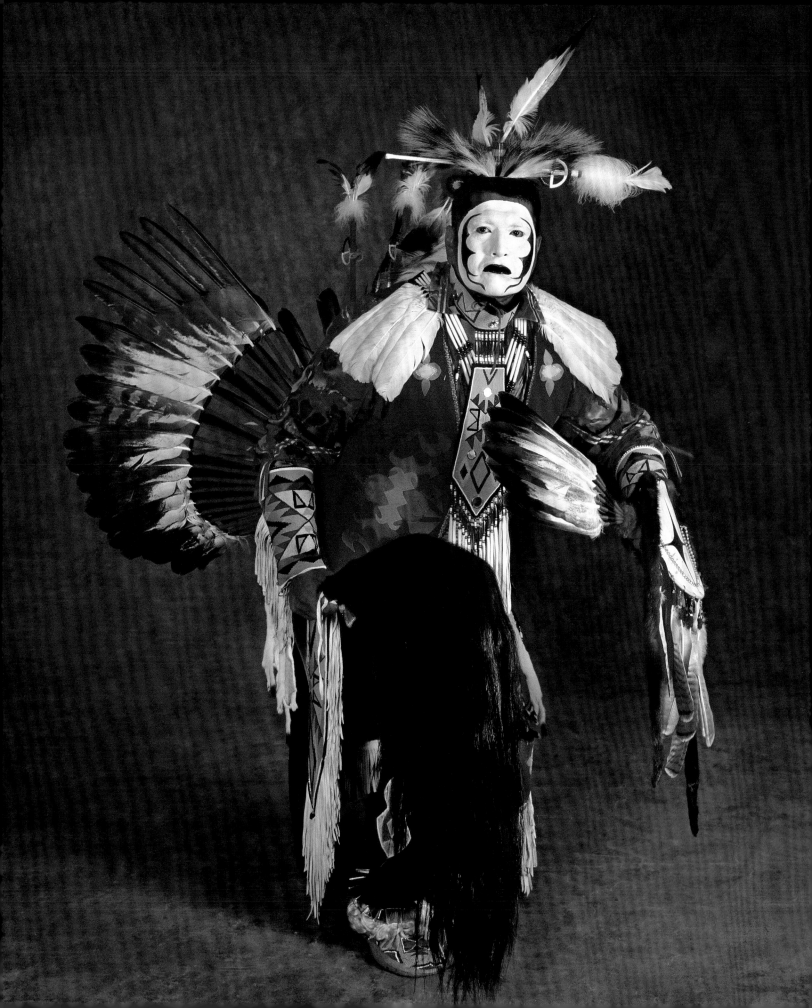

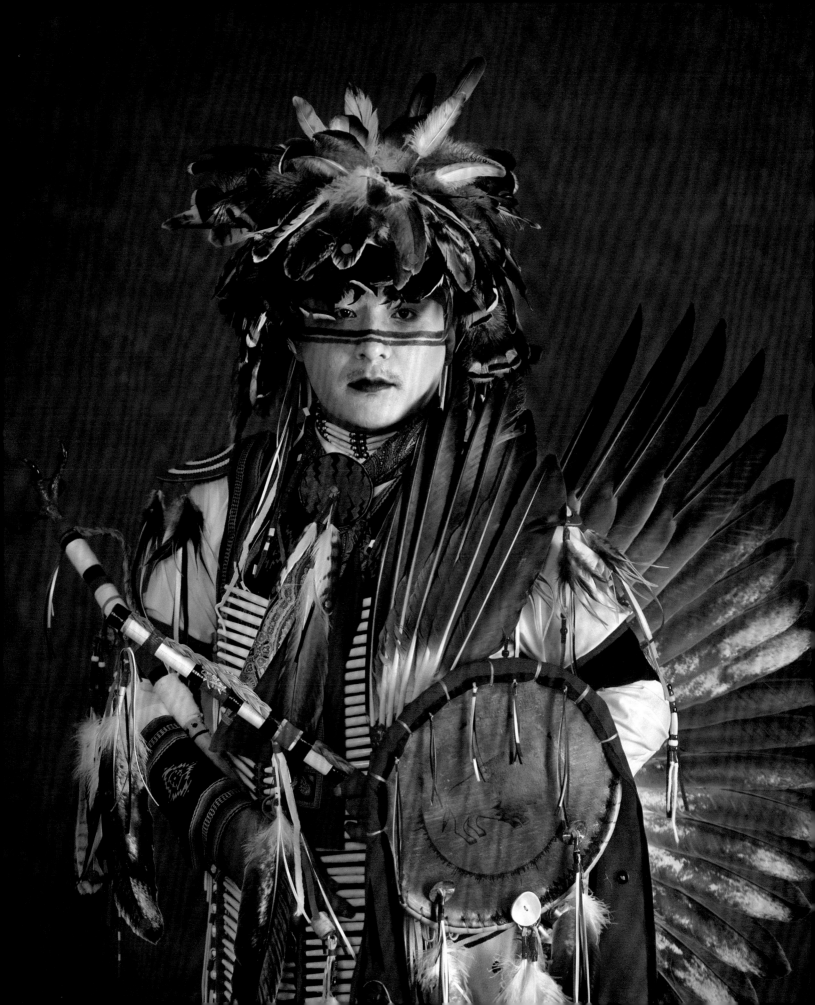

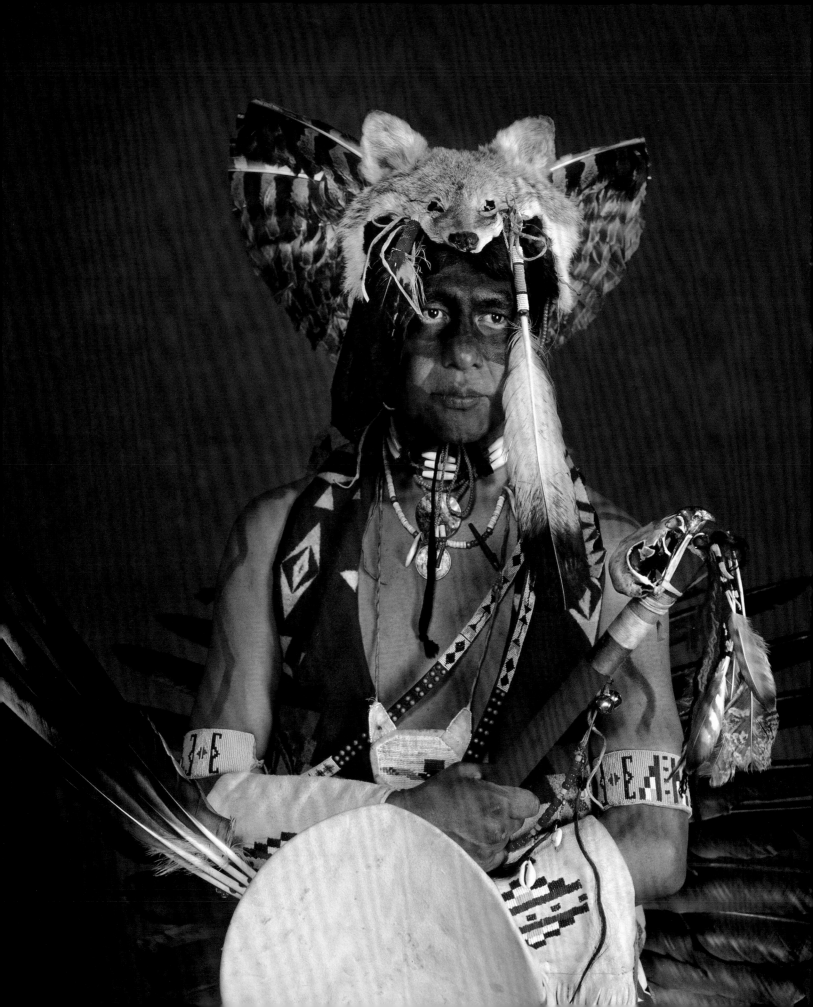

# 8

# "Whatever the gains, whatever the loss, they are yours."

—Pahkatos Owyeen (Five Wounds), Nez Perce

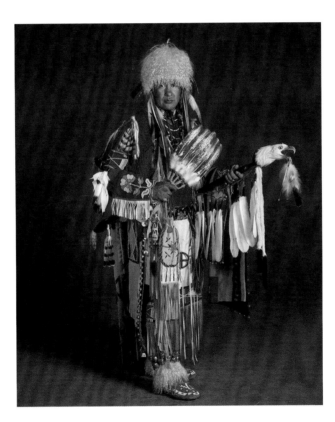

Gary E. Greene

previous pages:

# Gary E. Greene

*Nez Perce*

⍌ Dancing is my strength.

⍌ It provides me with a way of building and restoring pride in my culture.

⍌ It's an instrument that enables me to share and teach others what I know.

⍌ It allows me to honor the traditions of our elders, who hold it in a sacred way.

⍌ It helps me to dance with the older ones and to share a smile, a handshake, and maybe a story.

⍌ It's more than dancing—it's a way of life.

# Ardell Scalplock

*Siksika*

The outfit I wear was given to me by my father, Art Scalplock. My dad and I traveled to many powwows and he always taught me to have a kind word for everyone we meet. I've tried my best to make my dad proud, and I hope his legacy will always be carried on through me and my children.

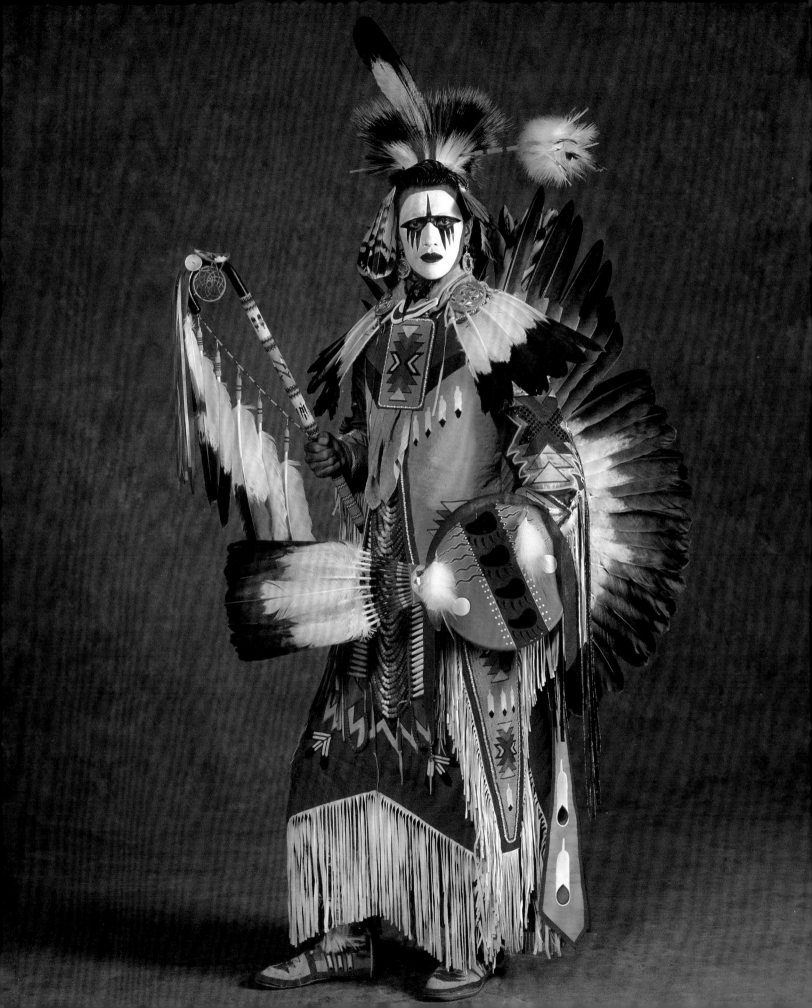

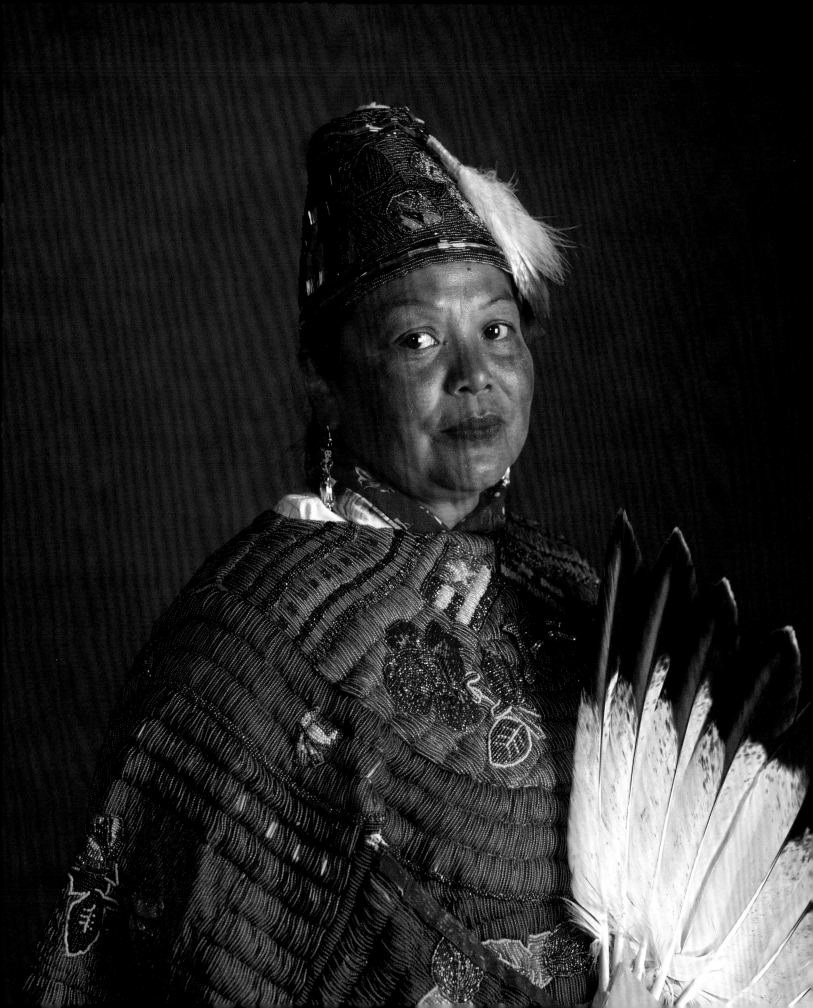

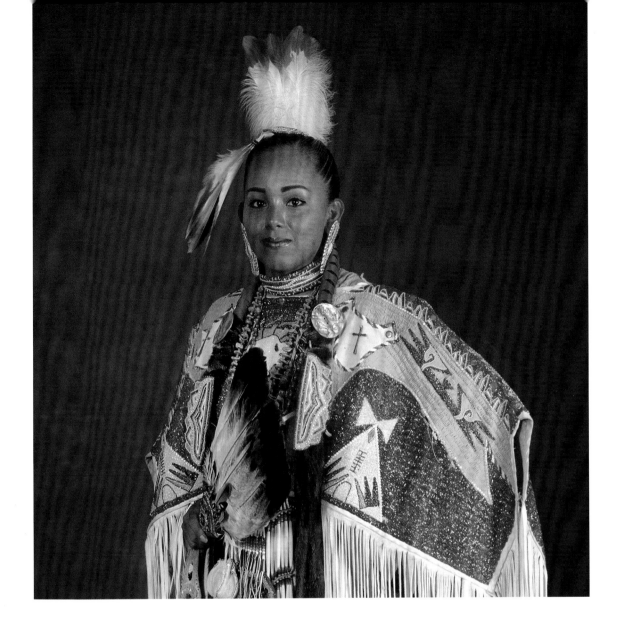

# Rena Greene

*Salish*

I'm a Stó:lô member from the Salish Nation in British Columbia, Canada. A Traditional dancer for twenty-seven years, I enjoy dancing because it helps my self-esteem. Dancing also encourages my family to live a spiritual and drug-free life.

# Violet Olney, Eck-Six La'Tit (Pretty Little Flower)

*Yakama*

The outfit I am wearing was beaded by myself, with the help of my mother, Audrey Olney (see page 61). I strongly believe in preserving my tribe's culture. I have dedicated myself to my reservation through actively leading, participating, learning, communicating, and helping in various activities, sharing my creativity with others to accomplish common goals and improve the cause.

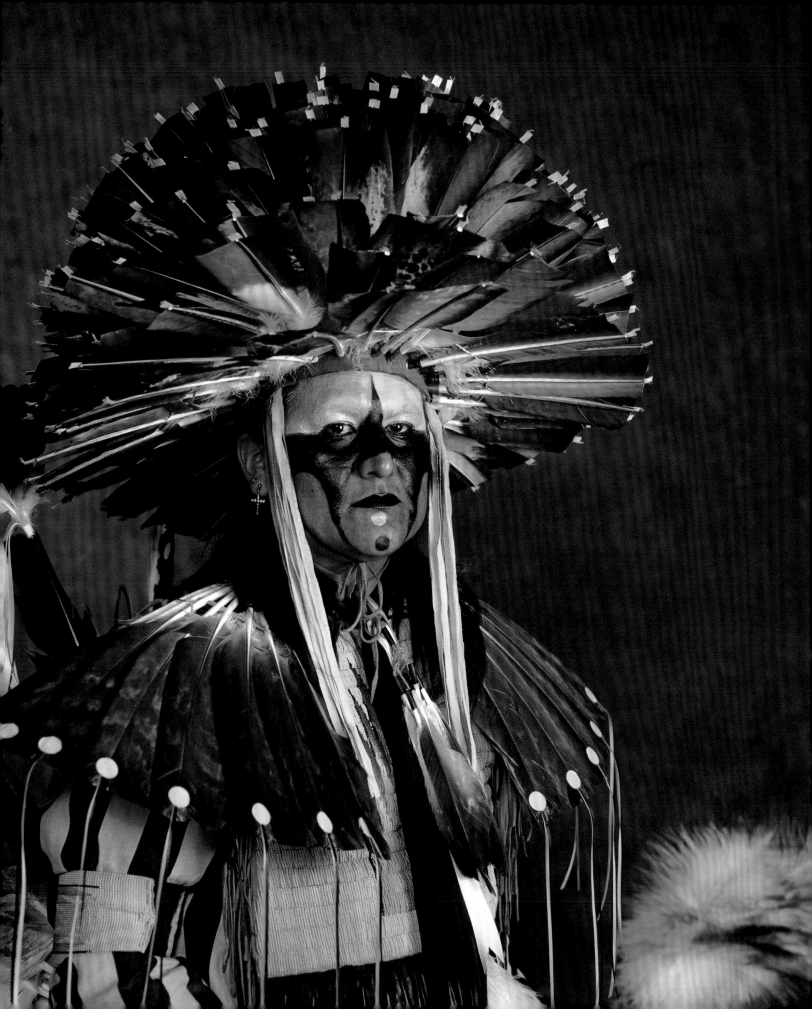

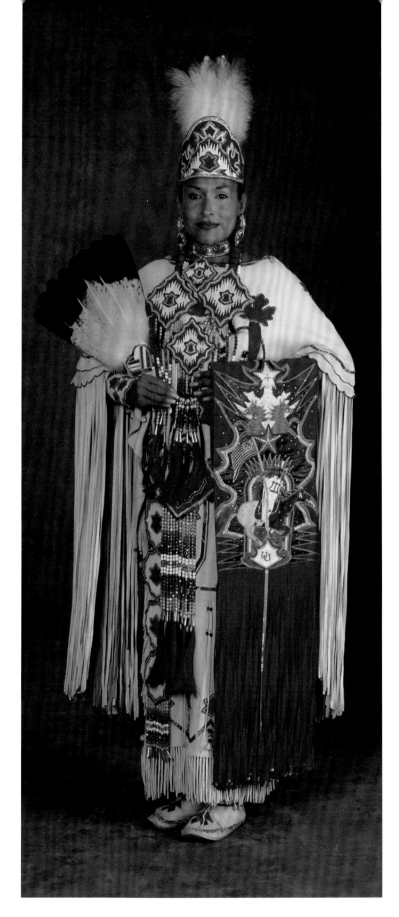

# Ron Walsey

*Warm Springs*

I have been dancing since I was in diapers, and all of my children (see pages 44–45 and 83–84) have been raised the same way. The design of my outfit came to me as a vision in the sweat lodge long ago. My wife, Edith, made the outfit: The yellow shows the sun as the earth comes alive; black represents night as the earth goes back to sleep. The feather hat is Mandan/Hidatsa style. Originally only men who kept order could wear this type of hat. The eagle feathers and head on my staff are very old and came from an elder in Pine Ridge.

# Keri Jhane Myers

*Comanche ⱴ Gros Ventre ⱴ Blackfeet ⱴ Nakoda (Assiniboine)*

I am of the Penneaducah (Sugar Eater) and Yappaducah (Root Eater) Bands of the Comanche Nation and the Gros Ventre, Blackfeet, and Assiniboine tribes of Montana. My dance style is the Southern Buckskin of the Plains Indians tribes. Family and friends made my dress, and all of their prayers and good thoughts are carried with me when I dance.

I have been fortunate to work with organizations that promote positive images of our Native people. But I do spend almost every weekend in my Buckskin and that is by choice! My best moments in life are spent watching my children continue in the circle of our traditions and culture. *Ud-dah.*

# Virginia Arbiso Balinski and son Robert Chavez

*White Mountain Apache*

*Virginia:* It is important to keep *who* we are alive. To remember who you come from and who you are—nothing and no one can take that away from you.

    *Robert:* Dancing and hearing the heartbeat drumming of my people helps to wipe away life's everyday stresses. The powwow is a constant reminder of what's most important…family.

# Leonard T. Cree, Ma-Oot (A Little Bit More)

*Umatilla* ⬇ *Yakama*

I was born on the Umatilla Reservation in 1926. I have danced on and off since I was a little boy—different styles over the years. I now dance with Traditional-style regalia. My headgear is Mandan, in a style that is reserved for warriors. I served in the U.S. Navy in World War II, which is represented by the ribbons and feathers on my shield.

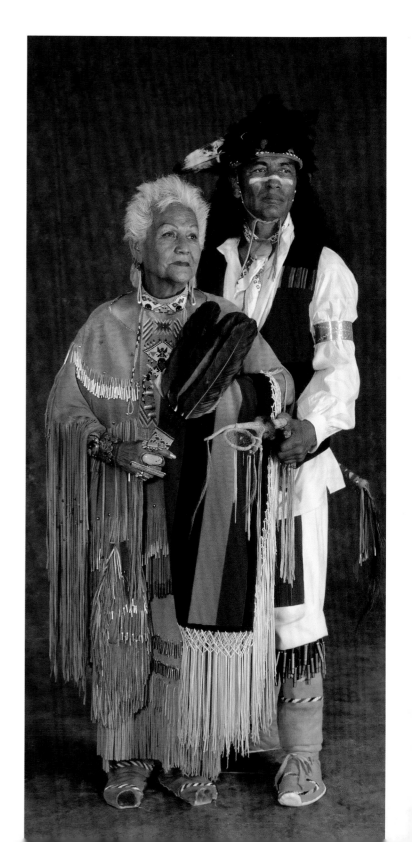

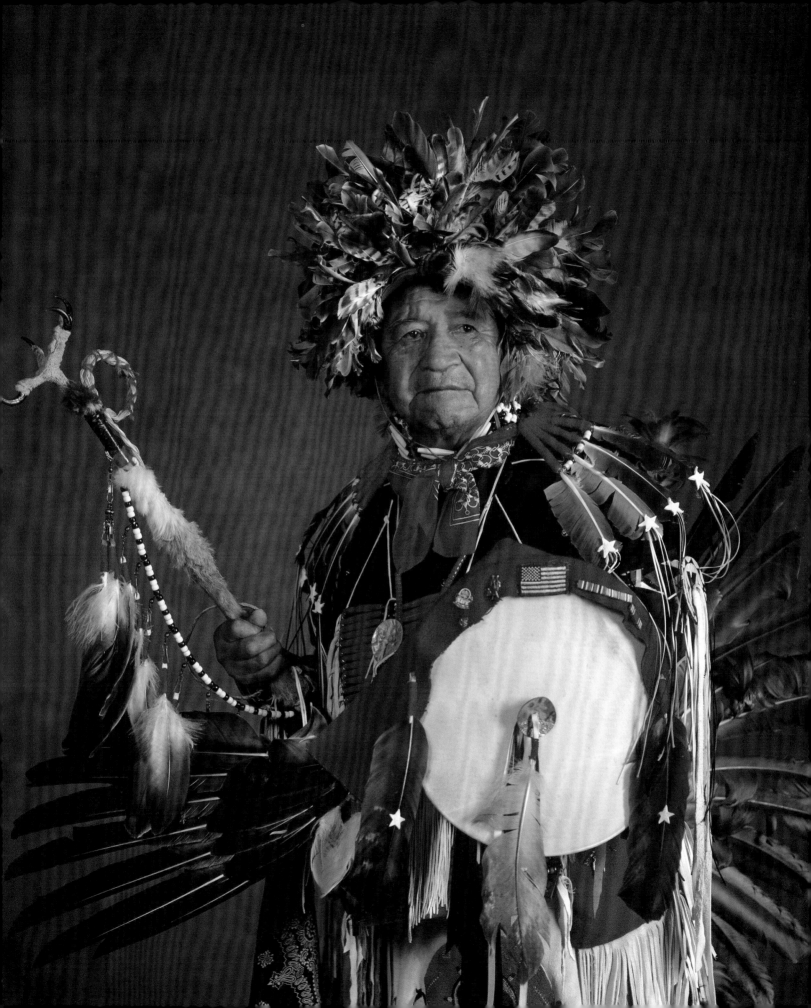

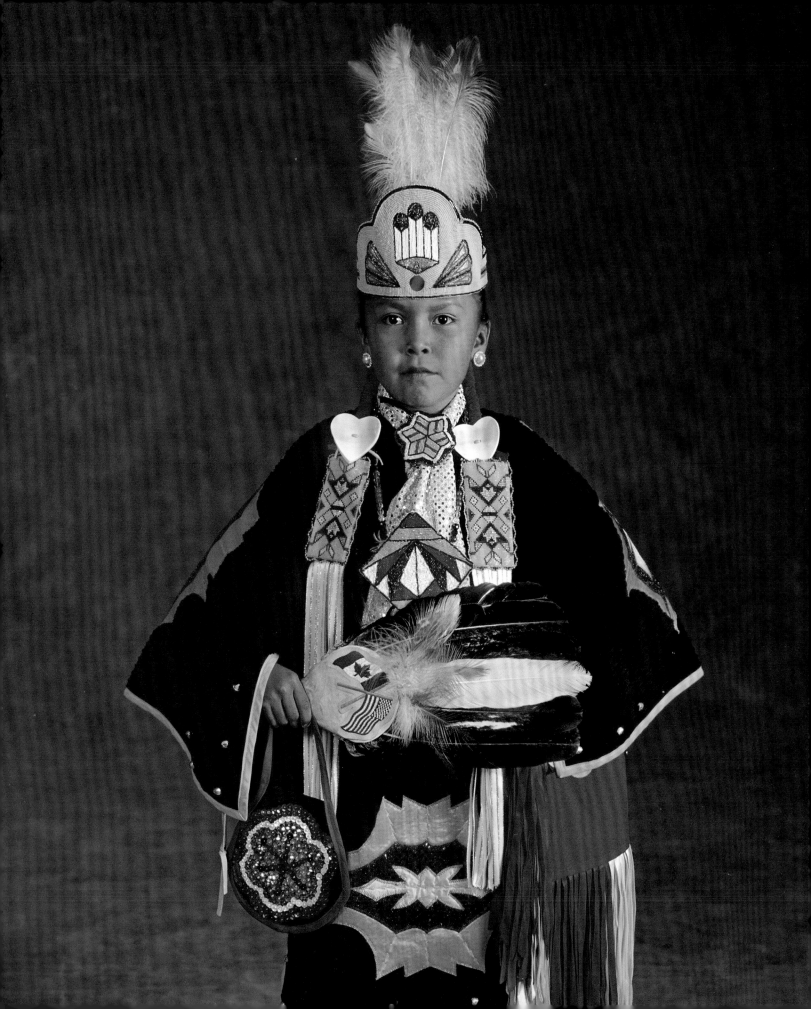

# Tierra Draper

*Diné*

I am seven years old and I live with my two broth-ers, Spike and Tyson; my sister, April; and my mother and father, Lora and Tommy. I dance Southern Traditional style. Our family is a powwow family, and we travel all over the country attending powwows. We have traveled to Europe several times to dance. My biggest influence is my brother Spike who is a champion Fancy dancer.

# Sissy Gopher (Cedar Flower)

*Blackfeet ⚜ Cree ⚜ Jemez Pueblo*

My Indian name was given to me by my grand-father of Jemez Pueblo, New Mexico. My family and I believe strongly in our Indian way of life. My grand-fathers on both sides of my family are medicine men, along with my grandmother Lyena Fish.

My mother makes all of my Jingle-style dresses except for two that were made by Crystal Whiteshield. My beadwork was made by my father and Selma Yellow Kidney. I have danced Jingle all my life—it was always my dream, to become a Jingle Dress dancer.

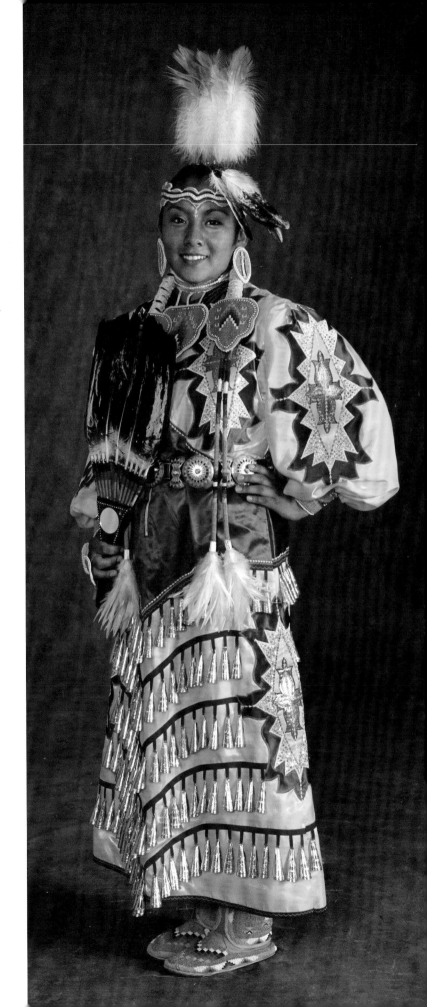

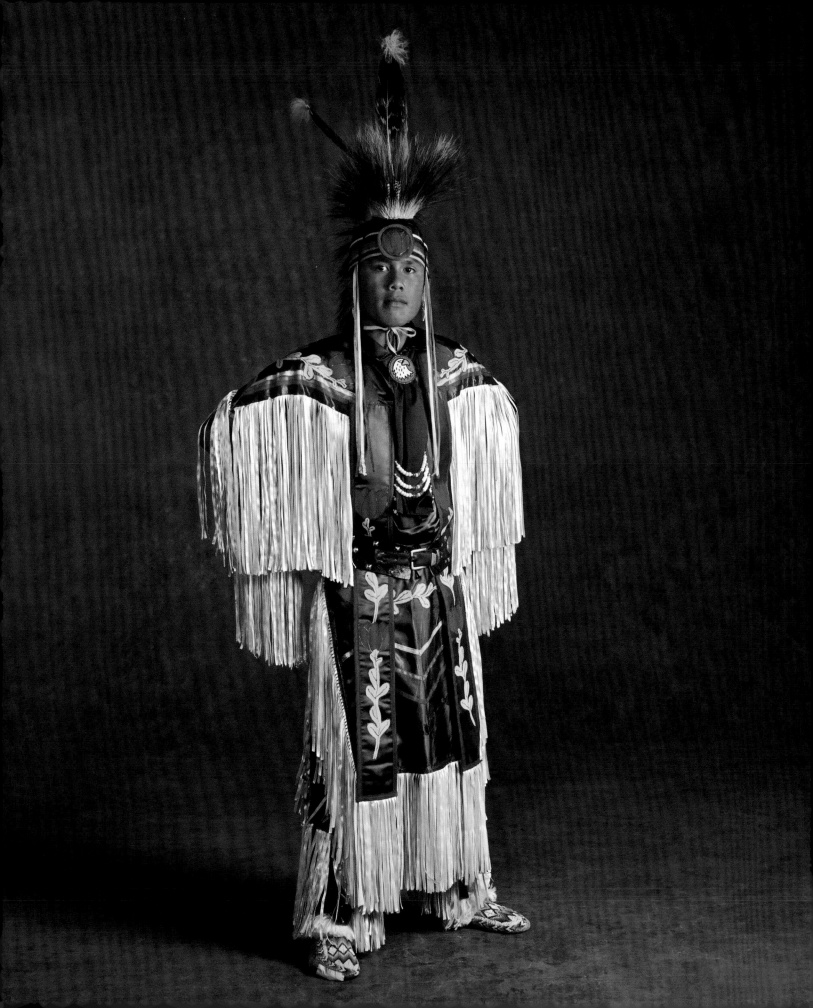

# Gary Michael Villa SoHappy

*Warm Springs ⬙ Yakama*

I was really young when this picture was taken—about twelve years old, if I remember. When the picture was made, I really didn't know it would make the covers of *History News* magazine and the 1998 Yakama Treaty Days poster. It was such an honor.

I want to thank my mom and dad for believing in me, and for taking me to powwows all over Indian Country. I don't think I would be a powwow person if it were not for them.

*overleaf left:*

# Robert Washington, U-Lath-Quin-Sit

*Lummi*

I was raised speaking my native tongue, and lost it at an early age when I was sent away to school. I was fortunate to have been raised by my beloved grandparents, learning the old ways, going to pow-wows to see the dancing and the stick games in which my grandfather excelled.

On weekends my family and I travel to pow-wows. As we drive up I feel like a small child again, all jittery with excitement as I hear and feel the drums surge through me like lightning.

I am a Traditional-style dancer. My bustle is made from my first eagle, passed to me by my grandfather. My cuffs were beaded by him as well; my jewelry was given to me by my granny. When I dance, I don't think about competition or money, I pray to my Creator. Every step I take is a prayer. I think and remember my grandparents. I feel the sadness that my grandmother never got to see me dance, but I know that she watches me now from the spirit world.

*overleaf right:*

# George Abeyta

*Eastern Shoshone ⬙ Isleta Pueblo*

The outfit I wear bears the emblems of strength and guidance inherent in the eagle and the buffalo. The war shield represents my home with the mountains of the Owl Creeks and Wind Rivers, as well as the rainbow and clouds, which provide the life-giving water. The eagle represents our prayers as the center of our livelihood. Whenever I enter the dance circle I pray that someone in attendance will be uplifted, inspired, and strengthened by the dance given to me by the Creator.

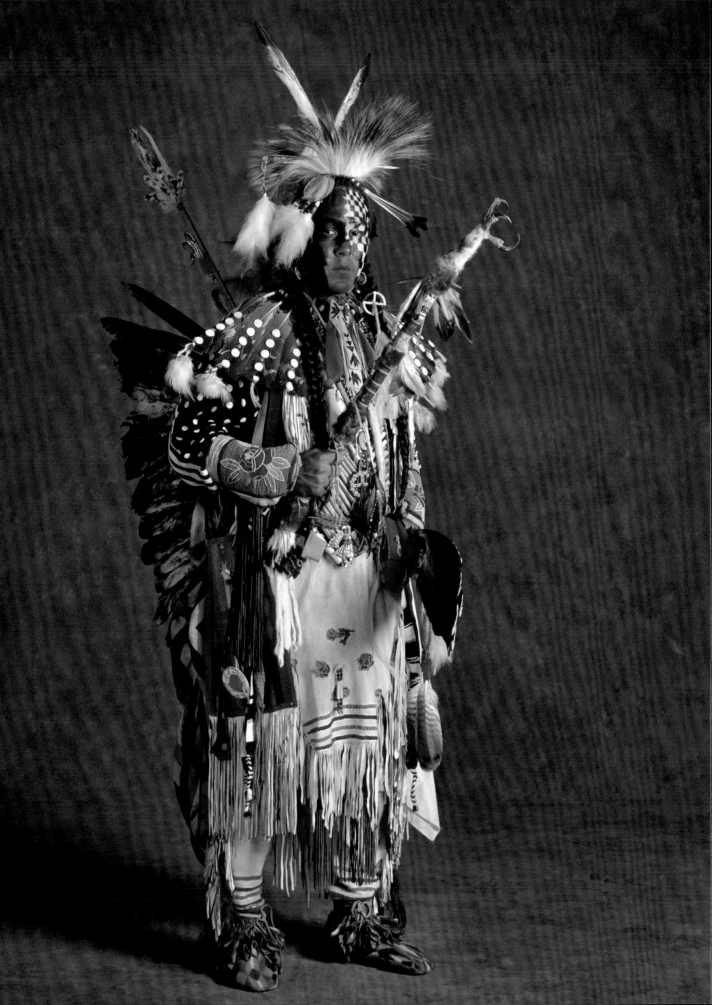

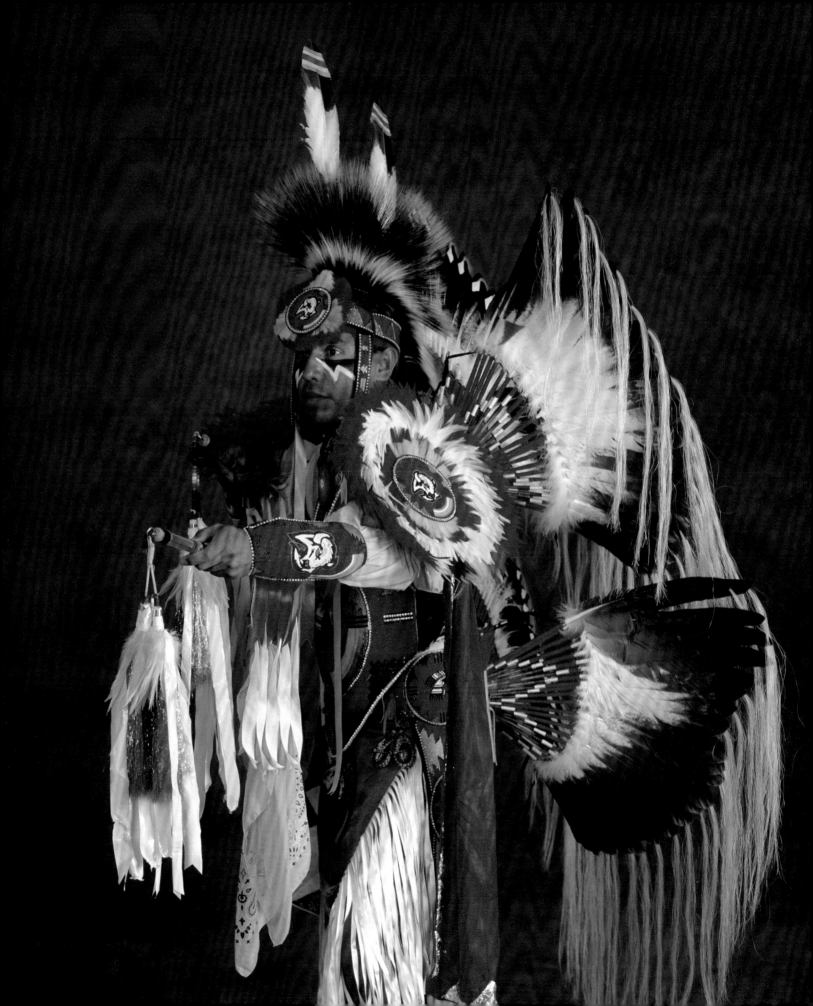

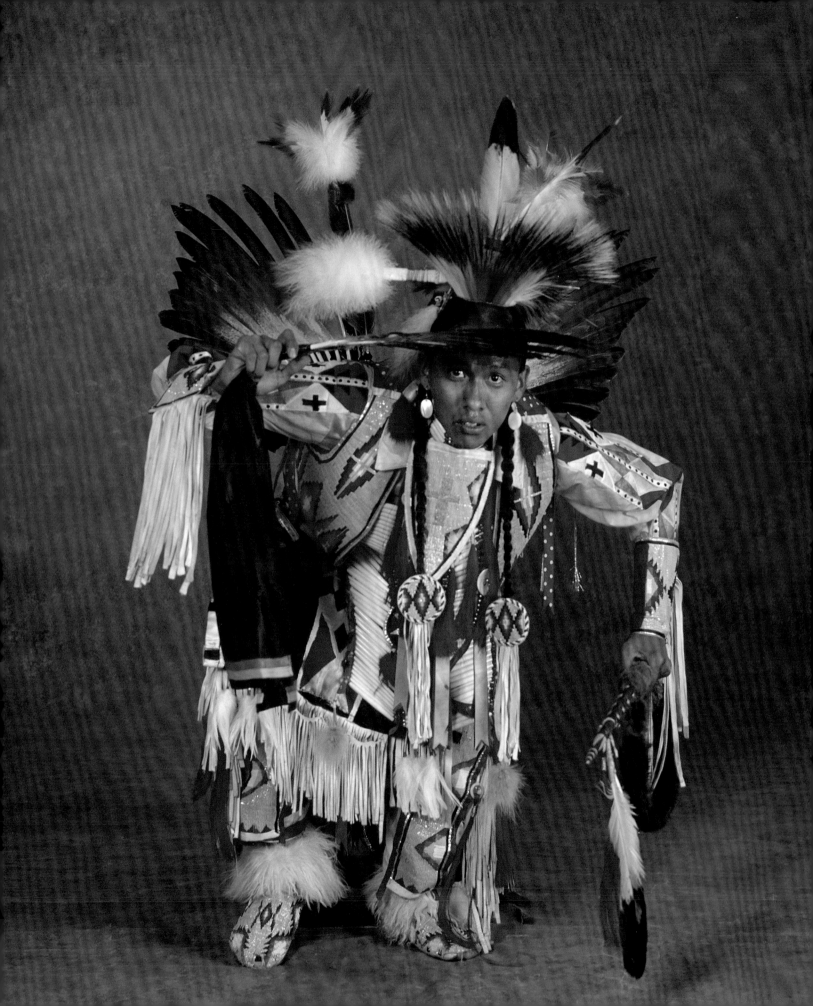

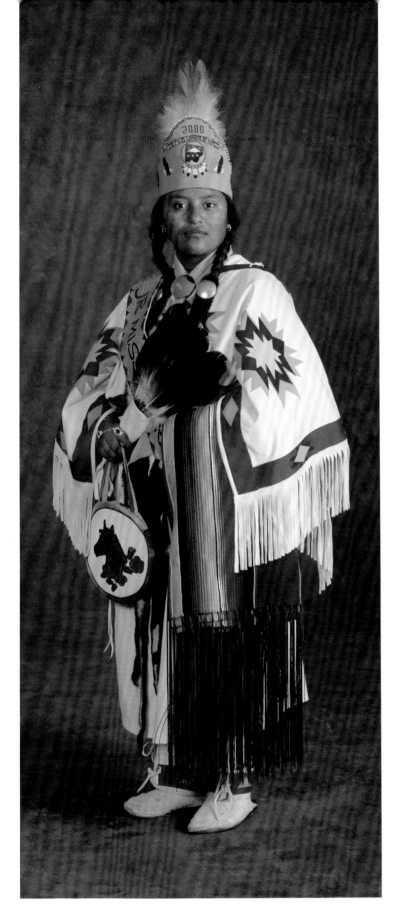

# Brando Jack
# (Turn Around with Meanness)

*Diné*

Throughout Indian Country—every powwow I attend—I try to uplift the crowd and anyone who is feeling down or not well. As a humble man, I encourage the younger generation to learn the ways of culture, spirituality, respect, and appreciation of one another.

# Cecilia Herrera

*Colville ⚜ Yakama*

I am a Traditional and Fancy dancer in the powwow circle, and I represented the Warm Springs Indian Reservation as Junior Miss Warm Springs 2000. I am involved in our Traditional longhouse ways and do many of the Traditional food gatherings for our feasts. I am not only American Indian but also Mexican American, so I am representing both halves of my bloodline.

I am pleased to say that I am planning to attend college and get my degree in education. I will return to my reservation and help teach our younger generation.

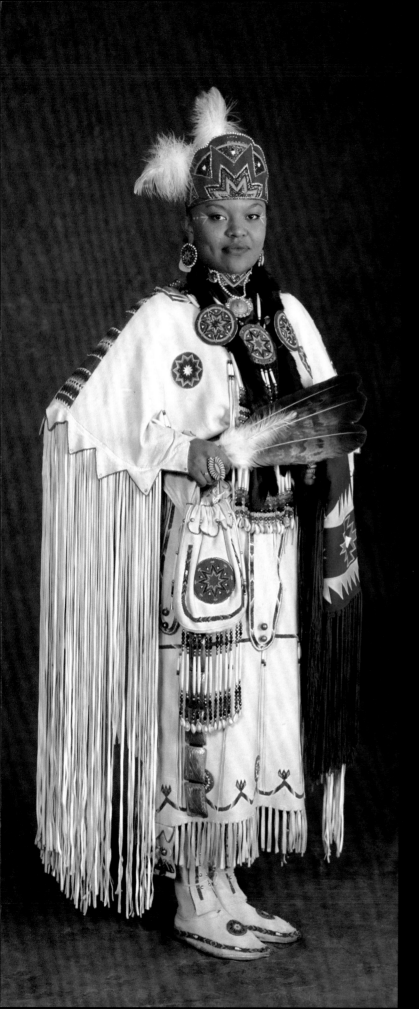

# O-Wind-dessa Todichiinii
# Nalwood-Arrow

*Navajo ⚜ Quapaw ⚜ Cherokee ⚜ Osage*

I was initiated at the age of seven as a Southern Traditional Buckskin dancer. When I was given my eagle feathers, I was told that this was my commitment for life.

Each and every piece of my outfit was handmade with a prayer for myself, my family, and each person and their family who is graced by my performance. Most people have church or religious activities that they participate in to renew themselves. My renewal comes with each step I take in the powwow arena. My grandmothers and grandfathers taught me to dance for the people before I dance for myself; they look upon me from above and give me the strength to dance.

# Mylan Murdo S. Tootoosis,
# Kanikanotet (Walks Ahead)

*Plains Cree ⚜ Nakota Sioux*

I realized at a very young age while growing up on Poundmaker First Nation in Saskatchewan, Canada, that the land and my spirituality are connected. One of the ways I emphasize this connection for myself is through my dancing. Not only does dancing help me endure the modernization of Western society and the adapting of my people to it, but it also instills a sense of pride, belonging, and spirit.

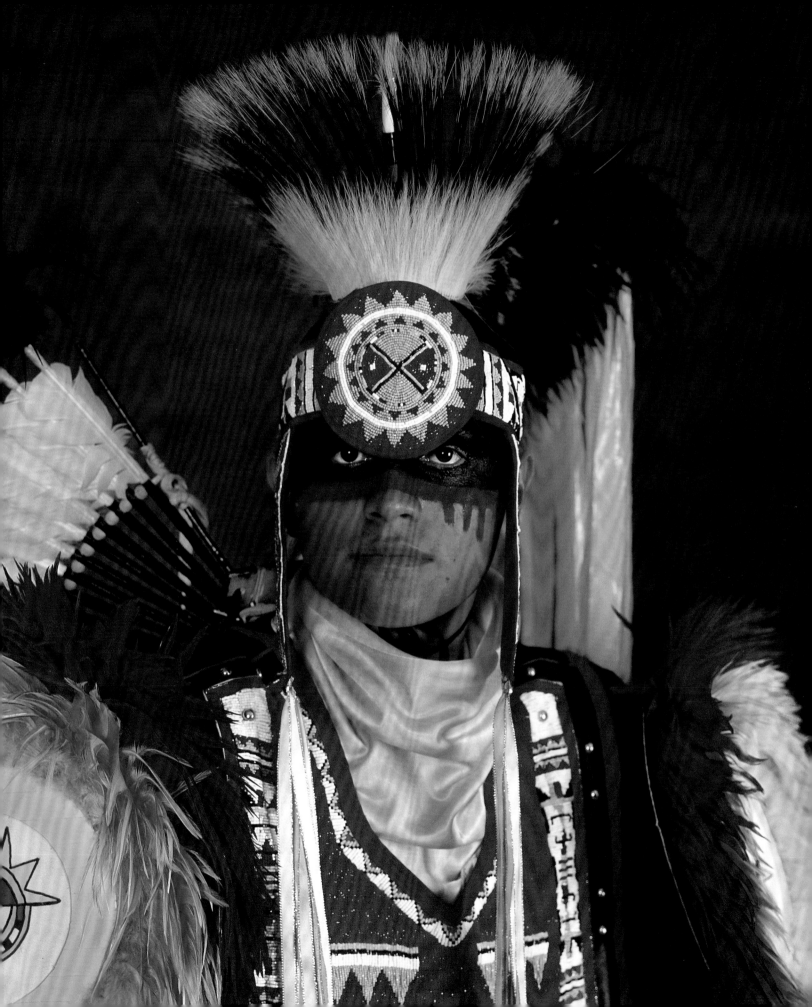

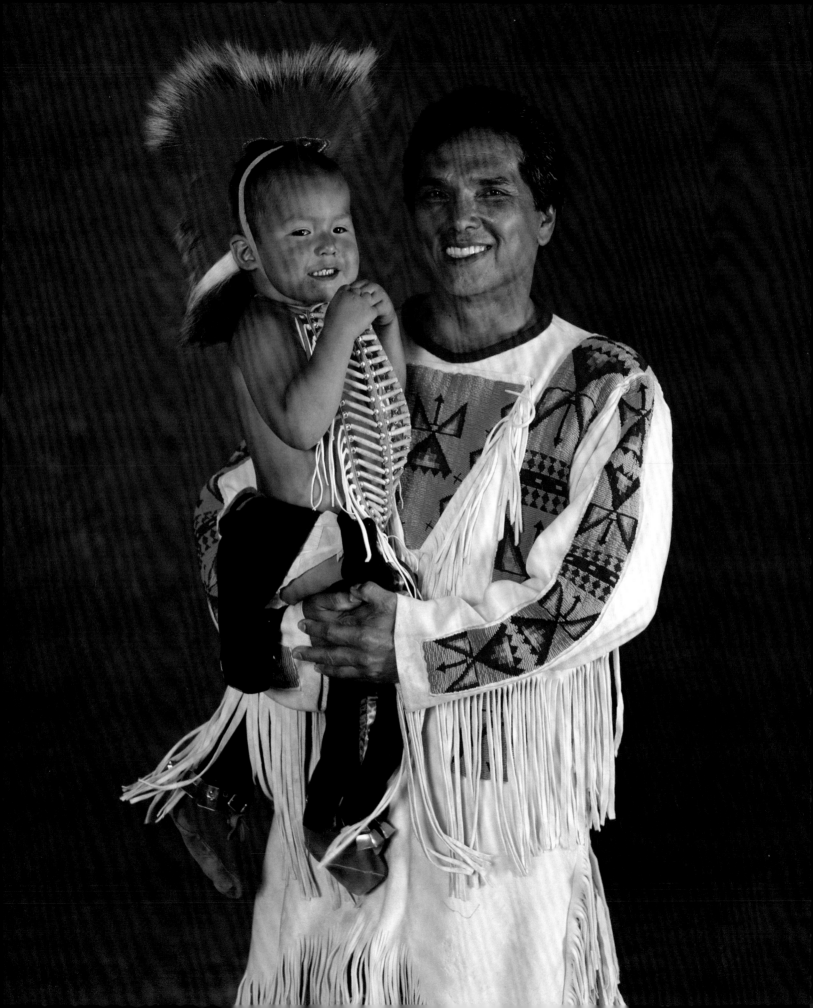

# David Matheson and grandson River Spotted Horse

*Coeur d'Alene*
*Coeur d'Alene* ⬇ *Sioux*

I remember how my grandfather would sing and dance, playfully swinging me around in his arms. I could also detect something more in his soothing tone and the blanket of warmth that was his grip. He was expressing his love and happiness in the best way he knew how.

Time and again, he said, "We Indians express what we cannot say in words, through our songs and our dance." Those times when no one else would do, he held me, rocking and cradling me and singing our traditional lullaby songs.

Now, some fifty years later, I sing these songs to my grandchildren and I know how he felt, and why the only way to really say it is through song and dance. When I see the sun shimmering off the waters of our great lake, when the eagle flies just so overhead, when the wind shifts just enough to get my attention, I hear the drumbeat. I hear his songs. I hear his voice. I know he is in powwow heaven, but nature is his powwow circle. The water is his dance arena.

When I hold my grandchildren, and sing and dance with them, I feel coming over me a spirit of peace, comfort, and happiness beyond words. Speaking louder than words ever can, I tell my babies how much I love them.

# Afterword

I first became acquainted with Ben Marra's portraits of powwow dancers in 1995. As the illustrations researcher for the Smithsonian Institution's *Handbook of North American Indians* from 1970 to 2006, my job was selecting and captioning the photographs for fourteen volumes of this projected twenty-volume encyclopedia. During my *Handbook* career I repeatedly sought out Marra's portraits documenting dance regalia among Native Americans. Although selecting several thousand images per volume did not leave me much time to linger over individual pictures, I always took the time to study Marra's magnificent portraits. The personalities of the individuals depicted in the images leapt from his frames. The photographs were often riots of color, each image like a faceted jewel.

As a visual anthropologist studying photographs of North American Indians, I am concerned with helping scholars learn how to use photographs as primary documents for study of the people and events depicted. So, while I enjoy Marra's powwow portraits aesthetically, I also look for the concrete information that his visuals can contribute. I want to know facts about the individuals pictured, family connections, techniques in the making of the regalia, and its history and disposition. Such information greatly increases the long-term value of the photographs.

The images alone are powerfully evocative. But the sensory experience can be enlarged upon by the addition of captions that provide personal and cultural context and allow the viewer to more fully grasp an image's unique meaning. In Marra's project, oral documentation was collected by his wife, Linda, and both photographs and text were united in the 1996 book *Powwow: Images Along the Red Road* and the traveling exhibition *Faces from the Land: A Photographic Journey through Native America*. I find it centering to read the words of the individuals photographed describing why they dance and what it means to them. It gives cultural significance to the images that cannot be gleaned from the photographs alone and offers insight into facts about the regalia itself and the individual dancer's own creativity, as well as traditions that are family- and community-based.

Ben and Linda stress that there is little time for them to meet each dancer and record documentation during the powwows, which compels them to let the pictures and transcribed oral statements speak for themselves. So we have to look at the Marras' work—over twenty years of attending powwows and building ties with individual Native Americans—as an opportunity to witness particular dancers repeatedly to deduce answers to questions about the inspirations and meanings in the regalia. While the clothing created for the powwow is part of competitions, it is also a sharing of outfit details among this group of highly skilled artisans. My mind cannot help jumping ahead to the future of these important images—which also serve as a record of how the designs, colors, and materials of the outfits have evolved throughout the years—and how they might be used by the individuals' families, in tribal settings, and by scholars of visual imagery. These photographs

and texts could be the nucleus for a late twentieth-century, early twenty-first century history of powwow regalia.

The fact is individuals view the same photographs differently. Viewer interpretation can be positive or negative. If the subject does not want to be seen, then the impact of the photo can be negative. If the subject wishes to be seen, then the viewer's gaze is positive. In addition, it is surprising how time can alter the perspective of a photograph. Many today criticize Edward S. Curtis' images as artificial, affected, contrived, and downright fake—concealing some kind of ultimate "truth." Perhaps it does not matter if the viewer reads an image differently from the subject. While they are grateful for the important information that historical photographers, particularly Curtis, left for them, I have had Native Americans comment to me that it is frustrating to them to sort out in some cases "the real" from "the staged." Still, I wonder what is "real" (i.e., "truth") and what is "staged"? Is it possible to know the real or the truth in a photograph, especially, like with Curtis' work, when the photographer and the subject are no longer alive? The best we can hope to achieve is a visual statement of the subject's absolute presence. This is what Edward S. Curtis and Ben Marra accomplish so effectively in their portraits.

Indeed, Marra's photographs of powwow dancers offer glimpses of an event that is central to contemporary Indian life. As Marra phrases it, by dancing, the participants are able to "heal their wounds and live with honor and pride in being Indian" (1996: 11). Dancers come to the photographer to have their presence at the event documented; they want to be seen, admired, and appreciated. Thus, the photograph is a natural extension of this desire to share with the public the joy of this event. One hundred years from now, viewers may question the reality or truthfulness of Marra's posed portraits, but for the subjects themselves, willing participants in the act of being captured by the camera TODAY, there is no question of duplicity in the creation of these photographs.

The power of a portrait comes from the interaction of photographer and subject. Without mutual cooperation such images lack integrity and dignity. I have never seen a Marra portrait of a reluctant, embarrassed, or hostile subject. The people he photographs look into his camera and trust him to bring out their individuality and confidence in their milieu. Thank heavens for photographers like Edward S. Curtis and Ben Marra. They have enriched our visual heritage of American Indians and offer an enduring tribute to their subjects.

Joanna Cohan Scherer
EMERITA ANTHROPOLOGIST
SMITHSONIAN INSTITUTION
WASHINGTON, D.C.

The following people have made *Faces from the Land* possible:

Robert Morton for his professional guidance and wisdom. Steve Tager for his inspiration; Darilyn Lowe Carnes for her beautiful design; and Magali Veillon for her vision and steadfast support; as well as the whole team at Abrams. Dick Busher and Ron McLean at Cosgrove Editions for their incredible scans.

Project Manager
MAGALI VEILLON

Editor
ELIZABETH SMITH

Designer
DARILYN LOWE CARNES

Production Manager
JULES THOMSON

Library of Congress Cataloging-in-Publication Data

Marra, Ben.
 Faces from the land : twenty years of Powwow tradition /
   by Ben and Linda
Marra ; foreword by George P. Horse Capture ; afterword by Joanna Cohan Scherer.
     p. cm.
 ISBN 978-0-8109-8335-9 (harry n. abrams, inc.)
 1. Powwows. 2. Powwows—Pictorial works. 3. Indians of North
   America—Portraits. 4. Indians of North America—Pictorial works.  I.
Marra, Linda. II. Title.

 E98.P86M36 2009
 394—dc22
                                    2008030823

Printed and bound in China
10 9 8 7 6 5 4 3 2 1

Abrams books are available at special discounts when purchased in quantity for premiums and promotions as well as fundraising or educational use. Special editions can also be created to specification. For details, contact specialmarkets@hnabooks.com or the address below.

**HNA** ▮▮▮▮▯▯
**harry n. abrams, inc.**
a subsidiary of La Martinière Groupe

115 West 18th Street
New York, NY 10011
www.hnabooks.com

*case:*
Derwin Velarde's bustle
(pages 87–88)